B was with Ms. Tyson for the most glamorous times—the Academy Awards, the Emmy Awards, White House functions, glittering galas—as well as the tenderest days. Their circle included a who's who of Black celebrities, including Sidney Poitier, Barack Obama, Common, Whitney Houston, Beyoncé, Lenny Kravitz, Viola Davis, Oprah, Tyler Perry, Valerie Simpson, Phylicia Rashad, and many more, most of whom are featured in personal and paparazzi photographs in these pages.

Throughout their time together, B and Cicely enjoyed shocking the fashionistas, shattering inane rules limiting what a woman of a certain age should wear, devoted themselves to changing the world for the better through philanthropic efforts, laughed, cried, and inspired and celebrated each other's excellence.

B shares every aspect of their time together—from the drama of a good sleeve to how to be the best friend possible to those we love.

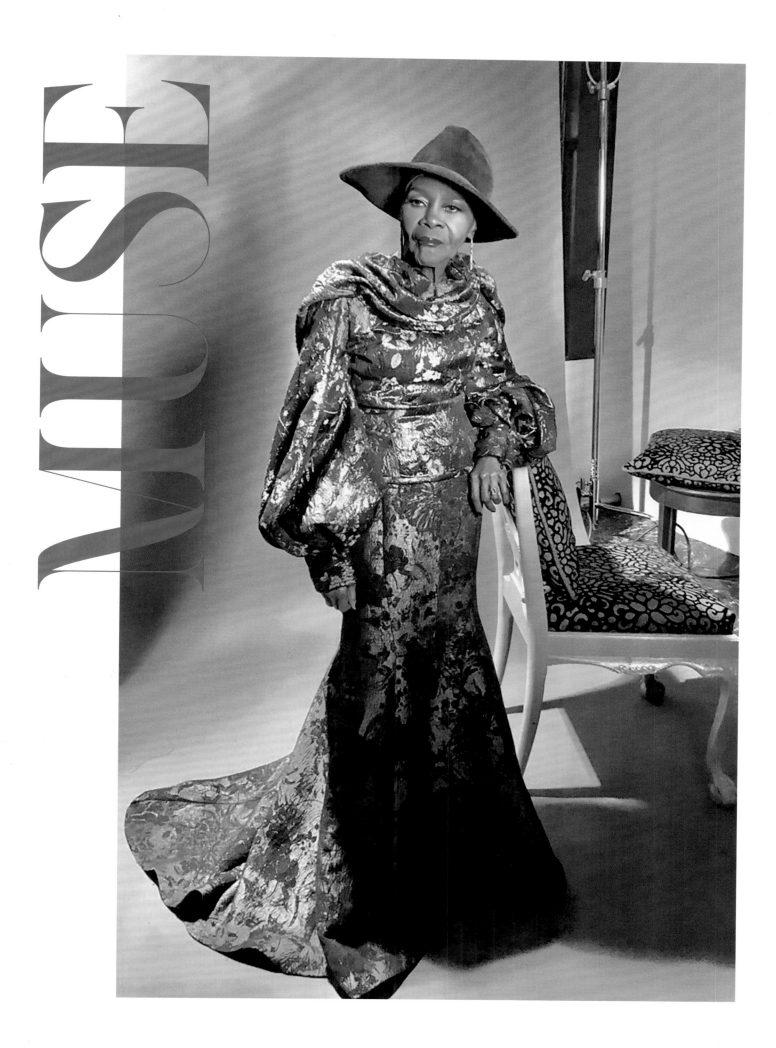

MUSE

# Cicely Tyson and Me:

## A Relationship Forged in Fashion

### B Michael

# MUSE

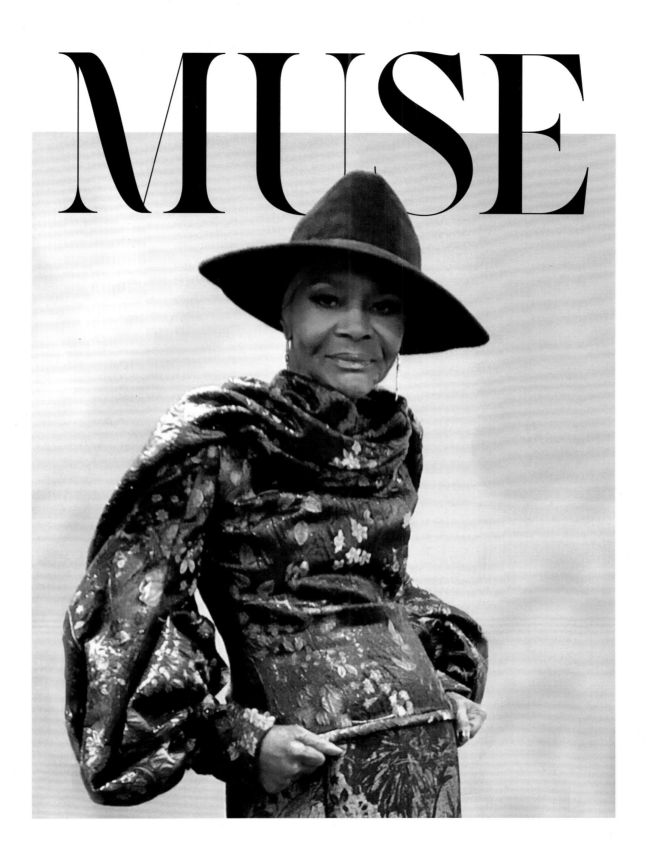

## AMISTAD

*An Imprint of* HarperCollins*Publishers*

**To**

CICELY L. TYSON,
my muse and devoted friend,
the world's legend, Hollywood's icon, cultural queen,
and so much more

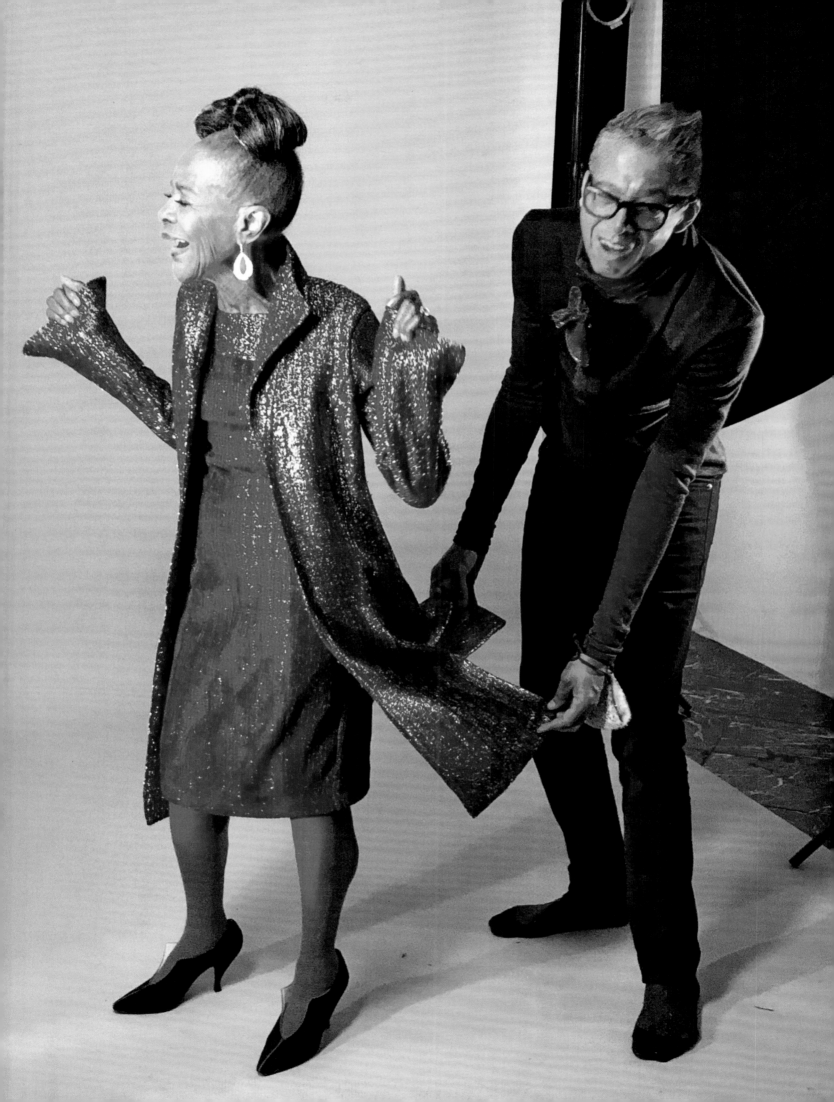

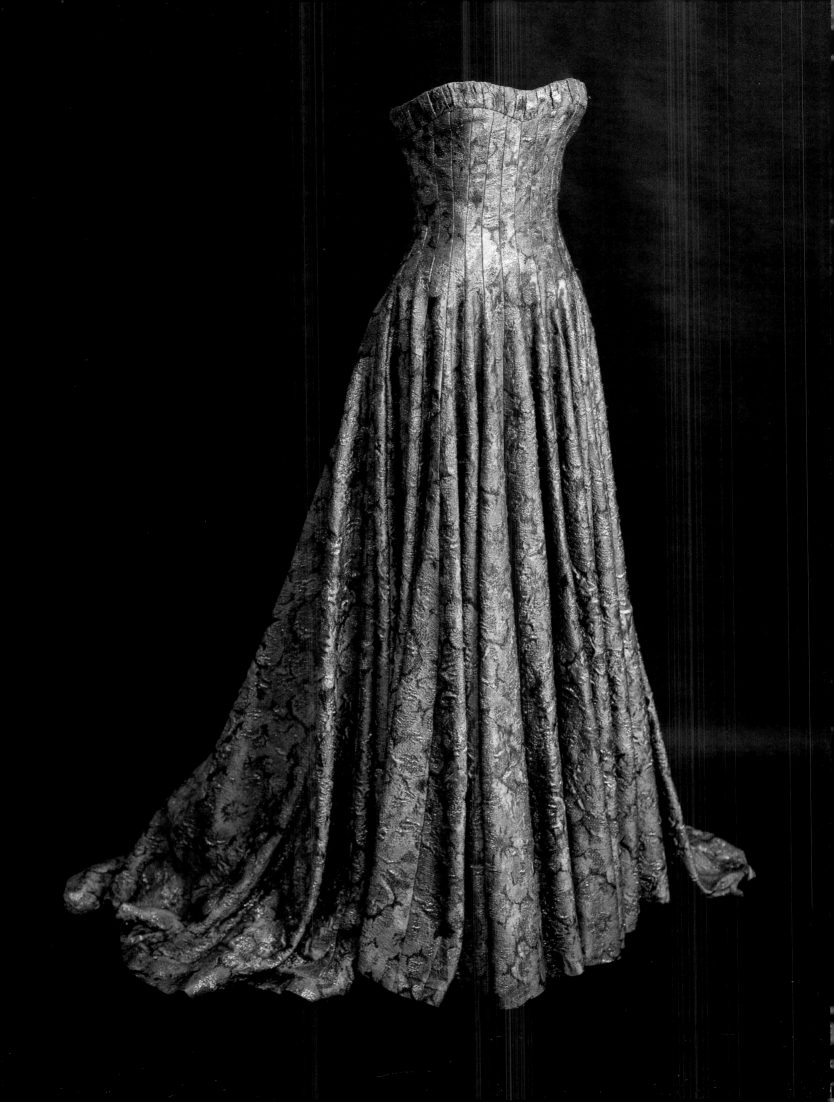

# CONTENTS

FOREWORD . . . XIII

PROLOGUE . . . XVII

My First Ball Gown for My Muse     **5**

The Importance of the Grand Exit     **17**

Celebrating Those Who Serve     **39**

Feathers, Sequins, and Leading Men     **47**

A Surprise Win     **57**

Dressing My Own First Lady     **63**

Thrilled by Life     **71**

The Kennedy Center Honors, Part II     **81**

A New Stage of Life     **87**

Women Dressing for Other Women     **93**

Legend Living in the Moment     **101**

Hope, Healing, Love, and Pride     **111**

Our Cover Girl     **115**

Getting the Call     **119**

The Red Carpet Moment     **131**

A Portrait in Elegance     **137**

A Deeply Personal Honor     **157**

Cicely Pays Tribute to Two Thirds     **163**

THANK YOU . . . 201

"Throughout the ages, as well as being an actress of the highest

level, my godmother, Cicely Tyson, was also the ultimate fashion and

style icon. With her hairstyles, makeup, and innovative ensembles,

she always made seminal sartorial statements while setting the

trends. When Godmother and B Michael crossed paths,

a relationship was forged that lasted until the final day of her life.

As designer, B Michael interpreted her spirit and elegance

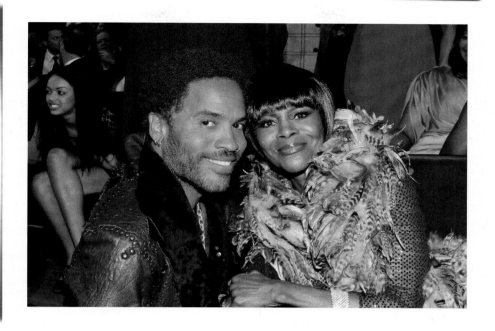

Lenny Kravitz and his godmother, Cicely Tyson, at the forty-third
NAACP Image Awards in Los Angeles, February 2012.

*Photo credit: ZUMA Press, Inc. / Alamy Stock Photo*

inspired creations. Their partnership of muse and creator was

natural and effortless. My godmother always looked and felt like her

amazing authentic self. Daring, confident, and full of life. If I close

my eyes and think of her, I see her dressed in B Michael. And what a

wonderful vision."

**—LENNY KRAVITZ**

"I was always amazed at a young Cicely Tyson's ability to channel elderly characters in her acting roles with such clarity and conviction. So isn't it ironic that in her later years, after meeting B Michael, she seemed to age in reverse, becoming younger and younger with his eye and vision—and her absolute trust in his ideas for her.

"Yes, it's about trust!

"Together they broke down the myths of what each decade should look like. We should all be lucky enough to have a B Michael on speed

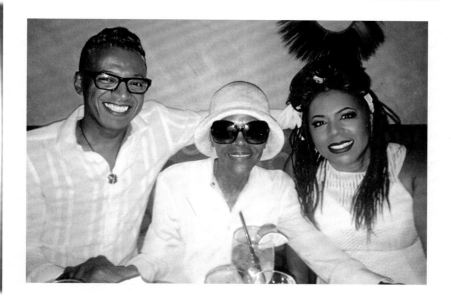

Me, Cicely, and Valerie at the White Party Valerie
hosted on the fifth anniversary of the passing of her husband,
Nick Ashford. Held at the Ashford and Simpson's Sugar Bar.
New York City, August 2016.

*Photo credit: Courtesy of the author*

dial, who can transform our everyday ordinary into elegant ease and/
or couture. Through his innovative designs for her and her ability to
pull them off, we realized you don't have to be dull and out of the
loop in your fashion choices just because you're not twenty or thirty.
Thank you, B, for lengthening all our lives with the knowledge that
we too can be forever fashion forward and fabulous at any age!"

—VALERIE SIMPSON

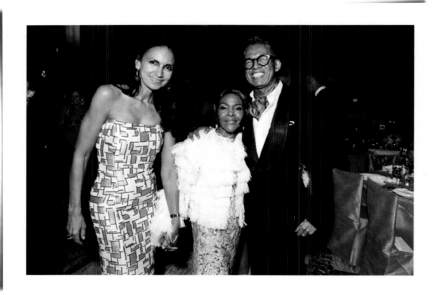

Susan Fales-Hill, Cicely, and me at the American Ballet Theatre
Fall Gala in New York City, October 2017.

*Photo credit: Hunter Abrams / BFA.com*

My late mother, Josephine Premice, held it as an article of faith that a garment should be so meticulously made that it was equally beautiful worn inside out. It was a principle she also applied to her choice of friends: fellow performers Diahann Carroll, Carmen de Lavallade, and Cicely Tyson, remarkable women whose beauty was not mere veneer but a direct expression of the splendor of their hearts and minds. These were shining artistic souls forged in America's crucible of racial adversity. At a time when their country wanted to consign them to the periphery and unapologetically denied them the full expression of their gifts, they refused to remain silent or invisible. Theirs was a daily battle, and unassailable style was a key weapon.

When your own country discounts your full humanity, dressing like the queen that you are is an act of reclamation. Depth, purpose, and exquisite, painstaking construction: that is how these warriors for justice and beauty chose their wardrobes and led their lives.

I met B Michael in 1999, just as my mother's brave and remarkable journey was nearing its end. His exquisite creations with their rigorous architecture and lush linings of paisley chiffon, extravagantly printed silks, and butter-soft satins met the high bar my mother set. His garments weren't thrown together, a reflection of a passing fashion or momentary whim; they had been carefully developed. Like the women who'd raised me, these clothes had provenance, history, and staying power. Throughout her life, my mother had been dressed by the bold-faced named couturiers of France and America: Jacques Fath, Nina Ricci, Givenchy, Charles James, and Pauline Trigère. Along with her friends, she had also sought out and supported the Black designers fighting against all odds to practice their art, much as she and her fellow performers fought to practice theirs: Arthur McGee, Stephen Burrows, Fabrice, and Willi Smith.

She knew, celebrated, and wore them all. Just as my mother was fading from this life, meeting B gave me hope that this line of geniuses, some of whom had already passed away (victims of the AIDS pandemic), had a worthy successor and heir. B became my go-to designer for everything from daywear to evening wear. He even saved me from the dreariness of leggings paired

with "Baby on Board" T-shirts during my pregnancy. At the same time, Aunt Cicely watched over me in the wake of my mother's passing, making certain I knew how much I was loved. In addition to seeing her at events, I'd often run into her on her speed walks through our neighborhood. In those moments, she wasn't put together as Cicely Tyson, award-winning star of stage and screen. She was Cicely the dedicated, intrepid health fanatic: sneakers, a sweater, oversize sunglasses, and a hat obscuring her perfectly sculpted face. We'd hug on the corner of Madison Avenue and 79th Street, she'd coo over my baby daughter and beam her perfect, thousand-watt smile, and, long before we all obsessively measured our daily steps on iPhones, she'd dash on, determined to complete her allotment of miles.

She'd always revered my mother's style, and she applauded the way I embraced my mother's teachings in everything from the way I raised my daughter to my choice of engraved stationery. She phoned me one day to tell me she'd been invited to Oprah Winfrey's Legends Ball and wanted my recommendation for someone to design her gown. "Who's that talented young man who makes so many of the wonderful things you wear?" she asked. Little did I suspect that an introduction and a dress commission for a single event would turn into an artistic union and friendship for the ages.

Looking back, it seems fated. Both Cicely and B elevated personal style to pledges of allegiance to an ideal of timeless elegance, a commitment to excellence, and irrefutable pride. Both have used their lives and gifts to magnify the splendor and dignity of Black women. Over the years, every time I saw Cicely, she would thank me for uniting her with this twin soul and necessary fellow traveler, one who escorted her through the whirlwind of the last fifteen years of her epochal life and career, his clothing providing the perfect setting to the jewel that was her radiant beauty. B made certain she always shone, as magnificent on the outside as she was on the inside.

The expression "icon of style" is, like the word "philanthropist," recklessly overused. But in the case of B and Cicely, their spiritual partnership created images that will fire imaginations and kindle hope for generations yet unborn. The beauty they created together reminds us of the best of who we are, of the promise and possibility of who we might one day be, of the sheer resilience of the human spirit. A Spanish proverb declares, "Traveler, there is no road; the road is made by walking."

Thank you, Aunt Cicely, and thank you, B, for lighting a new path.

"When your own country discounts your full humanity, dressing like the queen that you are is an act of reclamation. Depth, purpose, and exquisite, painstaking construction: that is how these warriors for justice and beauty chose their wardrobes and led their lives."

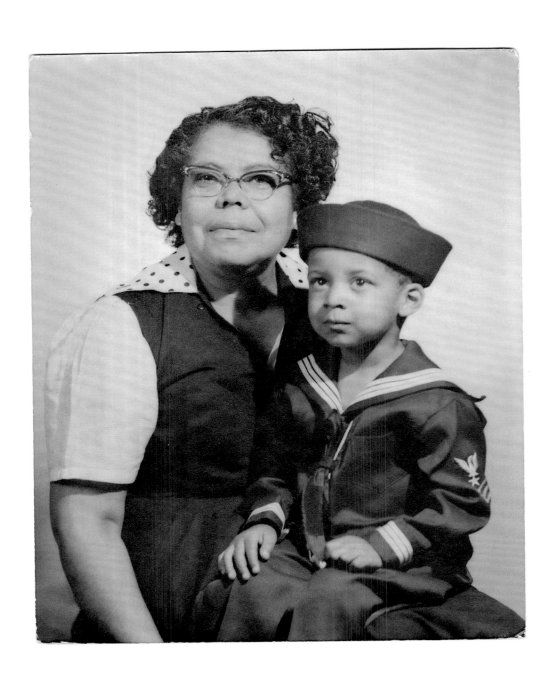

# PROLOGUE

by B Michael

I began the journey to this book as a child, though I didn't know it at the time. I will start by mentioning the person who perhaps did know: my paternal grandmother, Minerva, known as Minnie Mae Walker-Brown.

Instinctively, my grandmother gave me the task of selecting her complete outfit for church on Sunday or any occasion that required dressing up. I would first select the dress and drape it across her bed, and then, as if I were creating a display, I would lay out the shoes, handbag, gloves, hat, and even hosiery and jewelry. This is something I would continue to do for the rest of her life. And Grandmother lived long enough to wear hats and clothing I had designed. As my very first muse, my grandmother prepared me for the day Cicely Tyson would appear at the door of my atelier for the first time.

My favorite pastime as a young boy was dress and hat shopping with my grandmother, which always included lunch in the store or at a restau-

My grandmother and me, circa 1961.

*Photo credit: Courtesy of the author*

rant and a discussion about the fashions we saw. My grandmother bought most of her "good dresses" at a store called Kramer's that used to be in downtown New Haven, Connecticut. It was so glamorous, with valet parking, and the layout was salon style. Clients would be set up in a large dressing room, where lunch or beverages were served. My grandparents were not wealthy or well educated; they didn't attend school beyond the third grade. My grandfather migrated from the South to Connecticut in the late forties and worked for the railroad, a good job for a Black man, which enabled my grandparents to invest in their first home and send my father, their only child, to college.

My grandmother always made the case that taste is taste, unrelated to wealth. What she gave me with those shopping experiences was exposure to luxury fashion. Eventually, my grandmother would say to the saleslady, "My grandson will decide which dress I should take." That was quite a responsibility to give a fourteen-year-old, and yes, I always had an opinion, and Grandmother always trusted it.

I was also influenced by my mother, Sylvia, whose taste for classic silhouettes, fabrics like

English wools in solids and plaids, and classics like seersucker influenced my personal style. My obsession with navy blue comes from her. My mom could have been an interior designer; our home was her showcase, and I was her protégé. My love for textiles and architecture started with her. So, two perspectives shaped my creative point of view: mom's chic, understated way of dressing and my grandmother's full-on elegance, which included hats, gloves, handbags, and shoes in every necessary color.

Growing up, I was obsessed with women's hats and clothing. I enjoyed watching old films, reading about designers like Coco Chanel and Christian Dior, and looking through fashion magazines, which a neighbor, Mrs. Moore, an *Auntie Mame*–type character, would save for me.

Beginning my professional career as a millinery (women's hat) designer, I likened my trajectory to that of Coco Chanel and Halston, who had both begun as milliners and went on to design from head to toe. As a millinery designer, I always saw the entire look: I would sketch both the hat and the dress. I ended up creating collections for Louis Féraud, Oscar de la Renta, and other designers. Then, in 1989, my eponymous millinery collection was launched, leading me ten years later to the presentation of my first full collection on the world stage of New York Fashion Week under the tents at Bryant Park, which was then the official venue for the New York shows. I had hired Eleanor Lambert, considered to be the greatest American publicist. From that Fall/Winter 1999 season, my journey would take on a new path.

In those early years, my work attracted such icons as Nancy Wilson, the legendary jazz singer. She would continue to perform in my gowns until her retirement. One of my greatest honors was when she called me to say she had chosen one of my gowns to donate to the Smithsonian's collection of famed ensembles, which includes fashions worn by important women, including the first ladies and Ella Fitzgerald. Nancy and I were friends until her death in 2018. Another contemporary icon, Beyoncé, wore my couture pieces on her *B'Day* album cover.

The Universe was preparing me for some-

thing, but I didn't know what. Eleanor Lambert's agenda for me included a meaningful philanthropic cause, which led to an introduction to Dayssi Olarte de Kanavos and the organization New Yorkers for Children. The organization's mission is to improve the well-being of youth and families, with an emphasis on older youth aging out of the foster care system. Through Dayssi, I met Susan Fales-Hill around 1999, and another chapter would begin. Susan's style epitomized my aesthetic, and she became the visual inspiration for my work. I would later learn that Susan and I already had a connection through Diahann Carroll, a surrogate aunt to Susan. I had met Diahann during my time as the designer of the millinery collection for the TV series *Dynasty*.

And then another of Susan's surrogate aunts, Cicely Tyson, inquired about the new designer she had been wearing.

Although I am programmed for privacy—particularly about Cicely and others in my personal life—on the pages that follow I will share

**It is a story of friendship, about what we gain from celebrating beauty in those we love.**

how our creative vision unfolded and the tremendous personal relationship that came from it. My relationship with Cicely was forged in fashion and forged in history. And it is a story of friendship, about what we gain from celebrating beauty in those we love.

Cicely's vibrancy and sense of style kept her fashionably relevant. I was addicted to the creative charge to design for and dress my muse, who just happened to be a nonagenarian. Cicely's very presence pushed me creatively to see beyond age bias and see the woman beneath.

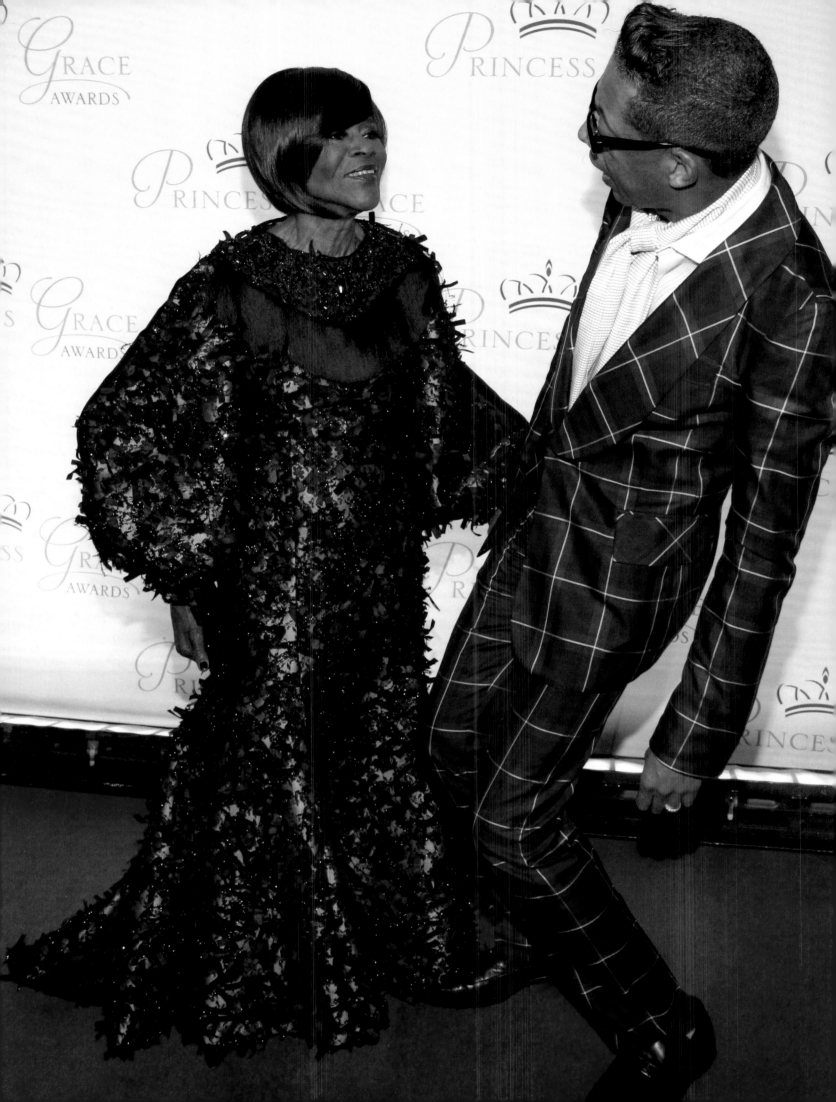

# FRIENDS AT FIRST SIGHT . . .

**E**arly in the week of Oprah Winfrey's Legends Ball in May 2005, groundbreaking Black American makeup artist Joey Mills telephoned me on behalf of Cicely Tyson. "Cicely Tyson would like to know if you would dress her for the upcoming Oprah Winfrey Legends Ball, and if so, she would like to come right over to your atelier!"

I can recall the overwhelming nervousness I felt in anticipation of the momentary arrival of Cicely Tyson. I had no frame of reference for how to dress her. For Nancy Wilson and Beyoncé, there were tons of images of them onstage. My image of Cicely Tyson was as the centenarian Miss Jane Pittman.

Cicely Tyson did indeed come right over, entering my atelier dressed respectfully "shabby casual," wearing a knitted cap over a bandana kerchief tied tightly on her head, and large sunglasses. I could not believe I was greeting Miss Jane Pittman!

There is something to be said about the theory Malcolm Gladwell describes in his book *Blink*. It is the power of thinking without thinking. You are responding to pure energy. You have not yet collected any facts or data or made an assessment. Strictly based on energy, you know instantly to embrace and move forward. *Blink* is what Cicely Tyson and I experienced when she walked into my atelier for the first time: a divine plan that was always in the making would manifest.

When I met Cicely Tyson, she was eighty years old, an iconic, world-renowned actor who had started as a fashion model, with an established sense of style that I would later describe as Haute Eclectic. I asked myself, *What is my creative charge and vision for Cicely Tyson?*

Cicely gave me just one week to prepare her for Oprah Winfrey's Legends Ball. It was like the original story of *Cinderella*, when it was announced, "The prince is giving a ball!" Of course, in this twenty-first-century version, Cicely Tyson was the queen attending the ball, and this designer would have to be the magic wand.

The Legends weekend was a three-day celebration hosted by Oprah Winfrey at which twenty-five Black American women were honored for their contributions to art, entertainment, and civil rights. Over three days, invitees attend a luncheon, a white-tie ball, and a gospel

Getting an affectionate pinch on my cheeks,
in my atelier during the *Zoomer* magazine
photo shoot, December 2020.

*Photo credit: Courtesy of the author*

brunch. Cicely noted that the invitation for the white-tie ball requested that guests wear black and white. Cicely was clear that she wanted something different: a statement and not just a beautiful dress.

Trying to deliver on her request, I suggested a white silk shantung blouse from my Spring 2005 Couture Collection. It had a large wing collar, Shakespearean sleeves, and covered buttons. Cicely found that last detail endearing, since her mother, who had made her own clothing, would send her out to have buttons covered. I completed the look with a black, double-faced, fitted, silk-wool evening skirt that opened to a grand five-point gothic train. To add bling, I provided a Swarovski crystal bib necklace, which also filled in the neckline.

Cicely and I exulted in our creative audacity. The very idea of wearing a blouse and skirt to a white-tie ball! I diverted my atelier team from their current projects so they could immediately begin work on the two pieces, which needed to

be fitted and completed within the week. When Cicely returned for the final fitting, I felt the skirt's waist was slightly too tight. Cicely said it was perfect. It was her routine to fast the day before a major event, and thus the skirt's fit was perfection.

To me, that event felt as important as my first show under my own label. I would enter the fashion world, but this time as the name Cicely would cite when people asked who she was wearing: *Why, it's B Michael.*

Here is the story of Cicely's hat. For the gospel brunch during Oprah's Legends weekend, the invitation suggested ladies wear hats. Cicely, who was just asking me to design her ensemble for the formal event, noticed the original sample of this hat on display in my showroom and asked if she could wear it for the gospel brunch. When Oprah saw it, she loved it, so Cicely gave her the hat as a gift. As my relationship with Cicely broadened over the years, so did our hat designs—as you will discover.

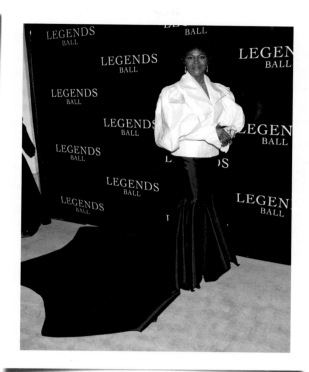

This is the look that started our journey, created for Cicely to wear for Oprah's Legends Ball—a white silk shantung blouse and black silk wool skirt from my Spring 2005 collection, California, May 2005. (Note the same skirt design was worn by Beyoncé in champagne silk wool for her *B'Day* album cover.)

*Photo credit: Frederick M. Brown / Getty*

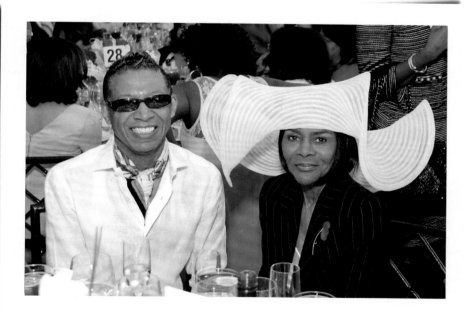

Cicely joined me for the big spring luncheon and fashion show hosted by the New York Chapter of the Links, an international not-for-profit organization with a membership of more than sixteen thousand professional women of African descent.

*Photo credit: Afrikanspot NYC Photographer*

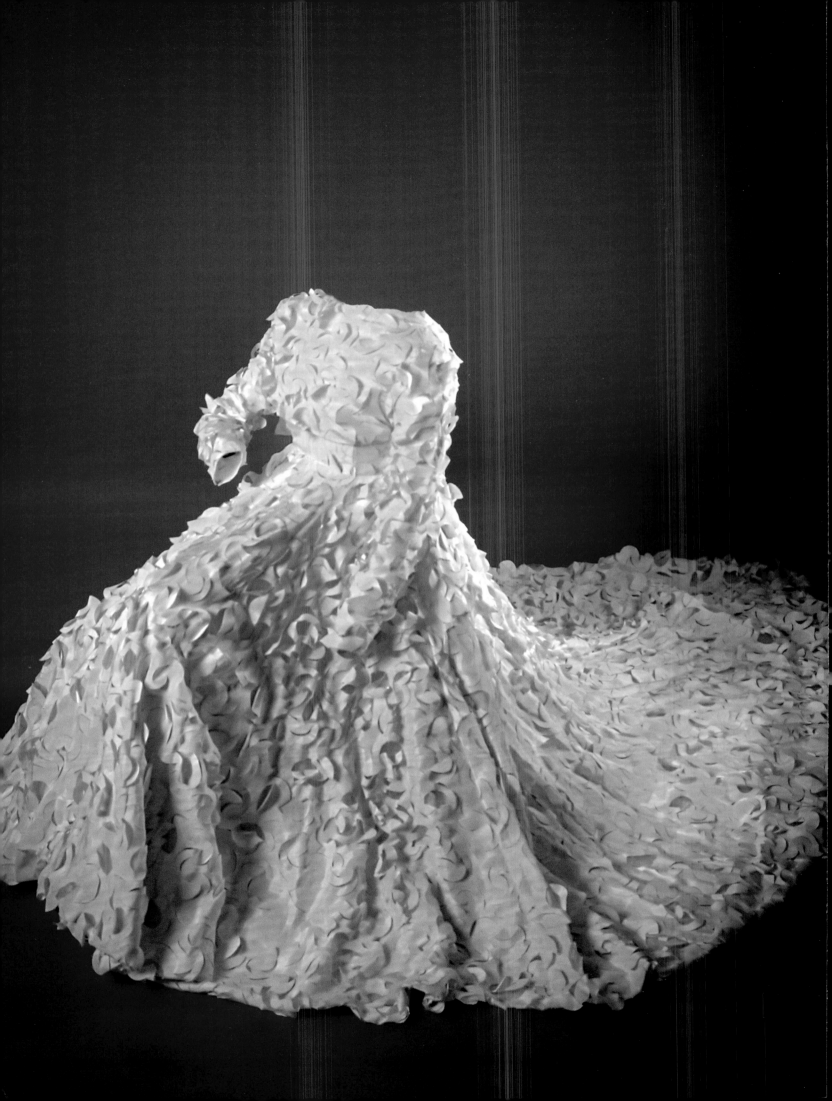

# THE ANGELIC WHITE BALL GOWN

### Spingarn Medal

Cicely always had award shows to attend and honors to accept for her amazing work on-screen. But one prize, the Spingarn Medal, meant more to her than any gold trophy. The NAACP created this honor in 1914 to applaud a man or woman of African descent and American citizenship for outstanding achievement "in any honorable field or endeavor." The medal bears the name of Jewish civil rights activist and former NAACP chairman Joel Elias Spingarn. Past recipients include a who's who of Black visionaries, including writer Maya Angelou, agricultural scientist George Washington Carver, concert artist, film and stage actor Paul Robeson, baseball great Hank Aaron, and heroic activist Rosa Parks.

For this important gala in July 2010, I wanted Cicely's ball gown to have the *pow* of a monochromatic pure-white palette but without any bridal or debutante references. I designed a strapless gown with a full sweep and train in champagne-hued silk Mikado that I overlaid with laser-cut white silk. I love the laser-cut technique because it gives the movement and dimension of lace but with a much more modern feel. The 3D swirls fluttered like petals in the breeze when she took the stage to accept this prestigious honor. I even created a canvas for the medal with the simple white bodice, square neckline, and chic laser-cut bolero jacket. Cicely always referred to this gown

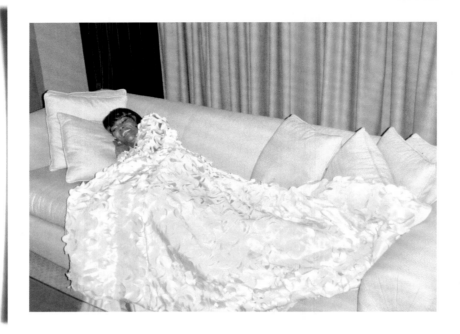

Cicely in relaxation mode in the
hotel suite after the show.

*Photo credit: Courtesy of the author*

as her favorite. She wanted to wear it again, although we only used it for that one occasion. The technique of laser-cut fabric would follow us throughout our fashion journey together.

Cicely was emotional as she accepted the award. "I have had the good fortune of being acknowledged for accomplishments throughout my career," she said, "but the fact that I am now being recognized for what has been my life's goal by the most distinguished organization within our community is moving beyond words." Mark-Anthony Edwards, my partner in life and cofounder of our business, and I watched her, mesmerized.

After any event outside of New York, Cicely and I would head back to the hotel suite to change into comfortable clothes and decompress. We loved to recap the night. But on this evening in Kansas City, Cicely didn't want to take off the gown. "I just love it too much to change!" she said, laughing from the sofa. So we ordered a feast of champagne and fried chicken to be sent up to the suite, and the three of us carried on the celebration well past midnight.

This selfie of Mark-Anthony, Cicely, and me
was taken when we moved to Harlem. Cicely was
our first guest, December 2013.

*Photo credit: Courtesy of the author*

## The Beginning of the Thirds

### BY MARK-ANTHONY EDWARDS

Who would have thought a chance meeting in an elevator more than seventeen years ago would lead to love and, later, a business collaboration that would change my life forever? I first encountered B soon after he had met Cicely Tyson. And I was blessed to witness the evolution of his gift—creativity and design genius—from a front-row seat.

When B introduced me to the incomparable Ms. Tyson, I found being in her presence indescribable. Her light and energy had to be experienced firsthand. To be completely truthful, I didn't know who either of them were initially. I was unfamiliar with their body of work, as I was not into fashion or film.

Over the passing years, I came to believe that the Universe (God) intervened in all three of our lives and brought us together with intention: first B and Cicely with Oprah's Legends Ball, then B and me in that elevator. I believe the Universe in its perfect divine order brought us together to disrupt and inspire change in our respective industries. The fashion industry was not kind to or inclusive of B Michael's genius. However, the three of us focused on our individual charge. Fueled by the magic and intention of the Universe bringing us together, we allowed the hard work to speak for itself. B and Cicely accomplished too many industry firsts to list, individually and together.

I am so grateful for knowing and loving them both. Cicely named us "the Thirds," and after our calls, visits, dinners, or goodbyes, Cicely would say, "Blessed be the tie that binds." The Universe performs amazing miracles every day. We must be open to seeing the magic in order to experience the miracle for a moment or, if we are truly lucky, a lifetime. I am grateful that my heart and mind were open that day in the elevator.

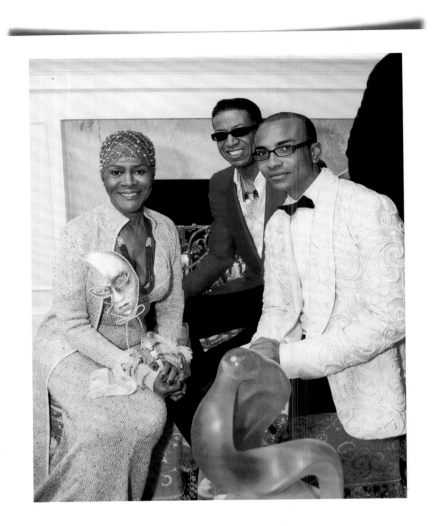

# CICELY AND I PLAY WITH THE FASHION RULES

Knitwear as Evening Wear

Cicely invited me to many parties and premieres, but on one night in 2008, she was actually my plus-one. Every year, my friends hosted a glamorous masquerade soiree for the holidays at their palatial home in San Francisco. When I asked Cicely to join Mark-Anthony and me a few years into our friendship, she didn't think twice. Cicely was like that: spontaneous and open to new adventures.

Even in her eighties (and nineties, as I would find out), she would hop on a plane for a one-night celebration. Needless to say, Cicely was the toast of the evening. The elated hostess announced and welcomed Cicely, prompting each guest to make their way to her throughout the evening to share a "when I saw the movie" story.

Later that night, one of the party guests invited us to stop by her husband's new restaurant. It must have been midnight, but we didn't hesitate. The next thing you knew, Cicely, Mark-Anthony, and I were feasting on the chef's specialty, shrimp and grits, dressed like royalty.

Cicely, me, and Mark-Anthony at our friends' holiday party in San Francisco, November 2008.

*Photo credit: Courtesy of the author*

The photo of us taken at the party captured what we were feeling. I now regard it as a family photograph and have it framed on my fireplace mantel. For the party, I created for Cicely an elegant but easy-to-wear knit evening ensemble: a floor-length sweater topper with fringe detail and fingertip-length fitted sleeves in metallic and wool bouclé yarns atop a matching gown with a plunging V-neck. I love the idea of creating evening wear with elements typically seen in daytime or casual clothing. We added our go-to accessory—a skullcap in gold beads—plus ropes of gorgeous rubies to accentuate her décolletage and the necessary accessory of the evening, a handheld Venetian mask.

A month after attending the party in San Francisco, Mark-Anthony and I were headed to the UNICEF Snowflake Ball. This annual gala raises funds for vulnerable children and is a highlight of the New York City social holiday season. Our table host asked if there was

someone we would like to invite. Of course, she was beyond excited that we invited Cicely to join us.

It struck me that night that the late actress Audrey Hepburn was one of the original ambassadors for UNICEF, and her pixie-like face became synonymous with the cause. Being there with Cicely, I realized that Audrey Hepburn's relationship to Hubert de Givenchy was like Cicely Tyson's relationship to me. It felt like yet another sign that we were meant to collaborate as designer and muse.

Before sustainable fashion was in fashion and in keeping with my philosophy of making couture that's timeless, I loved to repeat looks on the red carpet. Cicely wore that same knit ensemble to the UNICEF event. She laughed that she was wearing, in essence, "a sweater as evening wear." She loved nudging convention that way, in a look that was left or right of the norm. This time, we did her hair in a sleek, modern bob. Cicely was always on the prowl for a new hairstyle that would vary her head-to-toe look.

Sometimes, she would call me just to say, "B! I can't wait to show you the wig I just picked up!" Some women collect handbags or shoes—Cicely was like that with wigs. Her face was a canvas, and a wig became a sleek or ornate frame. We had easily over a hundred of them.

## Two Epic Women, One Dress

Dressing two epic women in the same look is typically not an option for a fashion house. In fact, it could be a disaster. Who hasn't heard the catty blowback when a starlet strolls the red carpet in a dress worn earlier by another actor? Some magazines will show side-by-side photos of celebrities in the same dress, with the caption, "Who wore it best?" But when Nancy Wilson's manager approached me about a gown for the jazz legend's performance at Lincoln Center, knowing we would not have an opportunity for a proper fitting, I had a thought. What if Nancy, who was a dear friend of mine, hit the stage in that knit ensemble Cicely wore a year earlier? I

Backstage flanked by Cicely and Nancy.

*Photo credit: Courtesy of the author*

felt as if the dress had an energy that these two iconic women shared.

First, I asked Cicely for her blessing, which she granted immediately. Then I approached Nancy, who simply said, "Wow! I love that idea." Their willingness to wear the same look nods to the overwhelming respect these women felt for each other—and to their security in themselves.

Neither woman worried about being eclipsed by wearing the same dress. That speaks volumes.

After the performance, Cicely, Nancy, and I had a moment backstage. I could feel that glorious harmony, just standing beside them. The fact that they both embraced me as an artist and a friend still brings me joy that never fades.

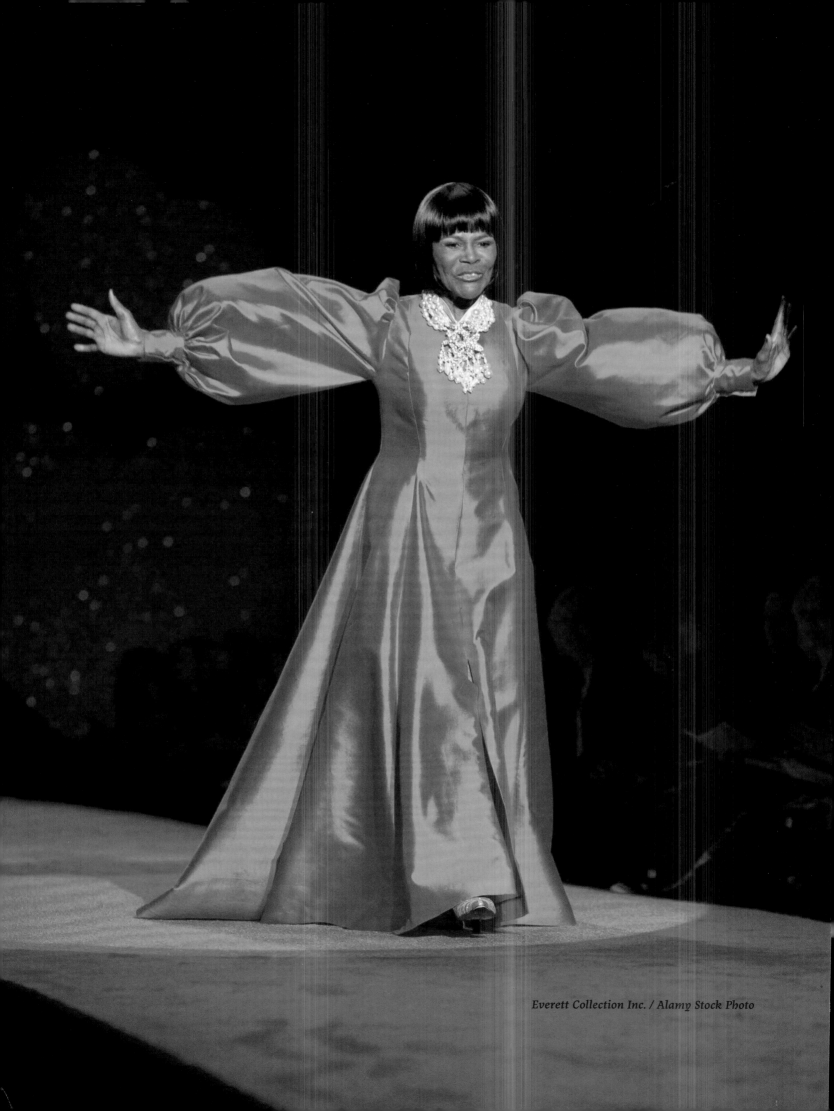

# WE DEBUT TOGETHER ON THE WORLD FASHION STAGE

The Red Heart Ball Gown

**A**lthough Cicely by this time was wearing my clothes publicly and privately, we had not yet captured the attention of the fashion industry. In 2009, when Cicely was invited to walk the celebrity runway for the national Heart Truth show during Fashion Week, rather than selecting a designer from the organizer's suggested list to create her red dress, she turned to me. You could say it was the industry debut of our bond as designer and muse. The national Heart Truth campaign launched in 2001 to alert women of the risks of cardiovascular disease—and the fashion industry joined forces a few years later with an annual Red Dress event. It's a fun, splashy night that opened New York Fashion Week in February.

In my mind, Cicely's red dress needed to stand out like the most elegantly appointed holiday window. I created a princess-line gown with godets inserted at the waist, cascading into a dramatic sweep of dazzling ruby red double-faced silk wool. The voluminous Shakespearean sleeves gave a regal touch and heightened the outsize silhouette. The effect was high-octane glamour—especially when we added a bold costume necklace in silk-satin ribbon, statement baroque pearls, and semiprecious stones that I had designed and used as a headpiece for one of my runway collections.

You would never know Cicely was nervous about strutting down the catwalk that night. But really, even though she started out as a model, Cicely wasn't accustomed to taking center stage out of character. As we walked to the event in the rain, with Cicely looking like Little Red Riding Hood, I gave her some advice: Pretend you're playing a role. The cameras are rolling. Act the part. And that's exactly what she did. Cicely sashayed out, with her arms open wide and an even wider smile. She laughed every step of the way, and her joy infected the crowd of typically stoic fashion insiders. For me, sitting in the front row, seeing our names up there together marked a milestone in our relationship. The deafening applause made my heart leap too. This was a defining moment.

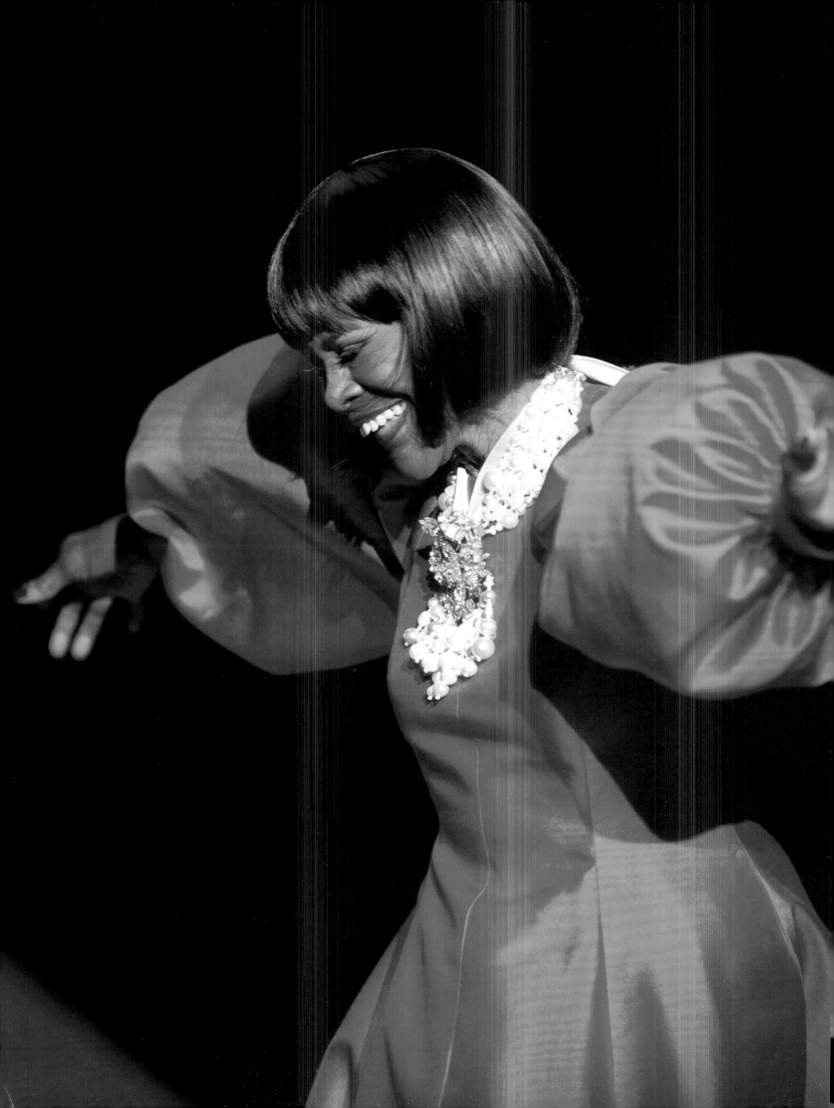

Marking the moment.

*Photo credit: Courtesy of the author*

# BLACK AND WHITE AND WHITE AND BLACK INVERTED GOWNS

**2011 BET Honors and 2015 Paley Center Gala**

I once complained to Mark-Anthony that New York Fashion Week was two months away, and I had no inspiration for the new collection. "Inspiration is for amateurs," Mark-Anthony matter-of-factly replied. I did not get the response I was hoping for, but I did get a lesson that now follows me: I don't need a thunderbolt of inspiration to start working; my entire life is rich in inspiration. From that moment on, I stopped having creative block.

I almost always carry a sketch pad in my street bag, but one day I didn't have it with me when I had an "aha" moment. At lunch at a café, I envisioned a high collar with points like church steeples. So, I sketched the design on a paper napkin. That shred of an idea evolved into one of Cicely's all-time favorite looks: this regal brocade strapless gown with a fluted trumpet skirt and a chic, fitted bolero jacket.

I knew that contrasting colors on the front and back of the gown would create what I call the "dramatic exit." Think of it as the opposite of the dramatic entrance. But I couldn't decide on the black or white sumptuous brocade for the face of the dress, so I created two gowns— one in each contrasting colorway. Cicely loved both and didn't want to pick just one, enjoying too much the idea of making people do a double take when they saw her in seemingly the same dress at two different events. She would say, "I'm going to wear the dress tonight in black. And another night, I'll wear the white.

Being introduced by Cicely to the award-winning
actor Jamie Foxx, 2011.

*Photo credit: Courtesy of the author*

People are going to think they had too much champagne!"

She wore the black version to the BET Honors in 2011. That year, Cicely was given the Theatrical Arts Award. "I'm told that I have one minute," she said when she got onstage, looking like a grande dame. "Well, it took me a minute to get up here." Of course, the crowd went wild.

One of my favorite looks came a few years later for a gala at the Paley Center for Media called A Tribute to African-American Achievements in Television. We went with the white-front gown for that. You can see how I styled the look completely differently. Cicely's lush afro and giant diamond hoop earrings made it feel both of-the-moment and retro. The event also commemorated the fiftieth anniversary of the Voting Rights Act of 1965, so Cicely's evocative vintage vibe felt right on point.

After Cicely and I decided to collaborate exclusively, she spread the word. When she brought me over to meet Jamie Foxx that evening at the BET Honors, she said, "Do you know my designer, B Michael?" That was her go-to introduction for me. Now if she wanted to have some fun, she had a special comeback. When someone told Cicely she looked fantastic in a dress, she would point at me, roll her eyes, and say, "Blame him." In this after-party snapshot of us, I'm wearing my signature red shawl jacket with a vintage silk ascot, and Mark-Anthony looks very posh in his embroidered dinner jacket and bow tie. I sometimes dressed to complement Cicely's look with a pop of color or a similar palette.

**We Took a Runway Bow as Muse and Designer**
Cicely loved attending my New York Fashion Week runway shows. She always sat front row center, as the official muse, with celebrity friends, couture clients, and fashion editors. By this point, she was a fixture in my life both personally and professionally. And though she started out as a model in her early thirties, Cicely didn't have any interest in revisiting those days of posing and pouting—or so I thought.

Shortly after the BET Honors, she turned

Taking a bow at the 2011 Fashion Week show at
the Plaza Hotel.

*Photo credit: Courtesy of the author*

to me and said, "I want to be in this season's runway show, and I have to wear that black and white brocade dress."

I was stunned, but not too much to understand that her statement was one of affirmation and not a question. I had no doubt Cicely loved me; but I was clear that her wanting to be in the show was all about how much she loved that gown.

On the afternoon of the show, Cicely slipped into the black gown backstage, while guests gathered in the ballroom of the legendary Plaza Hotel in New York City. Attendees included our good friends, the superstar musical duo Nick Ashford and Valerie Simpson. (Known as Ashford & Simpson, they wrote such hits as "Ain't No Mountain High Enough," "Solid," and "I'm Every Woman," to name just a few.) Also in attendance was another friend, Diana Ross's daughter Rhonda Ross Kendrick, a singer and actress, with whom Cicely, Mark-Anthony, and I had a very special relationship.

As the venue was filling up, everyone whispered, "Where's Cicely Tyson?" It was shocking that she wasn't there. When the lights

went down and we cued the music, people said, "How can B start without Cicely?" It was now a *thing.*

Then, just as the first model hit the runway, the lights dimmed, and the music died. We had a power outage! (I like to joke that Cicely caused the blackout with all of her star wattage backstage.) Of course, this is every fashion designer's worst nightmare. But the host of the event from Morgan Stanley—which had graciously sponsored my show—stood up and joked, "Hey, if we don't get the power back, Ashford & Simpson is in the house, and we can't have better music than that!" That cracked us all up, and then voilà: the power came back on.

Midway through the show, Cicely suddenly appeared on the catwalk, and everyone lost it. She strutted every step in her new favorite black-front gown as she faced the audience with a huge smile, and then as she walked back up the double-sided runway, she showed the white back of her gown like a supermodel. It was momentous for so many reasons. Nowadays, there's a lot of talk of inclusivity

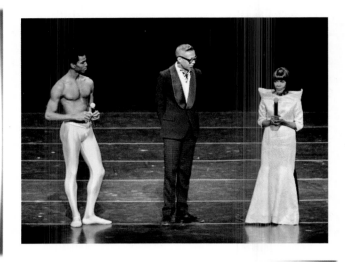

I love what this photo represents to the arts. Onstage
with American Ballet Theatre principal dancer Calvin
Royal III and Cicely at the YAGP gala and tribute to
Arthur Mitchell at Lincoln Center, April 2019.

*Photo credit: Courtesy of YAGP*

in fashion. But back in 2011, diversity wasn't
part of the discussion. To have a Black icon on
the runway of a Black designer at New York
Fashion Week stood out. It didn't even occur to
me that Cicely was eighty-six years old at the
time, which also shattered the ageist ideals of
the fashion and beauty industries. When Cicely
and I took a bow together at the end of my
show, we knew we were making history!

## Elegance Is Ageless, and Like Art, It Is Universal

I intentionally design classic, timeless couture
with no expiration date. My looks should last
many lifetimes and be passed down from
mother to daughter. With what we now refer to
as sustainable couture in mind, we returned to
the white brocade gown eight years later. This
occasion was an evening that celebrated the
late founder of the Dance Theatre of Harlem,
Arthur Mitchell, who was a very dear friend to
Cicely. In fact, she helped him launch the Dance
Theatre of Harlem—the first Black classical
ballet company—in 1969.

Cicely and I both loved dance. I'm on the
board of the Youth America Grand Prix
(YAGP), which is the world's largest nonprofit
international student ballet competition and
scholarship program. We also help young
dancers get placed with dance companies
around the world. At their 2019 Spring Gala,
YAGP hosted a tribute to Arthur Mitchell, so
I asked Cicely to pay homage to the pioneer
that night onstage. I knew the white gown
and steeple collar would make a dramatic
statement. Moments after Cicely's emotional
tribute, and before performing a powerful solo,
Calvin Royal III, the third Black dancer to be
a principal with the American Ballet Theatre,
told everyone that *both* Arthur and Cicely were
his role models.

Cicely looking daring and glamorous
at the Paley Center for Media event,
A Tribute to African-American Achievements in
Television, in New York City, May 2015.

*Photo credit: Everett Collection Inc. / Alamy Stock Photo*

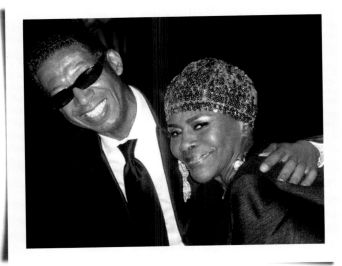

Cicely and me enjoying being together at the sixty-first Primetime Emmy Awards in Los Angeles, September 2009.

*Photo credit: Courtesy of the author*

# "I HAVE TO START WEARING YOU EXCLUSIVELY"

The sixty-first Emmy Awards will always stand out in my mind, but not because Cicely was nominated that night for outstanding supporting actress for her role as Pearl in the Hallmark movie *Relative Stranger*. "I'm here to promote the project. Not because I think I might win," she said to me as we swept down the red carpet.

"Cicely! Ms. Tyson!" reporters and paparazzi shouted at her, desperate for an exclusive interview or a great shot. Of course, they also wanted to know who she was wearing. It wasn't a B Michael look—although I helped select the pleated, black silk Issey Miyake from her wardrobe and got her ready. Cicely would later realize that our relationship was evolving—I was there as her friend and escort, but there was more.

After the awards show, we dashed over to the Governors Ball, which is a seated dinner for attendees. Cicely didn't take home an Emmy that night, but I felt as if I had won a prize when she said to me, "You know, B, I have to start wearing you exclusively because everyone will assume I'm in one of your dresses, especially since we're together so much."

In essence, Cicely Tyson was declaring she would be my muse, a creative inspiration and ambassador of my designs. I remember not wanting to show how emotional those words made me feel. I also wanted to present to Cicely a professional front—assuring her I was prepared to be her designer—while inside I was feeling the kind of euphoria one feels when what you once imagined is manifesting from one moment to the next. I told Cicely I had a different vision for her going forward: "You're Hollywood royalty, and I would like to dress you like a queen." She liked that, of course. And so began our new chapter as designer and muse.

CT
Elton John
Nov 2015

Lavender Silk Mikado

FRONT

BACK

B

**B** saw Ms. Tyson as neither fashion-obsessive consumer nor wannabe designer. A consummate professional, she believed in people doing their jobs; hers was acting; his, designing fashion and style-making.

Ms. Tyson found in B a couturier whom she could trust to maximize her beauty while dressing her appropriately for each occasion. He found in her that rare muse who inspires over the long term, yet not in the sense with which that word has come to be associated: the male artist driven to wild feats of creativity by the mere existence of a beautiful woman, passive in her inspirational role. Rather, they collaborated intellectually, with a like mindset.

In her book, Ms. Tyson acknowledged B's importance in her life. She described how she felt at the 2013 Tony Awards at Radio City Music Hall when she wore one of his most demonstrative creations, an indigo Mikado gown covered in sharp, architectural ruffles. "He aimed to make me feel like royalty. On that evening and a great many others, he succeeded," she wrote.

Surely, in B, Ms. Tyson found her couturier for life. More important, she found as well "a beloved trusted friend."

—**Bridget Foley**

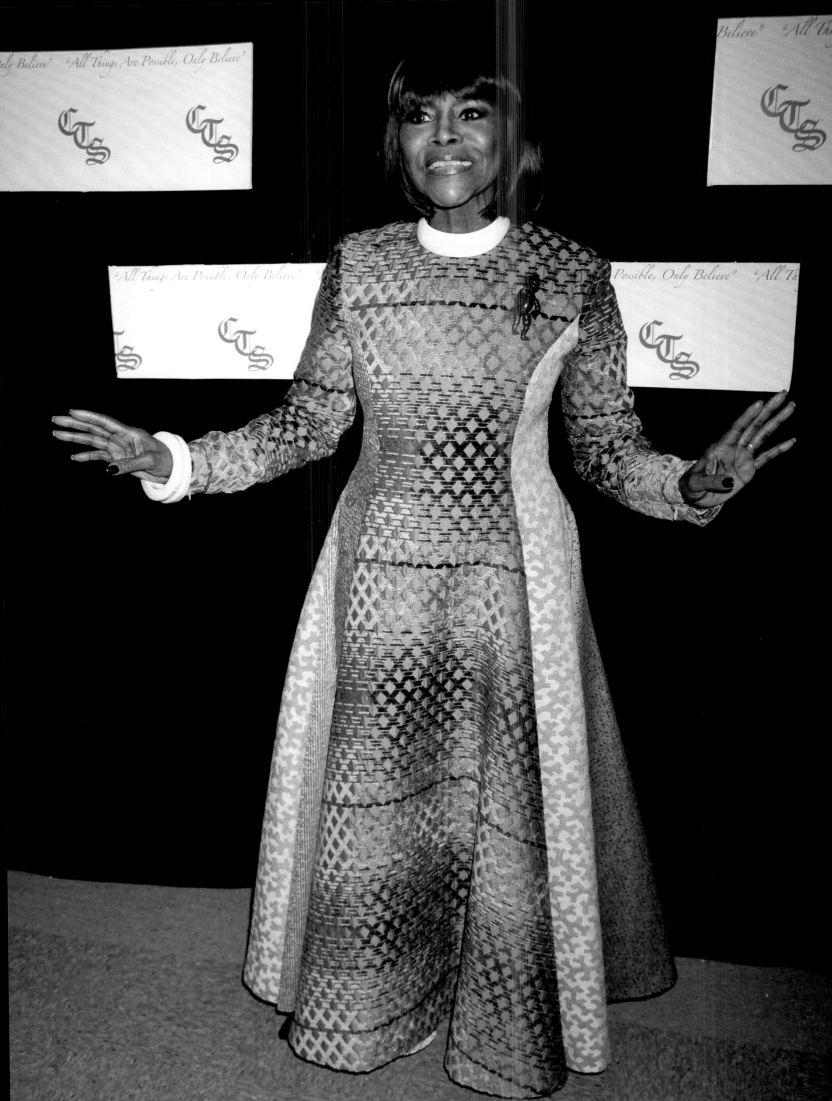

# CICELY: A LESSON ON CARING

## The Opening of the Cicely Tyson School

Cicely was no drive-by philanthropist. When she agreed to be the namesake of the brand-new Cicely L. Tyson Community School of Performing and Fine Arts in East Orange, New Jersey, she committed to walking its halls, seeing the performances, and holding the school to its promises of outstanding academic standards and quality opportunities.

She insisted that her school would be state-of-the-art, with an eight-hundred-seat theater built to Broadway standards. We all embraced the school's motto: "We Aim High. We Soar High."

For the opening gala, I had to aim high. With no warning, Cicely designated me as auctioneer to raise funds onstage. That was far beyond my imagination; clearly, Cicely saw something in me I had not yet embraced. Fortunately, I had friends in the audience, such as Valerie Simpson and Nick Ashford, Oprah Winfrey, actresses Angela Bassett, Tamara Tunie, and Lynn Whitfield, and so many others. Soledad O'Brien, the acclaimed American broadcast journalist and executive producer, who was the emcee, cheered me on too. And I did soar. I even auctioned off a few of my couture dresses to benefit the prestigious school.

In the years that followed, Cicely, Mark-Anthony, and I, as well as friends, family, and titans of various industries, attended graduations and took in student productions, such as *The Nutcracker*, which was always one of my favorites. In December of each year, the school would hold a staged performance or concert in celebration of Cicely's birthday; she was their matriarch. Cicely would go on to create life-changing experiences for the students—including arranging for the school choir to perform onstage at the John F. Kennedy Center for the Performing Arts in Washington, DC, for the thirty-eighth Annual Kennedy Center Honors, which was televised, when she received the prestigious Kennedy Center Honor's Lifetime Achievement Award in 2015.

For the formal unveiling of the school, I designed a multi-textured cotton-twill and silk-velvet dress in varying shades of brown. It was inspired by the medley of hues of the children who would learn to act, dance, or become classical musicians and sing their truth on Cicely's stage. Staying in the same theme, we added ivory bangles, a collar, and a Black baby-doll pin by the iconoclastic American-in-Paris fashion designer Patrick Kelly. Cicely felt the dress and her look were perfect, which was most important to me for this once-in-a-lifetime moment and celebration of her commitment to the school.

Cicely at the grand unveiling of the Cicely L. Tyson Community School of Performing and Fine Arts in East Orange, New Jersey, October 2009.

*Photo credit: Storm Media Group / Alamy Stock Photo*

Cicely and me walking to Lena Horne's
funeral at the Church of Saint Ignatius Loyola
in New York City, May 2010.

*Photo credit: ZUMA Press, Inc. / Alamy Stock Photo*

A page featuring Lena Horne's
hat and my handwritten
note from the catalog for the
auction of her estate, February
2011.

*Photo credit: Doyle Auctioneers
and Appraisers*

# FRIENDS IN GOOD TIMES AND SAD TIMES

Lena Horne's Funeral and the Auction Hat

On the morning of Lena Horne's funeral mass in May 2010, Cicely and I didn't discuss an outfit for the service. Without saying a word, we both knew this was not an occasion to get fancied up. We had that kind of telepathy. I simply picked Cicely up at her Upper East Side apartment that morning, and we walked to the Frank E. Campbell Funeral Chapel. After paying our last respects, we walked the ten or so blocks from Madison Avenue over to the Church of Saint Ignatius Loyola on Park Avenue.

Outside the church, some in the crowd of on-lookers held signs; others consoled each other. Their presence underscored the fact that the world had lost an icon. Of course, Cicely caused a tremor as we walked by. After the service, some of us gathered for a repast—including the extraordinary dancer Carmen de Lavallade and her husband Geoffrey Holder, the acclaimed actor, who was a principal dancer for the Metropolitan Opera Ballet early in his career, as well as an artist and costume designer. Talk turned to how we were losing so many of the great ones. "I don't know what the Lord is keeping me here for," Cicely said with a laugh—and that became her refrain whenever we lost another legend.

The year following Lena Horne's death, the prestigious Doyle auction house in New York held a private showing before the much-anticipated auction for her estate. Cicely and I attended, along with many mutual friends. Being among so many items—elegant jewelry, gowns, accessories, memorabilia, fine art, furniture from her home, and on and on—that were precious and meaningful for Lena throughout her well-lived life felt like another wake. I think Cicely first spotted one of the hats I had created for Lena, together with the original hat box and handwritten note dated June 18, 1992. I was overwhelmed with gratitude that Lena had cherished my work in such a way. Cicely planned to bid on the hat, but we were traveling on the actual day of the auction and missed the opportunity. I had met Lena Horne at the memorial service for the designer Patrick Kelly in New York City in 1990. She asked about a black hat from my collection that she had seen at the New York City flagship store for Saks Fifth Avenue. She wanted it in brown, took my contact information, and asked to come and see me. I made her the hat in brown, and we remained friends until her death. Lena was another connection Cicely and I later realized we shared.

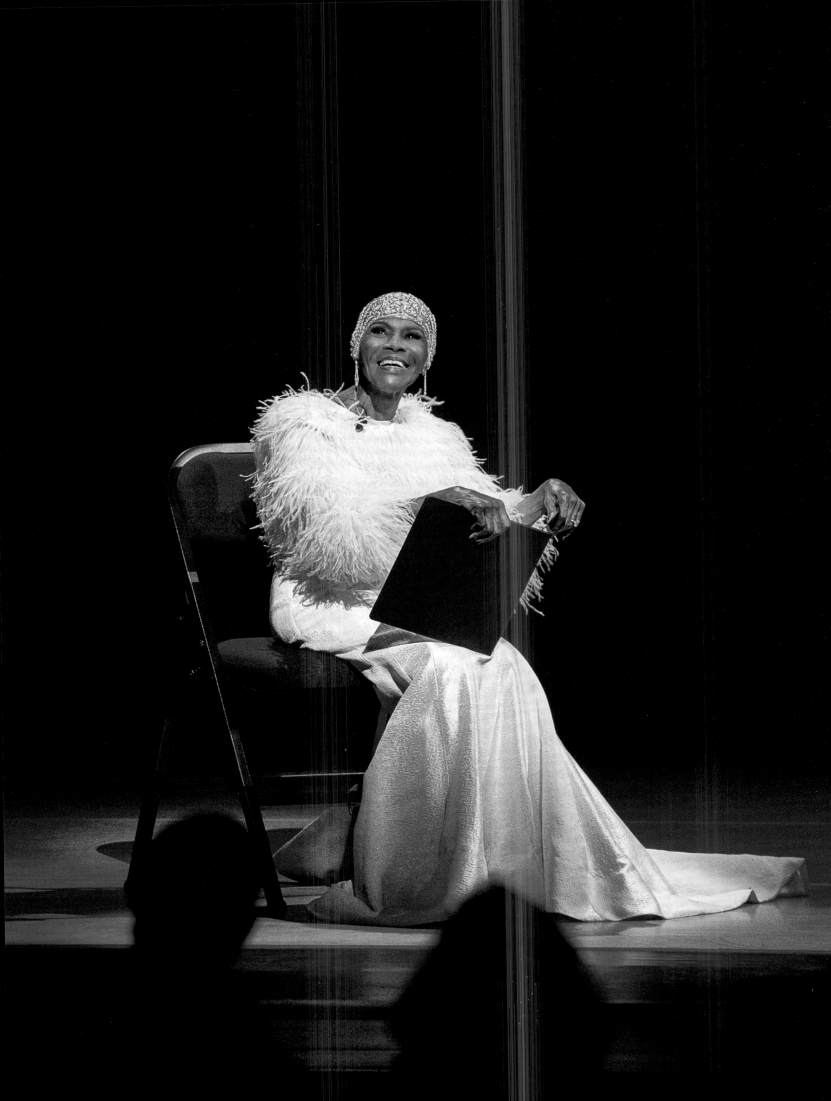

# DRESSING A MUSE IN MOVEMENT

Cicely was asked to cohost the Alvin Ailey Sixtieth Anniversary Gala in 2018 with another good friend of hers, the award-winning actress Angela Bassett. They would each have a solo moment onstage. I knew Cicely needed a ball gown that would be both dramatic and ethereal. By this time, I understood well the impact of dressing Cicely in white, especially when on a large stage with a focused spotlight.

For inspiration, I turned to *Revelations*, which is the signature masterpiece that Alvin Ailey choreographed in 1960 at the age of just twenty-nine. I recall when I first saw the spiritual ballet. It was a depiction of the human experience with leaps of joy and tumbles of grief. The company has performed this seminal dance every year for more than six decades—and it has been seen by more people around the world than any other modern work. Drawing on the use of traditional white for the costumes in the second act and inspired by its graceful flow, I created a dress from twelve yards of white silk brocade with sixty vertical seams in the bodice opening up

Cicely preparing to speak at the sixtieth anniversary of the Alvin Ailey American Dance Theater, November 2018.

*Photo credit: Courtesy of Christopher Duggan*

to a full sweep that mimicked the gentle, joyful movement of *Revelations'* "Wade in the Water."

Just before Cicely's onstage tribute to the master choreographer, I dashed out while the curtain was closed to prop the dress so it would cascade elegantly to the floor. When the curtains opened on a completely dark theater with Cicely seated in that stark spotlight, I heard a huge intake of breath. Cicely didn't speak for a moment. She let us drink in the impact of her presence and the even greater impact of the night. We did not know that moment would become one of the most referenced images of Cicely in her later years.

Following her tribute monologue, Cicely introduced one of the troupe's acclaimed dancers, Chalvar Monteiro. Cicely clearly had a connection with dancers. I remember feeling all the spiritual and creative energy coming from Chalvar as he stood onstage with the iconic Cicely Tyson. Brava!

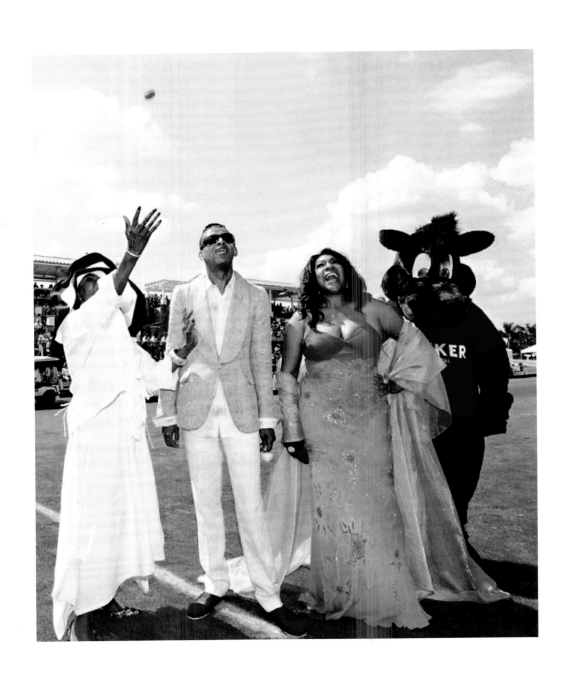

# WE CREATED NEW CULTURAL PARADIGMS

Palm Beach Polo Match

**B**y the time I met Cicely, she had traveled the world and done almost everything at least once. You couldn't surprise her or shock her. But when Mark-Anthony and I brought her to a polo match we had organized in 2011 to raise awareness for Autism Speaks, a nonprofit dedicated to research, Cicely got to toss a coin high in the air for the first time in her life to see which team had the advantage to start the match. That woman had an arm! We invited Mary Wilson—a founding member of the Supremes who went on to blaze a successful solo career—to sing the national anthem that day. Mary sang it like a soulful standard, evoking a roaring applause.

Indeed, another new moment in history was taking place. As a Black American power couple in the American fashion industry, Mark-Anthony and I were taking over the National Polo Center in the height of its season for our event. We always enjoyed attending matches there when we were in Palm Beach and had become friends with the club's president and his wife. We all recognized we were doing something that had not been done before. Our corporate partners for our New York Fashion Week shows spon-

Cicely tossing a coin to start the polo match at the Autism Speaks Awareness Event held at the International Polo Club in Palm Beach, April 2011. Mary Wilson and I are cheering her on.

*Photo credit: Courtesy of the author*

sored the event. In addition to Cicely and Mary, models wore my latest collection informally. The color scheme of the event—including the invitations and the dress code—was blue, the signature color for Autism Speaks. I chose soft azure linens for both the tables and the tent backdrop and blue hydrangea centerpieces for every table. It was a sea of blue, lit by the sun and framed by the club's green lawn.

Polo matches are as much about fashion as they are about galloping horses. We had thought initially that Cicely had a conflict and would not be able to travel with us to Palm Beach. But then she called and declared, "I will be there!" Bring something white to wear, I told her, and I will have a hat for you. Great hats are often worn at polo matches. Fortunately, I had a few hats in stock at our Palm Beach retail partner, the

Cicely appears joyful after tossing the coin to start the polo match, a first-time experience for a world traveler who has done nearly everything.

*Photo credit: Courtesy of the author*

luxury women's boutique John De Medeiros International on Worth Avenue.

I needed to add my touch to the ruched white cotton top and matching full skirt that Cicely had chosen from her wardrobe. That morning, I draped an umbrella-size hat of Swiss straw braid on her head and pinned the crown with the Autism Speaks logo. I wore a periwinkle viscose and linen tweed shawl-collar blazer, while Mark-Anthony took a more subtle approach with a sky blue shirt and a white B Michael seersucker suit.

Here is what's funny to me when I think about that day: a hat had actually brought Mary and me together years before. I designed the chic feathered chapeau she wore for an album cover, and we became so close that she called me her "little brother." (I referred to her as my "big sis" too.) Of course, Cicely and Mary already knew each other from way back, so that afternoon felt like a glorious family reunion. I last spoke with Mary on January 28, 2021, the evening Cicely died. Less than two weeks later, Mary too would pass away. The two friends had another reunion.

Cicely does her famous wave on the red carpet of the eighteenth annual Screen Actor's Guild Awards, Los Angeles, January 2012.

*Photo credit: Tsuni / USA / Alamy Stock Photo*

## SUPPORTING STAR

2012 Screen Actors Guild Awards

I love the lively and intimate vibe at the Screen Actors Guild Awards; you might be asking a future Oscar winner to pass the pepper. At the 2012 awards, Cicely and I sat with Viola Davis and her husband, the actor and producer Julius Tennon, as well as Octavia Spencer and her guest. It felt like we were at our own dinner party. When the ladies were called to the stage for their ensemble win for *The Help*, we all hooted for them, making it clear we were their guys! Viola and Octavia also won individual awards for their roles in *The Help*, so our table became quite cluttered with trophies.

*One might think that every movie star's intent for every red-carpet sojourn is to "steal the show." But not so, at least not for Ms. Tyson and B. In 2012, the cast of* The Help *received a Screen Actors Guild Awards nomination for outstanding performance by a cast. The primary players—Ms. Tyson along with Viola Davis, Octavia Spencer, Mary Steenburgen, and Emma Stone—would appear onstage together. B designed a lean, oyster silk–wool gown with shirred tulle overlay. "That was important for me," he says. "You can't wear a big ball gown when someone's standing next to you. I felt that it was really about Cicely being part of the ensemble and not like, this is my show."*

**—Bridget Foley**

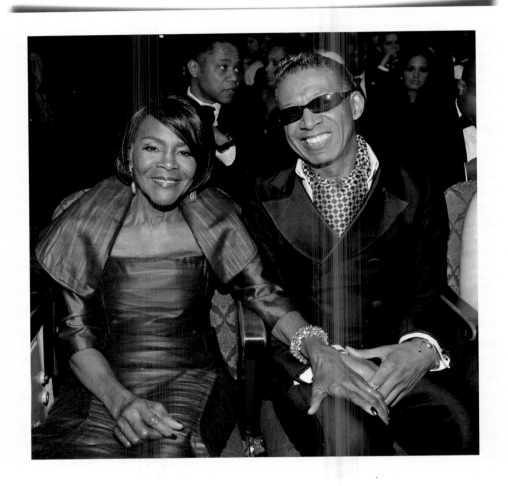

Cicely and I are seated in the Warner Theater in Washington, DC, for the BET Honors, January 2012.

*Photo credit: Frank Micelotta/Invision/AP*

# A GREAT DRESS DESERVES AN ENCORE

## 2012 BET Honors

Cicely, Mark-Anthony, and I traveled countless miles together through the air and on the road. For our trip to the 2012 BET Honors, we added train travel to our list, as we took Amtrak from Penn Station in New York City to Union Station in Washington, DC. We looked like a scene out of an old film, traveling with trunks and lots of porters through the station.

The BET Honors event that year was very special. One of the highlights came during the segment to honor the great American legend and poet Maya Angelou. She and Cicely were true soul sisters. Imagine the oratorical impact when Cicely, Queen Latifah (hip-hop icon, award-winning singer, and actor), Jill Scott (three-time Grammy award–winning singer, songwriter, and best-selling poet), and Willow Smith (new guard triple threat) all took the stage to recite the mighty poem "Still I Rise" by Maya Angelou. Published in 1978, the poem quickly became a lyrical affirmation for Black Americans across all sectors of society.

We had fun backstage and got to play with Mariah Carey and Nick Cannon's baby son. Another moment I'll never forget happened before the show. As we were making our way from the green room to the auditorium, the Secret Service alerted us that First Lady Michelle Obama was in the vicinity and we had to wait in an elevator. Trust me, it was a who's who of legendary people in there. And let's just say these were the type of folks who aren't usually kept waiting. Cicely looked around and cleared her throat. "Well, we all know the show's not going to start without *us*," she said, using a forced Caribbean dialect that she usually reserved for telling me a story or declaring some point. Leave it to Cicely to make a packed elevator shake with laughter.

For Cicely's appearance at the BET Honors, I created a trusted silhouette. I fabricated a satin-faced silk-wool trumpet gown in a bold, distinc-

The Secret Service alerted us that First Lady Michelle Obama was in the vicinity and made us all wait in an elevator. Trust me, it was a who's who of legendary people in there.

tive deep azalea that almost vibrated. To nuance the hue in the same way you vary a centerpiece of flowers, I added an overlay of shirred navy tulle. I also designed a matching demi bolero jacket with a flattering three-quarter sleeve and a capelet collar that framed Cicely's face.

Every designer should have a repertoire of silhouettes with one signature standout style. The classic strapless trumpet gown is my calling card. From across any gala or red carpet, you know this refined column dress with a gentle flare just below the knee is a B Michael couture creation.

## A Night of Things to Come: The *TIME* 100 Gala

When Cicely was invited to *TIME* magazine's 100 Most Influential People gala in New York a few months later, we decided to repeat our favorite du jour, the azalea gown. At this stage, we were both embracing the idea that dresses should be repeated—each time we fell in love with a dress, we referred to it as our favorite—until the next,

of course. Cicely would challenge me, "How are you going to outdo yourself?"

The *TIME* 100 event is such a cool departure from the insular worlds of fashion and Hollywood. You're surrounded by a true cross section of people—business titans, athletes, politicians, and thought leaders. That year's honorees included President Barack Obama, Rihanna, Apple's Tim Cook, and then Nigerian president Goodluck Jonathan.

Viola Davis, the acclaimed actor and producer with whom Cicely would work on the award-winning television series *How to Get Away with Murder*, was also on the list. Cicely had written a tribute to her for *TIME* magazine. Little did we know that Viola would go on to write the foreword for Cicely's autobiography, *Just as I Am*, less than ten years later. Or that Cicely would later receive the Presidential Medal of Freedom from President Obama in 2016 and appear on the cover of *TIME* at age ninety-four. Looking back now, that night seems like a rung on the ladder of our destiny together.

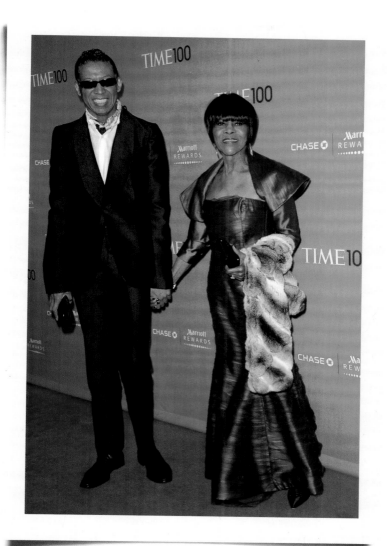

Cicely and I are walking the red carpet
for the *TIME* 100 Gala at the Frederick P. Rose Hall,
Jazz at Lincoln Center, New York City.

*Photo credit: Everett Collection Inc. /*
*Alamy Stock Photo*

# THE GLISTENING WHITE OPERA-COAT AND GOWN

**New York City Mission Society Bicentennial Gala**

So much of what Cicely and I brought to each other's lives was part of a divine plan that was well beyond our scope and sight. As I reflect, I can see that we added texture to each other. We aligned on philanthropic work and brought each other into the significant projects we cared about, thus expanding the circle of meaningful work in each of our lives. She encouraged and developed my artistry, and she challenged Mark-Anthony to move forward to bigger heights.

In that vein, Cicely asked Mark-Anthony and me to join her for a luncheon being hosted by her longtime friend Dina Merrill Hartley. Yes, *that* Dina Merrill Hartley—the American actress, heiress, philanthropist, and funding heart of the Mission Society of New York City. Dating back to 1812, the nonprofit organization originally helped newly arrived immigrants. Today, the focus is unlocking the potential of underserved families, including college access and workforce development. In addition to sharing a lovely lunch, Cicely and Dina had an agenda. They asked Mark-Anthony and me if we would serve on the Mission's two hundredth anniversary gala committee.

At the gala in December 2012, Cicely was honored for her work at the Mission's flagship community center in central Harlem, New York. We also honored another friend, philanthropist Kathryn Chenault, whose charitable work focuses on education and the arts.

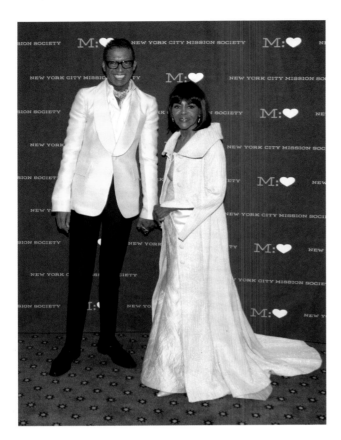

Cicely and I arriving for the Mission Society of New York City's two hundredth anniversary gala, New York City, December 2012.

*Photo credit: Courtesy of Annie Watt*

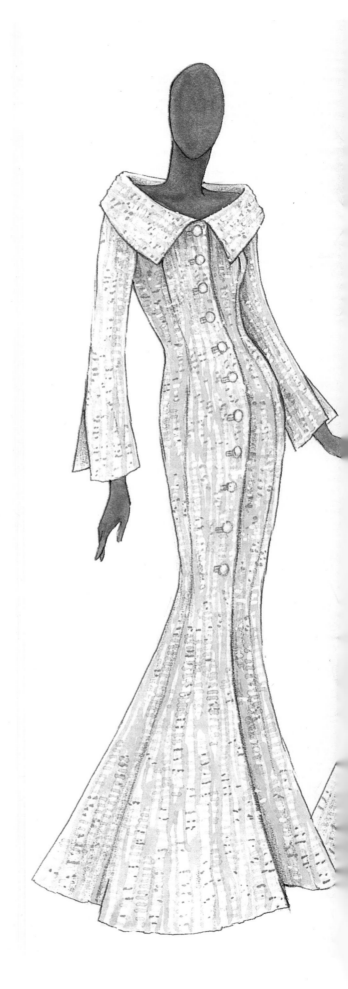

The Bicentennial Gala's honorary chairs were Dina Merrill Hartley and the Reverend Calvin O. Butts III, the senior pastor of the historical Abyssinian Baptist Church in Harlem.

The idea of two hundred years of service was my inspiration for the winter-white trumpet gown and matching opera coat that I designed for Cicely to wear. The elegant silhouette in white brocade threaded with glistening silver made Cicely stand out like a beacon at the black-tie event at the Pierre Hotel. That evening, Cicely was our Lady Liberty! The coat had a shoulder-width collar, covered buttons, and an elegant back-sweep train. Cicely loved the coat so much that she wore it the entire night. But we never used it again. We both felt it belonged to that evening.

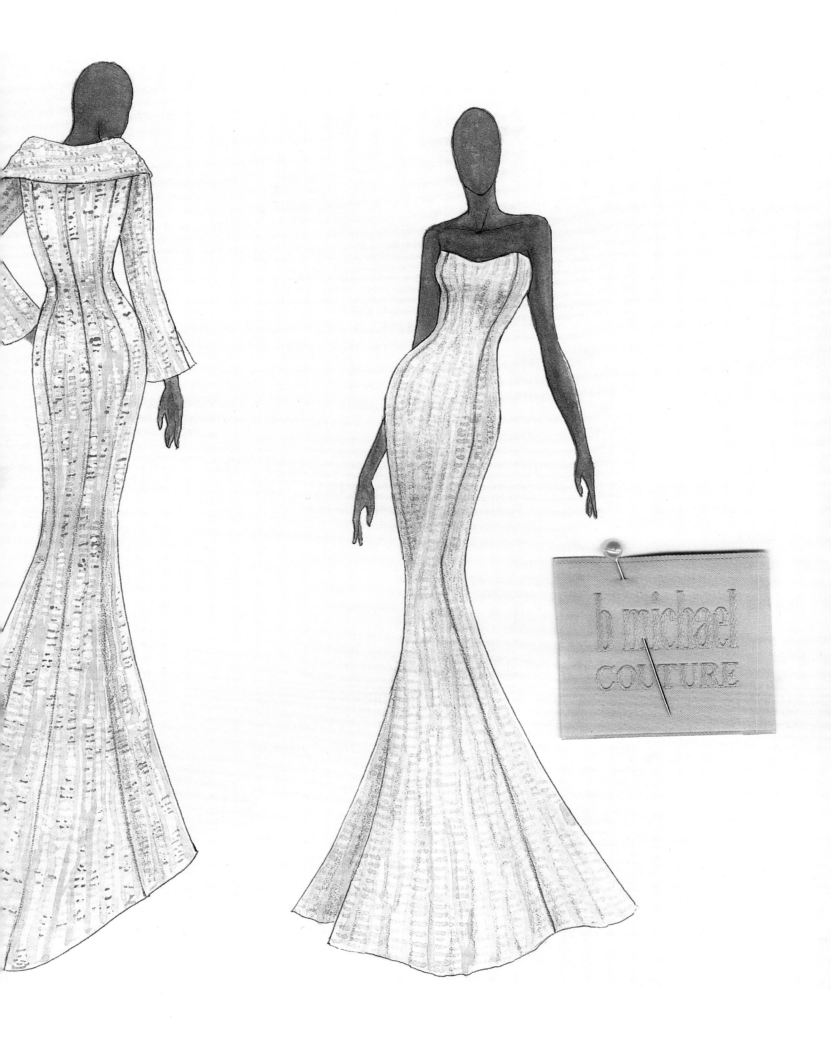

# ROLE REVERSAL: CICELY ESCORTED ME

## The Topaz Dress

*Sparkle* Premiere

The Hollywood premiere of the film *Sparkle* in 2012 felt like an emotional roller coaster. The legend Whitney Houston, who starred in the movie, had died suddenly just six months earlier, and the event reminded us that an unparalleled voice was gone for good. It was particularly poignant for me because I had collaborated with the Oscar-winning costume designer of *Black Panther*, Ruth E. Carter, to create Whitney's looks for the film. I had always imagined dressing Whitney Houston—another dream manifested. You can imagine how moved I was when one of the ensembles worn in a pivotal scene in the film, a dusk blue silk Mikado topper over a blue brocade sheath dress, was later included in an exhibit at the Grammy Museum.

That night, I brought my muse as my plus-one. But when anyone approached her at the premiere, she sidestepped the attention: "It's all about B tonight. I'm here to celebrate him," she said with both pride and humor.

In homage to the retro flavor of the film, I created a silk gazar dress in a beautiful topaz shade for Cicely; the dress mirrored the style of the late 1960s with its open funnel collar and flirty trapeze cut. The dress was actually constructed of two pieces of fabric, so it floated and flicked with every movement. Just before we walked out the door, Cicely had the idea to tie a satin ribbon around her ankle. She loved an eclectic touch.

### New York Fashion Week

A month later, when I showed my collection for Spring/Summer 2013 at New York Fashion Week, we revisited that dress. Cicely loved that she could twirl in it—which she did!—and honestly, I had no time to design a new couture look for her. For the show, Cicely sat front and center with a dear friend, Suzanne Cohn, who attended

Cicely, in the Topaz Dress, with her dear friend and show guest Suzanne Cohn, on the front row of my Spring 2013 New York Fashion Week Show, New York City, September 2012.

*Photo credit: Shawn Punch*

the show with her husband, Norman Cohn. Mark-Anthony and I have been adopted into the Cohn family, thanks to Cicely sharing all of us.

This is how she brought people together: Cicely didn't squander time or opportunities. She would hop on a train or a plane to get to a great party and see dear friends. Cicely met Norman and Suzanne Cohn through their son Matthew. Matthew introduced himself to Cicely in a store when he was just a young boy, and now he's an adult with children of his own. Their relationship fostered a family-wide, lifelong friendship.

We were introduced to the Cohns when Norman and Suzanne invited Cicely to a party in Philadelphia and sent a car and driver for her. She asked Suzanne if she could invite us to join her, and then told us we *must* go. It was a soiree to introduce Indian royals H. H. Maharani Padmini Devi and Princess Diya Kumari and unveil Norman and Suzanne's new state-of-the-art apartment. Cicely was excited to share the Cohns with her Thirds. Mark-Anthony and I remain a part of the Cohn family. Blessed be the tie that binds.

Cicely Tyson and Bill Cunningham
at the Alvin Ailey gala.

*Photo credit: Courtesy of the author*

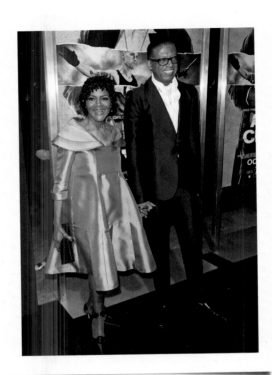

Cicely and me on the red carpet at
the *Alex Cross* film premiere, which
featured Cicely and Tyler Perry.
Hollywood, October 2012.

*Photo credit: WENN Rights Ltd. / Alamy
Stock Photo*

# THE PYRAMID DRESS

The Pyramid Dress from my Spring 2012 collection was meant to evoke the precision of architecture. If you had laid this dress out flat before it was sewn together, the pieces would have looked like a blueprint. Cicely loved the juxtaposition of her slight frame with the volume of the silhouette. When we were getting her ready, she discovered the hidden pockets. Cicely loved pockets! To balance the look, I added a retro bugle-beaded skullcap that contradicted the dress's modern design. I love mixing styles from different fashion eras.

I am always in awe of colors from nature. For the dress, I selected a vibrant hydrangea-lavender shade in silk-wool. You can see how the lilac undertones highlight the hues of Cicely's gorgeous skin, which literally radiated when she wore any floral shade.

## The Dress Appears Again with Bill Cunningham

A month after the Pyramid Dress debuted at the premiere for the film *Alex Cross* in October 2012, we revisited the look with that same fitted cap for a splashy Alvin Ailey gala. That night, we chatted up Bill Cunningham, the *New York Times* photographer who pioneered candid, documentary-style fashion photography on the streets of Manhattan. Bill once said, "Fashion is the armor to survive the reality of everyday life." I agree, and so did Cicely. To her, dresses were fancy costumes for the roles she played offstage.

Bill and I bonded over the fact that we both started our careers as milliners. Bill supported me throughout my career with coverage in his addictive photo-journal columns in the Sunday *Times*. Everyone read that column. Because Bill wasn't political, it was a big deal when he chose to photograph you. It meant that your personal style truly stood out in a city of eight million people. Both Cicely and I were featured a few times. The best quote about Bill comes from Anna Wintour, the editor in chief of American *Vogue* and chief content officer of Condé Nast: "We all get dressed for Bill."

# THE NIGHT SKY TRUMPET GOWN

**2012 NAACP Image Awards**

Right after my New York Fashion Week show for the Fall/Winter 2013 collection, I needed to prepare Cicely for the forty-third annual NAACP Image Awards. Cicely and our special friend Diahann Carroll—two giant "sheroes"—would be presenting the award for Outstanding Actress in a Motion Picture to Viola Davis. The gathering would pause and pay homage to Whitney Houston as well, so it was a bittersweet moment. I knew that the Image Awards ceremony would be a special night, particularly for Black American artists in film and music impacted by such a tremendous loss. When world-renowned gospel singer Yolanda Adams sang "I Love the Lord," let's just say it brought me back to Whitney.

I channeled Whitney in my vision for Cicely on that night. I designed a sleek, fitted gown with a trumpet train in blush silk double-faced satin that I overlaid with sumptuous, shirred navy tulle, embroidered with petite midnight blue sequins. Navy is such a chic alternative to black, and Cicely literally sparkled with each step. The effect of the scattered sequins was almost like stars peeking out in the night sky. The hint of blush satin highlighted the beautiful pink undertones of Cicely's complexion. My demi bolero jacket in a frenzy of blush and mauve feathers added just the right pop of glamour.

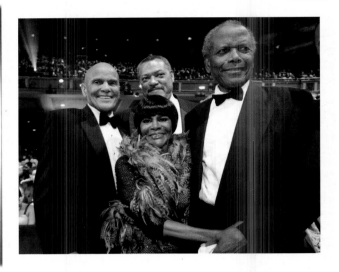

I take credit for helping capture this iconic photo of Harry Belafonte, Cicely Tyson, Laurence Fishburne, and Sidney Poitier at the NAACP Image Awards.

*Photo credit: REUTERS / Alamy Stock Photo*

## Cicely and Her Guys

I call this photo "Cicely and the Legendary Leading Men"—and it never would have happened without me. After the show, Cicely ran into world-renowned American actor, film director, and diplomat Sidney Poitier; American singer, songwriter, actor, and activist Harry Belafonte; and award-winning American stage and screen actor Laurence Fishburne. The meetup quickly became an emotional reunion. It couldn't have been more iconic. Cicely had told me many stories about her theater days with Sidney and Harry early on in her career, so I already knew about the depth of their relationships and the massive respect they had for one another. But to witness them all together was a whole other experience. I could not chance that this spontaneous gathering would ever occur again. When a photographer passed by, I said, "Please capture this!" All of a sudden, other photographers came over, and it became a memorable paparazzi moment.

For me, Sidney Poitier was always a giant. I remember seeing his film *Lilies of the Field* as a young boy growing up in Connecticut. In the movie, there's a scene where one of the actresses, Lilia Skala, wears a beautiful wide-brimmed black hat. If I close my eyes, I can still see that hat. Did it inspire me to go on and become a milliner and design hats early on in my fashion career? I'm not sure. But Sidney became the first African American to win the Academy Award for Best Actor for his role in that 1963 film. That was enough inspiration for me.

Cicely walking onstage at the Shrine Auditorium in Los Angeles for the NAACP Image Awards, February 2012.

*Photo credit: Kevin Winter / Getty Images*

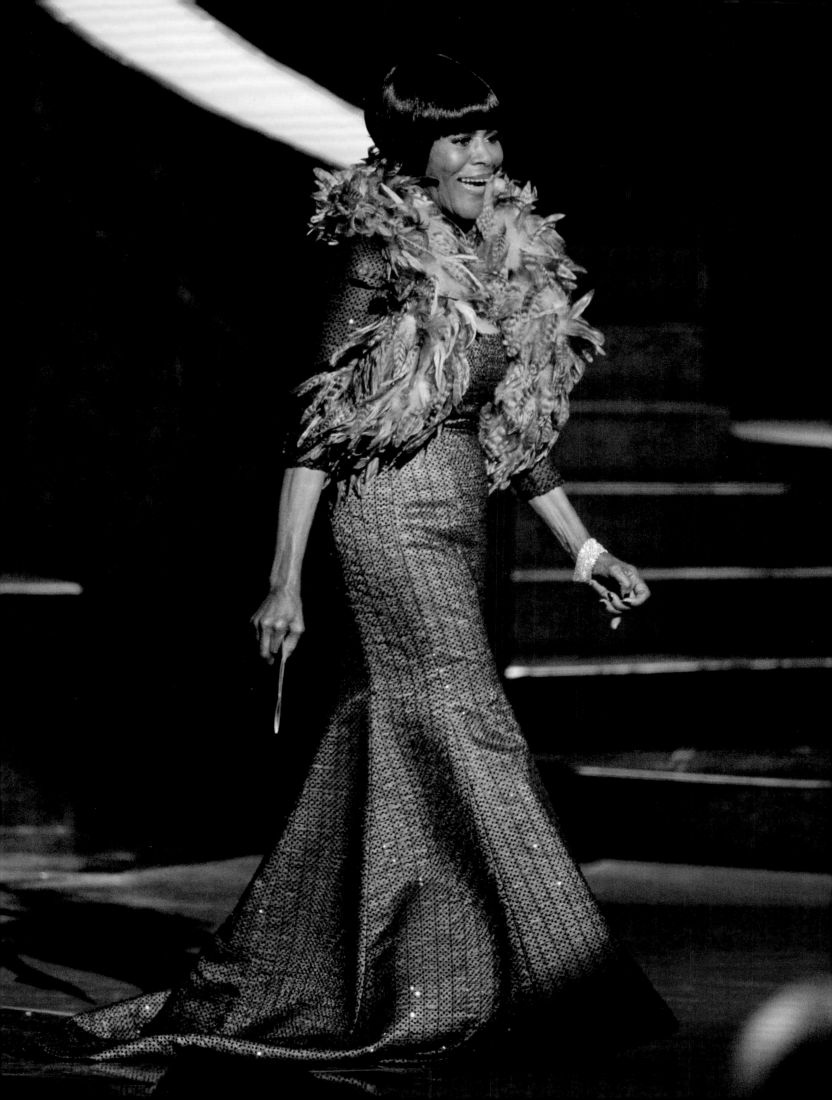

# DESIGNING FOR THE LEADING LADY OF THE THEATER

*The Trip to Bountiful*'s Opening Night on Broadway

When Cicely returned to Broadway as a lead in Horton Foote's play *The Trip to Bountiful*, she was joined by a stellar cast: Academy Award–winning actor Cuba Gooding Jr., acclaimed actor and recording star Vanessa Williams, and stage and screen actor Condola Rashad. After a thirty-year hiatus from the stage, Cicely got swallowed up by her theater schedule. But what I recall most when I look at this opening night photo is that Cicely was eighty-seven when she took on the demanding role, and she never missed a single show, even though the play's run was extended by months and lasted 187 performances. I cannot tell you how many times Mark-Anthony and I saw the show. So many of Cicely's friends from near and far, celebrities from every field, and even First Lady Michelle Obama watched her remarkable performance. With all of that, Cicely still managed to attend my New York Fashion Week shows. We even had occasional late-night dinners and our daily calls. Two people worked almost as hard as Cicely during that time: her assistants, Lois Harris and Carl Foster.

On the night of the show's opening, Cicely needed to look like a leading lady, but with an evening casual look for the opening night party at the Copacabana—and she would have only minutes for a quick change. Fortunately, she still had her model instincts. I thought that the easiest thing for her to slip into would be a pair of full-leg trousers in a lustrous six-ply bronze silk charmeuse. I added a mock turtleneck, but the standout of this ensemble was a bronze silk foil lamé topper with an elongated ruffled shawl collar that framed Cicely's face. With this event, Cicely brought me behind the scenes into a world I only imagined through vintage films: dressing the leading lady of the theater! I loved it!

My red-carpet moment with the leading lady at the Broadway opening night party for *The Trip to Bountiful* at the Copacabana in New York City, April 2013.

*Photo credit: WENN Rights Ltd. / Alamy Stock Photo*

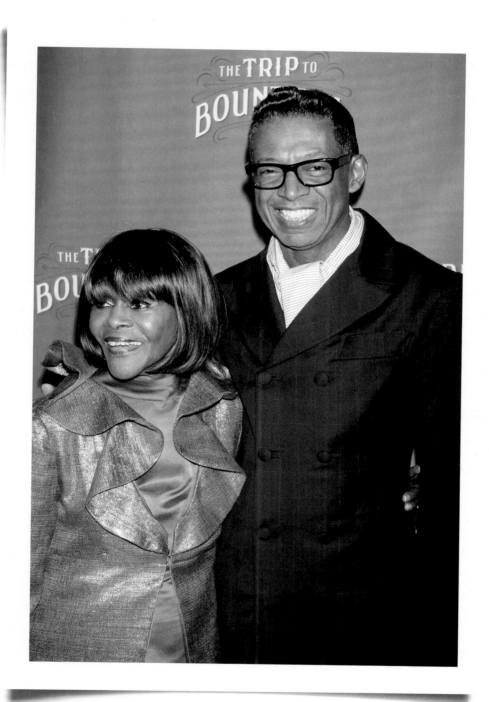

**B** Michael. He was not only Cicely Tyson's friend but also her exclusive couture designer. She wore the most elegant yet dramatic hats, a throwback to a tradition and a time when ladies dressed to the hilt. Her stockings, her gloves, and her coats were chosen with great discipline and personal attention to quality and luxury. When she received her honorary Oscar in 2018, she wore gray and silver crystal pleating and superb silver lamé leather opera-length gloves. Total elegance.

I always looked forward to greeting B Michael and Cicely in church after service, just to have that warm smile and that golden, perfect diction, like fresh butter, flow over me.

Cicely Tyson was better than best. She was *the Best*. She shall endure through the ages.

—**André Leon Talley**

*Photo credit: Annie Leibovitz*

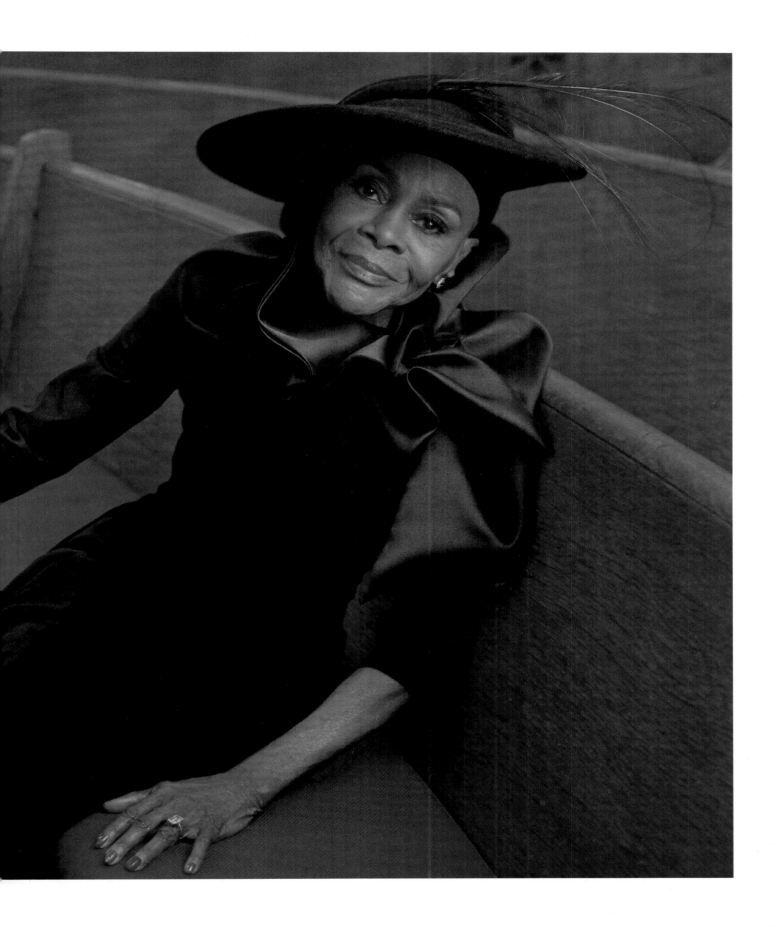

# MY HERO OF DESIGN:
## ARTHUR MCGEE

It's widely known that Cicely purposefully chose roles as an actor that championed the image of women of color. But she committed to promoting people of color in all areas of her life. In 2009, when I was asked to serve on the host committee of a luncheon honoring the legendary designer Arthur McGee, I was blown away to discover that Arthur was one of Cicely's favorite designers. She said in her tribute that his clothes always made her feel like she was "floating." The luncheon was hosted by the Costume Institute at the Metropolitan Museum of Art.

That afternoon, Arthur spoke of the obstacles that sometimes stalled his success. For instance, when he went on fabric appointments in the mid-fifties, people would assume that he was there to pick up or make a delivery and would ask, "Where's the designer?"

I can't imagine the sting he must have felt. But I do know that it makes me feel that, in the face of systemic challenges within the fashion industry, I have no option but to succeed.

For me, Arthur was a force and a source of inspiration. In the early to mid-fifties, while studying at New York's Fashion Institute of Technology, Arthur began working for the American couturier Charles James, and in 1957 he was the first Black designer to run a Seventh Avenue design studio, Bobbie Brooks. He sold to stores including Bergdorf Goodman, Henri Bendel, and Lord & Taylor. Arthur was an in-comparable pioneer, and he mentored many fresh, young designers. He would comment on

His shop on St. Marks Place in the East Village—known to those in the know simply as "The Store"—became a fashion magnet for celebrities like Cicely, Stevie Wonder, and Lena Horne in the sixties. What a fashion trailblazer he was!

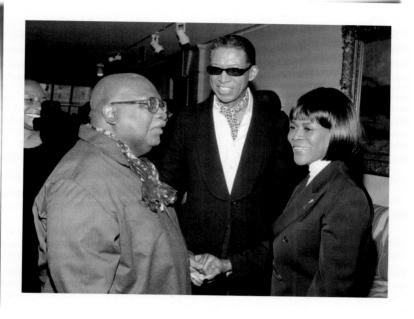

Arthur McGee and Cicely, with me in between, at the
Metropolitan Museum luncheon honoring Arthur.

*Photo credit: Courtesy of the author*

photos of my work, particularly photos of Cicely in the clothes, which meant everything to me. I came to think of Arthur as an uncle in the industry. His shop on St. Marks Place in the East Village—known to those in the know simply as "The Store"—became a fashion magnet for celebrities like Cicely, Stevie Wonder, and Lena Horne in the sixties. What a fashion trailblazer he was!

Cicely and I visited with Arthur in Harlem many times after the luncheon—and even spontaneously celebrated with him what would be his last birthday. On that day, March 25, 2019, Cicely and I were in Harlem to attend the memorial service for our friend Nancy Wilson. Afterward, Cicely said, "Let's stop and visit with Arthur while we are uptown"—and it turned out to be his birthday! This was proof to me that, as I would tell Cicely, she had some sort of clairvoyant power. Coming full circle, the Smithsonian National Museum of African American History and Culture created an installation on Arthur McGee and filmed a video segment in my NYC atelier that included Cicely and me.

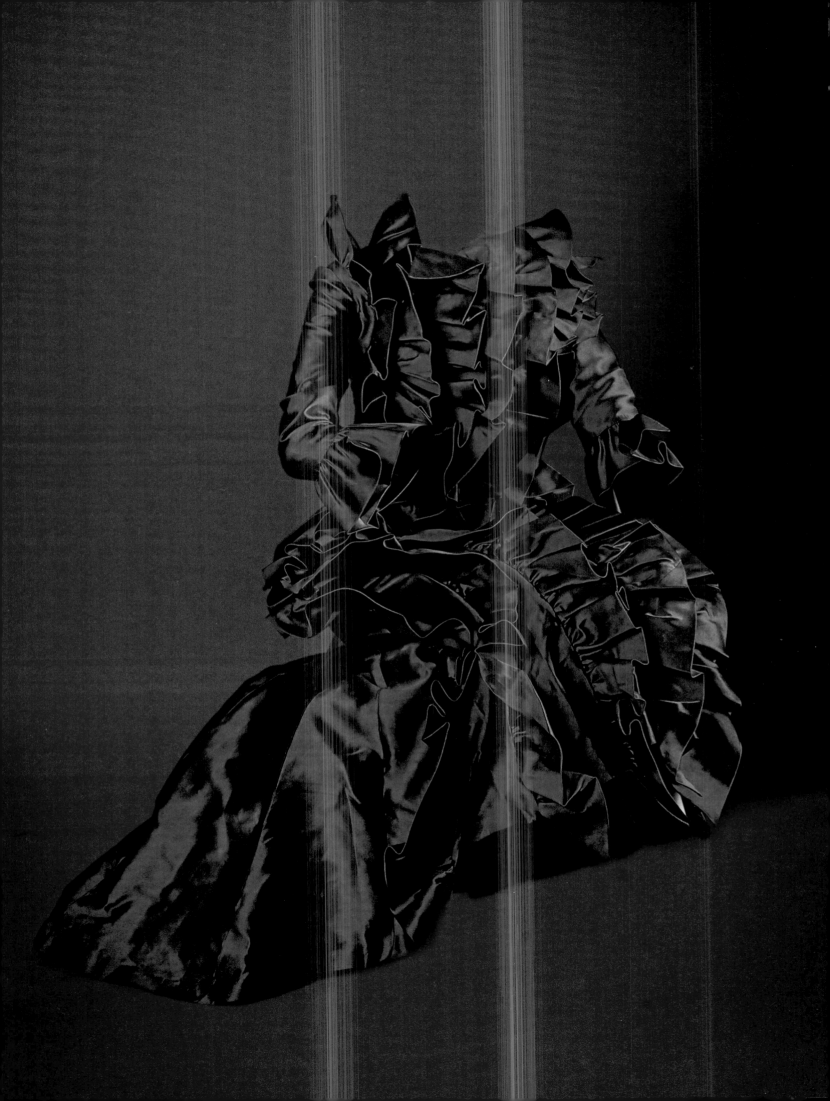

## A Surprise Win

# SCULPTURED HAUTE COUTURE GOWN

**The Tonys**

When Cicely was up for a Tony Award for her role as Mother Carrie Watts in *The Trip to Bountiful*, I teased her and said, "I am going to pray to God for divine inspiration for your gown."

Well, be careful what you pray for. I created an avant-garde trumpet gown in a sublime indigo silk Mikado with sculptural bias points around the neckline and yards and yards of hand-draped ruffles, creating a haute couture sculpture.

It was all accentuated by bespoke diamond and purple sapphire earrings by AU Jewelry Design and Cicely's sleek bob, which was styled by Armond Hambrick as the perfect chic helmet. As you can see from my sketch, the dress took on much more exaggerated proportions when we hand-draped it, evolving into a more powerful statement.

Cicely didn't even prepare a speech, but I knew in my heart she would win. When her name was announced as the winner, she remained in her seat. Cicely later joked that she asked her assistant Carl Foster, "Am I supposed to go up onstage?"

It was a euphoric moment—Cicely was receiving her very first, and only, Tony Award. Her speech came from her heart and charmed the usually highly critical audience.

It was really only in that moment, seeing Cicely onstage, that I realized the scale of the dress I had designed. Many critics loved its sheer audacity, but a few sniped that it was

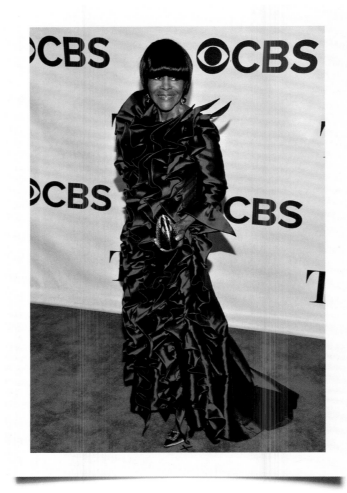

Here's Cicely, looking like the Leading Lady of the Theater, at the sixty-seventh annual Tony Awards in New York, 2013.

*Photo credit: Charles Sykes / Invision / AP*

too architectural or abstract. Someone on Twitter even compared it to a hair scrunchie! I just laughed because the dress had started a conversation. It is the most written-about dress ever worn by Cicely, which only adds to its magic. However, what was interesting to me was that the press wondered who designed the gown after all the good and bad reviews. Some critics even suggested that the designer of the dress was afraid to step forward. The reality is this: not one person on the red carpet asked Cicely who she was wearing that

night, and I was there with her. That story is just one example of how the fashion industry consistently sidelined Black actresses and Black designers way back then—in 2013, that is. History prevails, however. We cannot un-ring the bell of the greatness of that moment.

My pencil sketch of the dress.

*Illustration credit: Courtesy of the author*

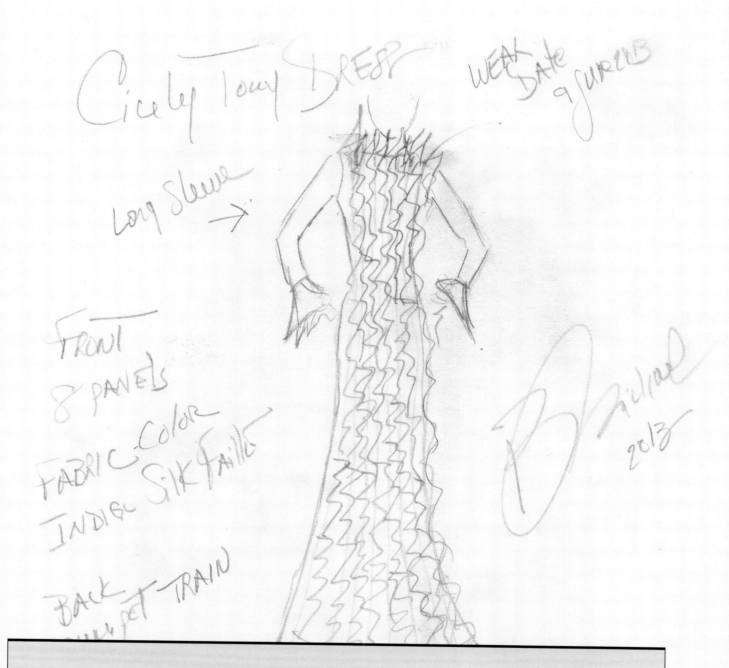

Cicely Tony Dress    Wear Date 9 June 2013

Long Sleeve →

Front 8 Panels

Fabric-Color Indigo Silk Faille

Back Trumpet Train

B. Richard 2013

## The Sleeve

A simple dress with a dramatic sleeve becomes a statement piece. Sleeves can be sexy and create mystery. I don't think of sleeves as being a covering or age-appropriate—although that's a sidebar attraction for many. Instead, I believe sleeves make the arms interesting when presenting or receiving, waving, or shaking hands. You will see how sleeves helped create moments for Cicely throughout our fashion collaboration. Right from the start, it was a sleeve that endeared Cicely to the white blouse she wore to Oprah's Legends Black and White Ball when we met in 2005 (see page 3). And then there was that memorable wave from the balcony of the Kennedy Center, during the televised ceremony of her Kennedy Center Honor (see page 82).

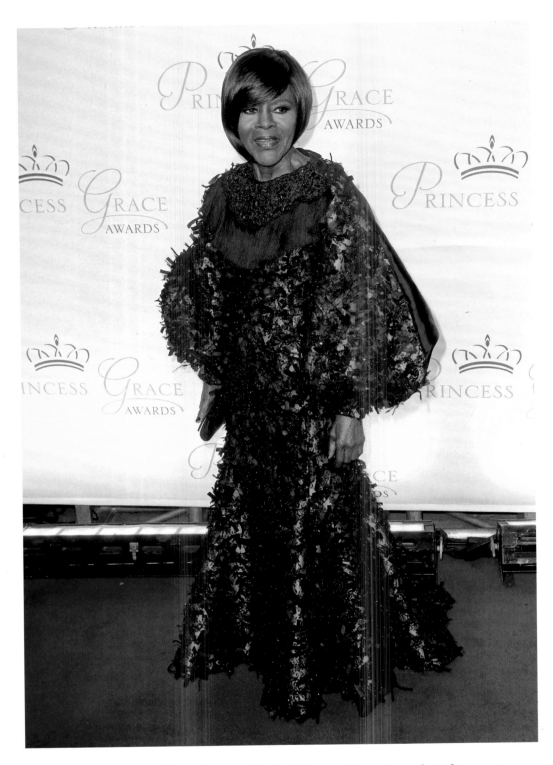

Cicely on the red carpet for the Princess Grace Awards Gala
at Cipriani 42nd Street, New York City, October 2013.

*Photo credit: Abaca Press / Alamy Stock Photo*

# DRESSING ROYALTY TO MEET ROYALTY

Prince Rainer III Award

**W**e all know that Grace Kelly, the princess of Monaco, epitomized elegance. I always think about the gowns she wore in the 1955 film *To Catch a Thief*, which were designed by Edith Head, who reigned in Hollywood as a fashion and costume designer from the fifties to the seventies. Edith was perhaps the most awarded woman in the Academy's history, with eight Academy Awards for Best Costume Design. Also noteworthy, Edith Head referred to Grace Kelly as her muse.

It was deeply meaningful when Cicely was honored with the Prince Rainer III Award by the Princess Grace Foundation for her accomplishments in the arts and her leadership and dedication to helping students in the performing arts.

The glamorous black-tie gala was held at Cipriani 42nd Street, one of New York's architectural masterpieces. Cicely's award would be presented by Princess Charlene of Monaco, the regal daughter-in-law of Princess Grace and wife of Prince Albert II, the reigning prince of Monaco.

In my imagination, this would be a royal gathering and Cicely would be representing American Hollywood royalty. I knew her dress had to be incredibly opulent, on par with the European formality you might see at a fairytale chateau in Monaco. So, I designed her luscious azure blue silk gown with a fitted torso that gently hugged her silhouette, opening to a waterfall train. The silk Mikado had been imported from France and was overlaid with a delicate black Spanish lace embroidered with satin ribbon and petite jet crystals. To heighten the mix of textures, I embellished the collar with an embroidered crystal-beaded bib edged with a fringe border. Her oversize poet sleeves were backed in black silk. I was thrilled with the blended impact. When Cicely swept up to the stage to accept the award, she looked every inch like royalty, an icon of style like Grace Kelly.

Unfortunately, I wasn't there during the awards presentation. So I did double-duty by escorting Cicely to the awards gala—in my Tartan shawl-collar suit—and then dashed off to my own event.

But before I left, I dropped in at the silent auction and bid on a gorgeous tea set made in Monaco. Cicely assured me she would monitor the bids. I just assumed she would get caught up in socializing, especially since she was being honored. But Cicely surprised me with the tea set the next day. It's just one of the many keepsakes I treasure from our time together.

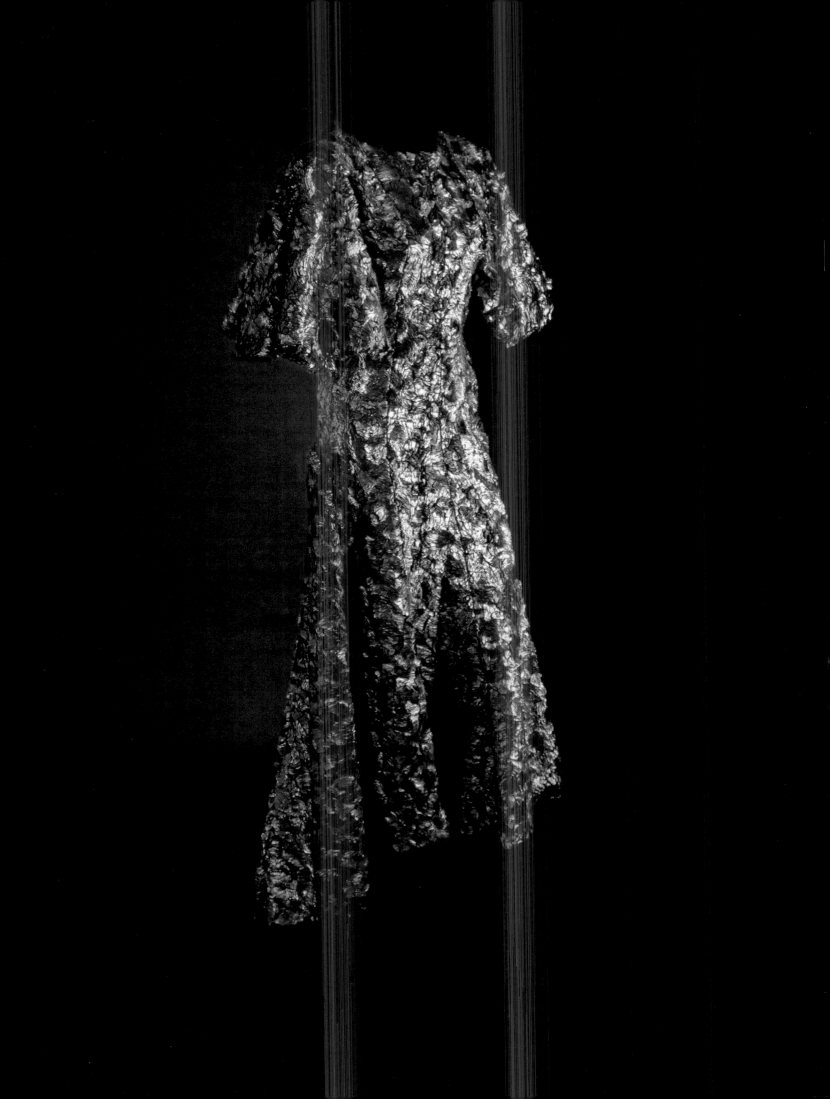

# THE BRONZE VELVET-FEATHERED GOWN

**White House State Dinner**

It's one thing to design a gown for Cicely to wear to a state dinner at the White House—especially if it includes First Lady Michelle Obama, a formidable ambassador for all women and a style icon in her own right—but when the honoree is the president of France, François Hollande, an American actor is expected to be an elegant ambassador.

In the early days of my career, I had spent time in Paris, and there I felt immediately as though my creative soul had found its place. So, yes, the idea of designing a gown that would be in the presence of the French president was provocative. The timing could not have been trickier, though. I created Cicely's gown for the White House affair during the home stretch of finessing my Fall 2014 collection for New York Fashion Week. Fortunately, I thrive on creative pressure! The dinner was held on the night before my show, so I couldn't accompany Cicely to Washington. She was escorted by her nephew, but she promised me she would catch a train home in time to grace my front row.

My inspiration for the dress channeled Jacqueline Kennedy, but in a modern sense. It had to be grand but not glitzy. The trumpet gown I designed, in black feather-textured velvet flocked with bronze lacquer, reflected light with every turn. Cicely literally glowed like warm, flickering candlelight. Capelet sleeves and a back train amped up the opulence. I added my couture black leather opera gloves, which Cicely never peeled off

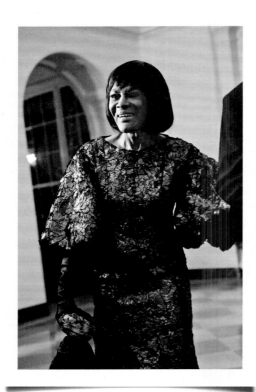

Cicely arriving at the White House
state dinner in honor of French president
François Hollande, February 2014.

*Photo credit: Nicholas Kamm / Getty Images*

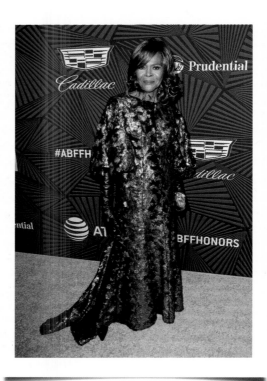

Cicely on the red carpet at the Beverly
Hilton for the American Black Film Festival
Honors ceremony, February 2017.

*Photo credit: Media Punch Inc. / Alamy Stock Photo*

that night. My only regret is that I didn't get to escort my own first lady in that dress. If you're wondering if Cicely made it to my runway show the next day, indeed, yes.

### American Black Film Festival Honors
Three years later, for the inaugural American Black Film Festival Honors ceremony, we revisited the gown created for the White House state dinner. For this occasion, we added a longer wig, shaded to match the dress, which was an intentional nod toward Hollywood glamour in contrast to Cicely's elegant Washingtonian appearance.

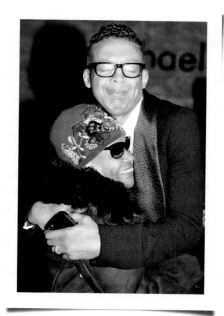

Cicely congratulating me
after my show.

*Photo credit: Courtesy of the author*

## AN "ALWAYS SHOW"

Direct from the White House to My Front Row

Cicely returned from the White House state dinner in time to sit in her front-row seat at my Fall 2014 runway show. We both knew that there would be no time for conversation about what Cicely would wear. Only Cicely, at eighty-nine, could rock streetwear and evoke the same awe as she commanded in a ball gown. She showed up at New York Fashion Week dressed in leather pants, silver moon boots, sunglasses, and a floral bucket hat. I intentionally sat Cicely next to Condola Rashad, who had costarred with her in the Broadway production of *The Trip to Bountiful*. Condola was nominated for her second Tony at the age of twenty-six for that role. I love the idea of this warm reunion of the old and new guard unfolding in my front row—especially since Cicely radiates like any twentysomething. Condola's mother, the acclaimed actress of stage and screen Phylicia Rashad, is also a good friend who always elevates my designs with her natural grace and elegance. A year later, both Condola and Phylicia walked the runway in B Michael couture at my Fall 2015 fashion show.

# MAKING HISTORY

The Council of Fashion Designers of America—better known as the CFDA—was founded in 1962 by the legendary publicist Eleanor Lambert, who was my first and biggest ally in the fashion industry. (She was known as "the empress of Seventh Avenue" and invented the concept of New York Fashion Week.) We met around 1995, early on in my career, when she consulted for the Plaza Hotel and commissioned me to create millinery designs for a colorful annual event, Easter at the Plaza Hotel, which featured a fashion show after an Easter parade. Not only was it a huge opportunity for me, but Eleanor Lambert—or Ms. Lambert as I preferred to address her—would continue to call on me for various collaborations and even invited me to attend events with her.

Ms. Lambert represented me for my first two runway collections. That put me in the ranks of American designers such as Bill Blass, Halston, and Calvin Klein, whom she also represented. A few years later, in 1998, the impeccable designer Oscar de la Renta sponsored me to become a member of the CFDA. I was proud to join this organization, which I viewed as a tapestry of American fashion designers. Ironically, it was through the CFDA that I first realized I was a *Black* American fashion designer.

With the pressing narrative around racial inclusivity in the American and global fashion industries, I am optimistic that the CFDA will do more than just note the contributions of Black designers. I hope the organization will seize the opportunity to support independent Black American talent, including creating paths for equity that build global brands and wealth.

In 2014, our company made a major contribution as a patron sponsor of the annual CFDA Awards. Mark-Anthony and I felt we were supporting the organization and expressing our intention to be involved. For the event, we hosted many high-profile couture clients and their husbands: Karen and Charles Phillips, Kathryn and Kenneth Chenault, Dr. Amelia Quist-Ogunlesi and her husband Adebayo Ogunlesi, the award-winning journalist and author Amy Fine Collins, and of course my muse, Cicely. All of the ladies wore B Michael couture. On that evening we made a powerful, history-making statement. Imagine the scene: a Black American designer attending the awards with his Black American muse, who happens to be legendary, and with several Black American guests who were prominent philanthropists, business titans, and heads of major American corporations. I don't recall

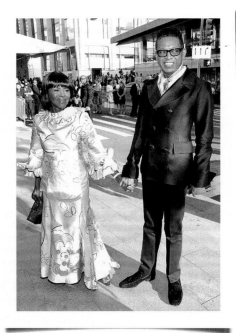

Cicely and I arriving for the 2014 CFDA Awards at Lincoln Center, New York City.

*Photo credit: Courtesy of the author*

ever seeing such a photo in the history of the CFDA Awards, and yet we went unchronicled. Of course, this was several years before the racial reckoning we're now seeing in the fashion industry.

It was wonderful to see Black American talent being recognized at the ceremony. Among the awards that evening, Rihanna accepted the Fashion Icon award, and groundbreaking Black model, advocate, and founder of her namesake modeling and management agency Bethann Hardison was honored with the Founders award.

Dressing the five ladies was like preparing for an haute couture presentation with lots of fittings. For Cicely, I used a luxurious eight-ply silk fabric I sourced in Paris. The abstract floral pattern was sumptuous but also subtle enough to make you lean in and look closer. The hand-pleated halo collar and sleeves—which required

On that evening we made a powerful, history-making statement. Imagine the scene: a Black American designer attending the awards with his Black American muse, who happens to be legendary.

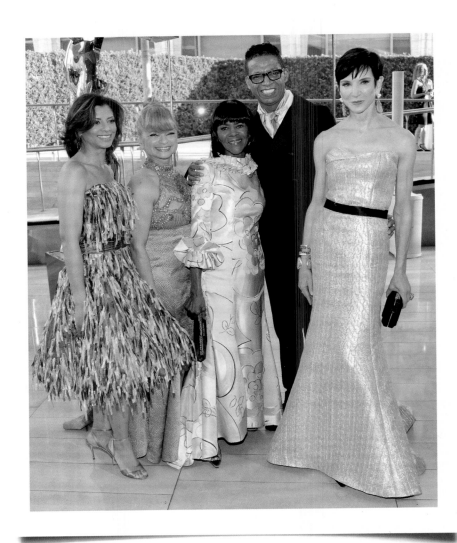

As good as it gets: being surrounded by
amazing women, Karen Phillips, Kathryn Chenault,
Cicely, and Amy Fine Collins.

*Photo credit: Larry Busacca / Getty Images*

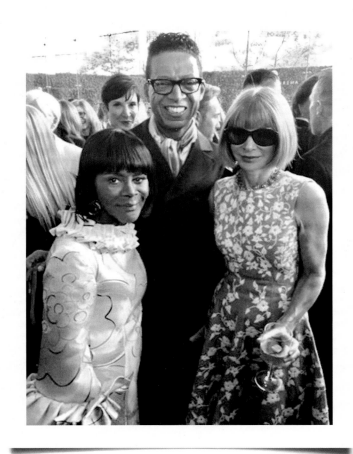

Cicely and I posing with Anna Wintour,
June 2014.

*Photo credit: Courtesy of the author*

countless hours of hand-stitching by the talented craftspeople in my New York atelier—infused the gown with a regal flair. Amid a sea of the most fashionable people in New York City, Cicely and all of my other ladies still stood out.

The CFDA Awards are the Oscars of the fashion world, and the ceremony draws fashion industry luminaries. Cicely and I paused to pose with Anna Wintour, the editor in chief of *Vogue*.

But for me, the ultimate triumph of the event was to see that photographer and style arbiter Bill Cunningham recognized our efforts—and my couture designs—by including us in his wildly popular "Evening Hours" column of the Sunday *New York Times*.

# THE RED BLANKET-CAPE

## Macy's Thanksgiving Day Parade

What do you give someone who has everything? A parade! Cicely seldom shocked me, but she knew how to surprise me occasionally. One day over lunch, she said, "I have always wanted to be in the Macy's Thanksgiving Day Parade."

Mark-Anthony and I responded together, "Really?!"

I will say Mark-Anthony got right on it. We knew Terry Lundgren the CEO of Macy's at the time, and the next thing you know, I'm creating a dramatic festive red bouclé cape for Cicely to wear with her leather pants and turtleneck. (Mind you, it was a very cold New York City day.) The cape doubled as a blanket. I added red leather opera gloves and feathers to her neckline for warmth and a touch of holiday glam.

On the day of the parade, Mark-Anthony and I watched her make her way down Sixth Avenue with her great-niece in a horse-drawn carriage . . . on our TV. I told her, "Cicely, we made this happen and I'm happy to design a look for you, but we'll pass on freezing from the sidelines."

Another of Cicely's unusual requests was to have a front-line seat at the Macy's Fourth of July fireworks—which we made happen and attended together. Cicely was so excited!! It was my first time venturing that close to the fireworks. Great experiences are wonderful gifts for people who don't need another trinket.

The smile on Cicely's face says it all as she fulfills a dream by riding in a horse-drawn carriage in the Macy's Thanksgiving Day Parade, November 2013.

*Photo credit: Charles Sykes / Invision/AP*

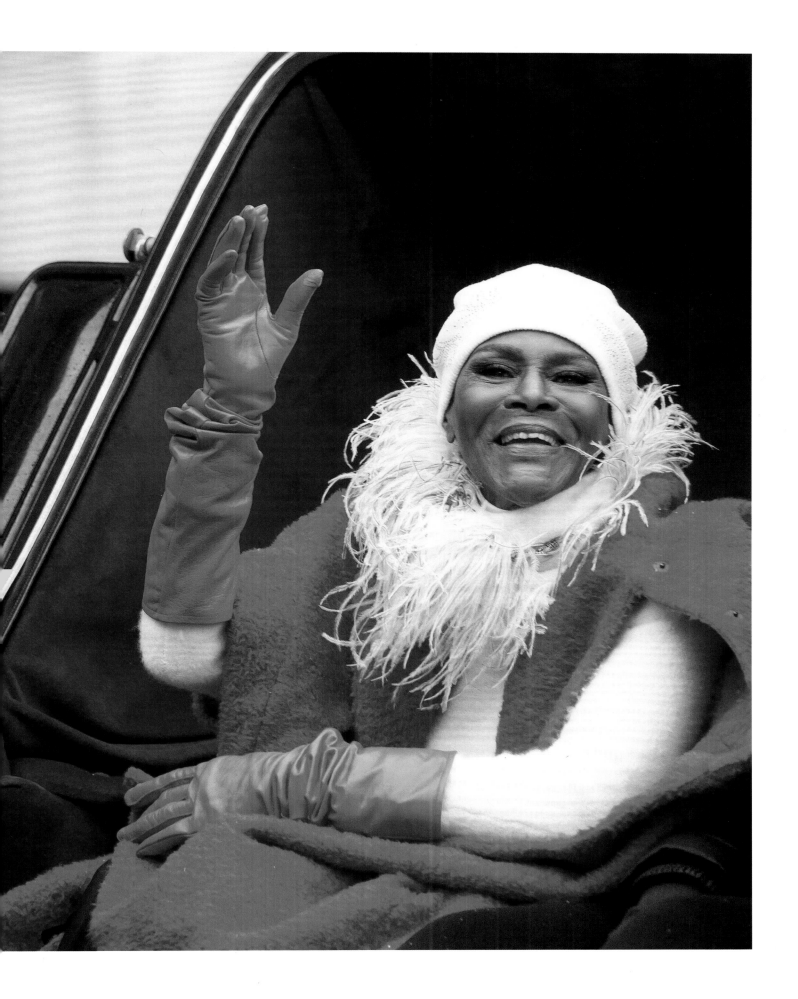

Runway photo of the gown
Cicely wore to the American
Theatre Wing's Award Gala
honoring James Earl Jones,
Fall/Winter 2015 New York
Fashion Week show.

*Photo credit: Marsin Mogielski /
courtesy of the author*

**Pencil sketch
of the gown.**

*Illustration credit: Courtesy
of the author*

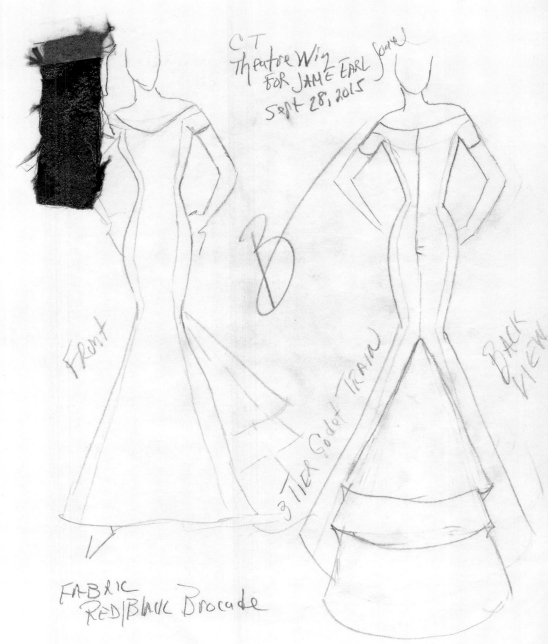

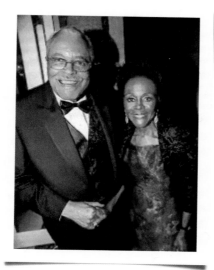

I captured this photo of James Earl Jones and Cicely after the actor received his award from the American Theatre Wing at the Plaza Hotel in New York City, September 2015.

*Photo credit: Courtesy of the author*

# THE LEADING LADY PAYING HOMAGE TO THE LEADING MAN

## The Red Brocade Gown

In September 2015, the American Theatre Wing honored the iconic James Earl Jones. I was so excited that I would accompany Cicely to honor this giant of stage and screen. The two got their start together in the 1961 off-Broadway production of Jean Genet's *The Blacks*, and at the time they were starring together in the revival of *The Gin Game*. For the American Theatre Wing event, we sat alongside Earl and his wife, the actor Cecilia Hart.

Cicely was elated to be celebrating one of her dearest theater colleagues. Being Cicely's escort was always meaningful, but that particular night stands out for a few reasons. Each guest at the event received *Voices and Silences*, the honoree's autobiography—and James Earl Jones even signed mine with a personal inscription.

For the formal event, we took another look from my Fall/Winter 2015 runway collection: an autumn red silk brocade gown with a three-tiered train that gently cascaded down the back like a waterfall. It's the first time I triple-layered a train's sweep to increase the dramatic volume. I love the idea of rethinking glamour through fabrication. We went on to use this gown several times, always with a slightly different spin.

For myself, I chose a men's suit in black and red wool-brocade, from that very same runway collection to escort Cicely in grand style.

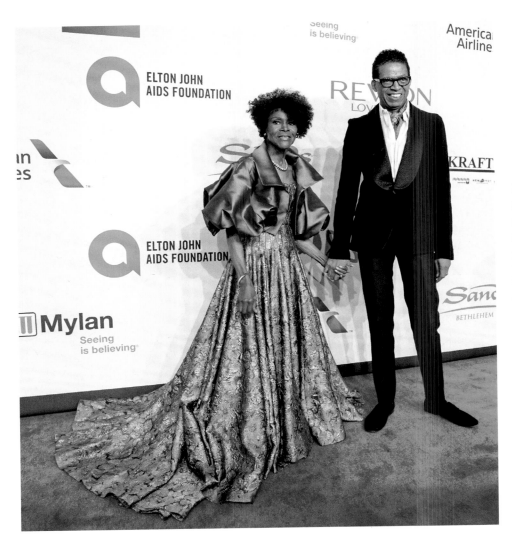

Having just emerged from the on-site dressing room, we are on time for the fourteenth annual Elton John AIDS Foundation Enduring Vision Benefit, held at Cipriani Wall Street in New York City, November 2015.

*Photo credit: WENN Rights Ltd. / Alamy Stock Photo*

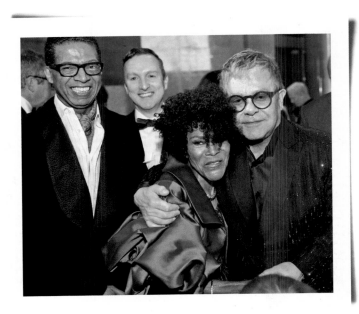

I love the way Cicely and Sir Elton John embraced each other that evening.

*Photo credit: Dimitrios Kambouris / Wireimage*

# THE GIVERNY BALL GOWN NEEDED ITS OWN ZIP CODE

Sir Elton John's Party

When Elton John throws a party, you know it's time to play dress-up with unapologetic glamour. Cicely accepted an invitation for the Elton John AIDS Foundation's Enduring Vision Awards Gala, which was held at Cipriani Wall Street in downtown New York. The annual event is always a rambunctious night with elbow-to-elbow luminaries. Cicely was looking forward to seeing Sir Elton John. I'll admit that I too was excited about it. Although I don't consider myself to be starstruck, Sir Elton John is more than a celebrity—he is, after all, *the* Sir Elton John!

Hesitant about the logistics of arriving downtown, with Cicely fully dressed and on time, I requested a dressing room on location at Cipriani. To my delight, a dressing room was provided. That afternoon, hours before the red carpet, I arrived with Cicely. Armond Hambrick, her trusted makeup and hair maestro, was already there, set up and ready for the glam process. One of my mottoes is "A good evening, for a good cause, in good clothes." I chose an ethereal French silk brocade creation from my Fall/Winter 2014 runway collection, inspired by my fixation on Impressionism. The palette of pale blues and garden lilacs reminds me of being in Giverny, Claude Monet's home in France, one of my favorite places to go for inspiration. I added a statement silk Mikado bolero in a glossy violet with my signature "awning sleeves." (You'll see more of that bolero because it became one of Cicely's favorite go-to accents.) The architectural bolero balanced out the volume of the gown's thirty-two seams opening up to an eleven-yard sweep, which Cicely's small frame navigated with ease. I collaborated with Armond to heighten the romanticism with a berry lip and a halo of natural curls. The look was uplifting and made us happy, in the way spring does—a magical escape on a blustery November night!

Needless to say, Sir Elton John was the warmest host. Even the iconic Cicely Tyson was gushing.

The recipients of the thirty-eighth annual Kennedy Center Honors posing at the US Department of State: *(seated)* Seiji Ozawa, Carole King, Cicely Tyson; *(standing)* Rita Moreno and George Lucas, December 2015.

*Photo credit: dpa picture alliance / Alamy Stock Photo*

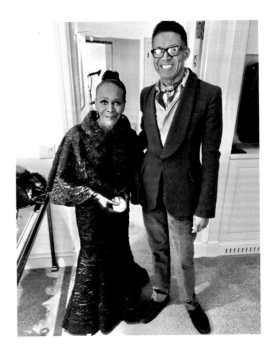

Cicely dressed for the Department of State dinner, Washington, DC, December 2015.

*Photo credit: Courtesy of the author*

# THE KENNEDY CENTER HONORS, PART I

Dinner at the US Department of State

There are some achievements we could not have imagined when we started out on our journey.

As artists, we regard our journey as a mission fueled by passion. Practicality, necessary resources, acceptance, and recognition are the key forces outside of that passion. I confess I did not always know this. To be applauded and recognized for our "art," our true DNA, is inspiring and gratifying for the soul and the ego.

Cicely was both surprised and thrilled when she was told she had been chosen to receive the Kennedy Center Honor for her life's work in the performing arts. Amplifying that honor was the fact that she received it under the administration of President Barack Obama. The Kennedy Center Honors, which date back to 1978, are not about a single performance or a hit record. These awards acknowledge a lifetime of contribution to American culture. In other words, you need to be an icon to be given the coveted medal. When Cicely was invited to the nation's capital to be honored, she joined the ranks of such legends as her good friends Sidney Poitier and Aretha Franklin.

The epic occasion called for an epic look—make that "looks." The weekend would include two black-tie events. Cicely needed one gown for the formal awards dinner hosted by Secretary of State John Kerry at the US Department of State, and a second gown for the star-studded televised performance and gala on the following night at the John F. Kennedy Center for the Performing Arts. The design challenge for me was that both dresses had to complement the rainbow ribbon medal that Cicely would wear throughout the weekend of festivities. I recall Cicely sharing with me that this award would be her "swan song," so I best design the two dresses as "finale" pieces. She could not imagine what else there could be for her. How wrong she was about that. This weekend was really the beginning of a new tier of recognition.

For the medallion presentation and secretary of state's dinner, I channeled classic White House elegance. I created a navy silk, eight-ply satin-crepe column gown, completely ruched to create three-dimensional texture right down to the fluted train. Paired with a matching, high-waist-length jacket with dramatically wide sweep sleeves, the effect was like a cape—along with bespoke navy leather opera gloves, which we boldly accessorized with a dinner ring flown in from Beverly Hills jeweler Pamela Froman. Cicely loved her look that evening from head to toe—from the upswept hair by makeup and hair artist Armond Hambrick to the navy hosiery and evening shoe. I loved it too!

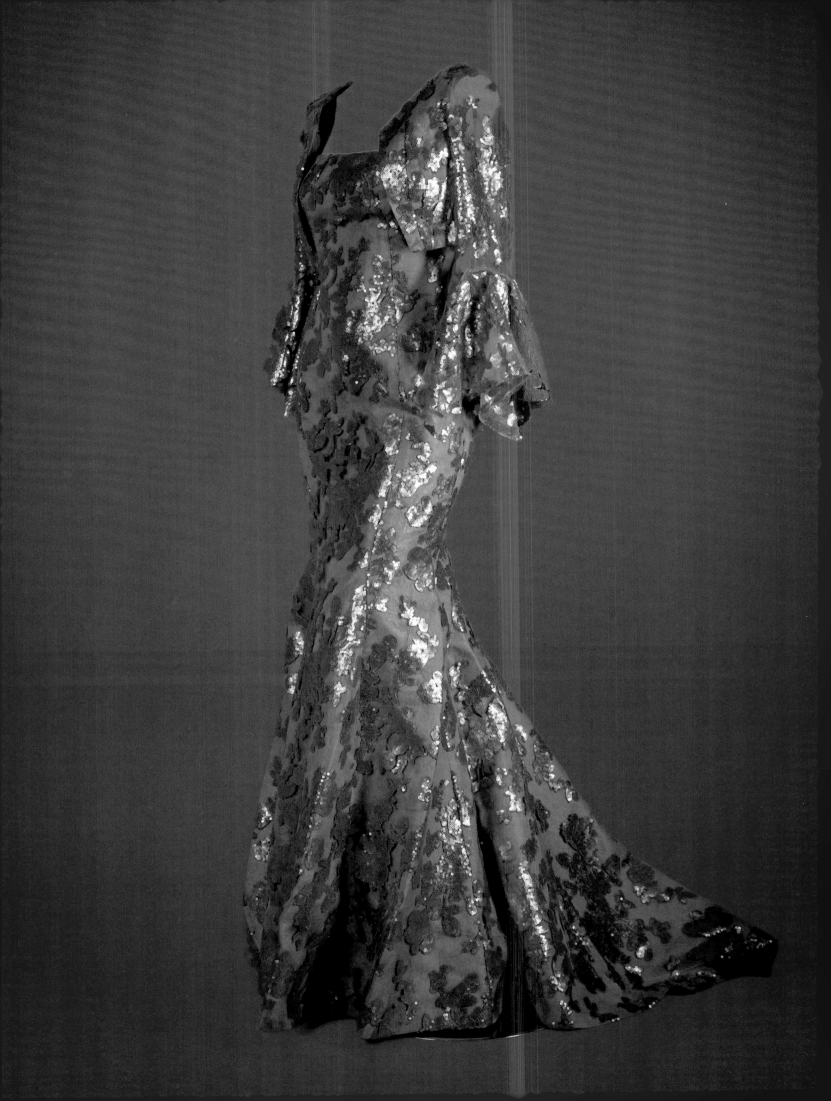

# TELEVISED PERFORMANCE AND GALA

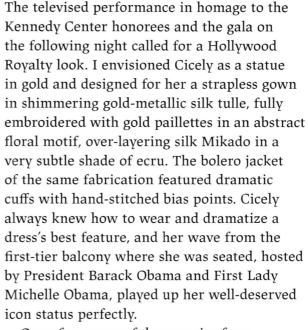

The televised performance in homage to the Kennedy Center honorees and the gala on the following night called for a Hollywood Royalty look. I envisioned Cicely as a statue in gold and designed for her a strapless gown in shimmering gold-metallic silk tulle, fully embroidered with gold paillettes in an abstract floral motif, over-layering silk Mikado in a very subtle shade of ecru. The bolero jacket of the same fabrication featured dramatic cuffs with hand-stitched bias points. Cicely always knew how to wear and dramatize a dress's best feature, and her wave from the first-tier balcony where she was seated, hosted by President Barack Obama and First Lady Michelle Obama, played up her well-deserved icon status perfectly.

One of my powerful memories from that euphoric weekend is of the musical presentations. The choir from the Cicely L. Tyson Community School of Performing and Fine Arts sang Cicely's favorite hymn, "Blessed Assurance." And the incomparable Aretha Franklin brought everyone to their feet with a tribute to songwriter and honoree Carole King. In fact, that was the last night I saw Aretha perform live. It was an authentic Aretha performance, with piano, that phenomenal voice, and a full-length fur coat. I will always cherish that moment.

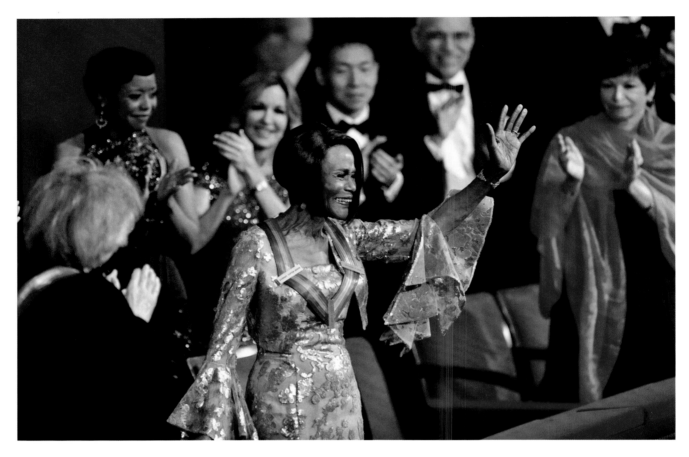

I call this photo "Cicely's Royal Wave." Here she's acknowledging the applause at the Kennedy Center Honors, where she was seated with President Barack Obama, First Lady Michelle Obama, the evening's honorees, and other dignitaries, December 2015.

*Photo credit: CBS Photo Archive / Getty Images*

### From the Kennedy Center to the Runway

Although I showed the gold gown and bolero that following February on the runway for my New York Fashion Week Fall/Winter 2016 collection, I decided I would never make the dress for anyone else. The look would go into history belonging to that moment, to Cicely.

### My Lighthouse Guild Design Visionary Award

Most people don't know I'm shy. Like many artists, I express myself through my medium. I make sweeping statements with luxurious fabrics and punctuate my thoughts with well-placed seams. When the Lighthouse Guild, a nonprofit organization that supports the blind and visually impaired, honored me with their hallowed Design Visionary Award, this "man behind the seams" had to step out and speak up.

The elegant award's dinner and curated exhibition of my couture dresses, including the gold gown I designed for Cicely's Kennedy Center Honor, was held at the Four Seasons restaurant in the Seagram Building in Midtown Manhattan. Now closed, it was considered the quintessential New York City restaurant, and its walls concealed many stories.

Cicely began the tribute by recalling how

Cicely and I examining the gown she wore for the Kennedy Center Honors, which became part of the installation of dresses for the Lighthouse Guild's posh awards gala, May 2016.

*Photo credit: Courtesy of the author*

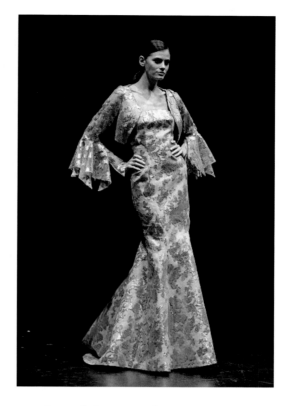

I showed the Kennedy Center Honors gown as part of my Fall/Winter 2016 runway show for New York Fashion Week, February 2016.

*Photo credit: Courtesy of the author*

she first met me through Susan Fales-Hill, who was in the audience that evening. When Cicely joked, "B ruined me for anyone else wanting to dress me," it truly hit me that she and I had been, with intention, a designer and muse duo for more than a decade. Cicely went on to say that I always "make it work"—and I thought, *We make it work together*. Our relationship relied on our mutual trust and love as rare friends, and our shared pleasure in—and even desire for—creative authenticity.

To celebrate the Lighthouse Guild's Design Visionary tribute, my dear friend Valerie Simpson performed one of my go-to favorite songs, the seventies hit "Reach Out and Touch (Somebody's Hand)," which she and her husband Nick Ashford had written. It was incredibly touching that she personalized the song with a few new lyrics tailored to me. The musical ballad brought to mind the Lighthouse Guild's art-based school for the visually disabled. Before the event, Mark-Anthony and I had toured the classrooms and had spoken to the gifted art students about our love of art and our personal passion for fashion design. We returned to the school throughout the remainder of the academic year, championing the students and the art they were creating.

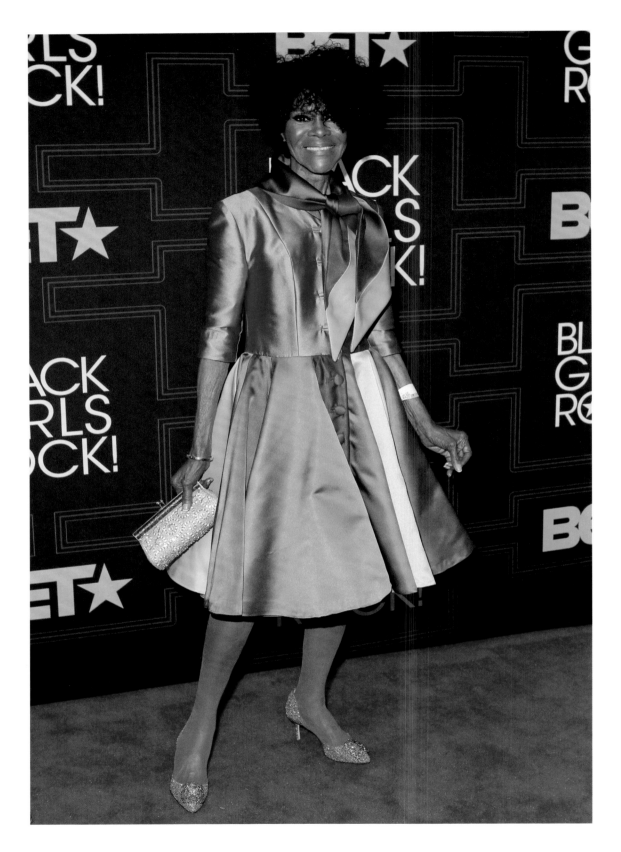

Cicely at the Black Girls Rock! Awards in New Jersey, April 2016.

*Photo credit: WENN Rights Ltd. / Alamy Stock Photo*

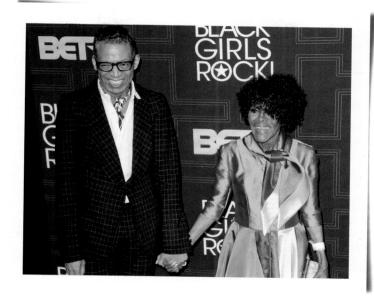

# BRIGHTENING THE WORLD

Black Girls Rock! Awards

When Cicely Tyson throws up her hands to get down in the aisle to a live performance by Lauryn Hill, you know you're at the Black Girls Rock! Awards. Founded by author, former model, and DJ Beverly Bond, this annual ceremony, which is televised on BET, has honored transcendent women in the arts, from hip-hop queen Missy Elliot to the legendary singer Dionne Warwick. The performances and fashion always slay. That night, host Tracee Ellis Ross had five outfit changes!

Cicely, who had been named a Living Legend the year before, captured the spirit of the joyful dress I designed for the awards ceremony. It was pieced together from remnants of sumptuous French double-faced silk satin—true sustainable couture. She literally screamed when I first showed it to her, and she later referred to it as her own "Joseph's coat of many colors." My only regret is that I didn't wear something bright and whimsical to the show too.

Cicely and I enjoying a moment on the red carpet at the Black Girls Rock! Awards.

*Photo credit: WENN Rights Ltd. / Alamy Stock Photo*

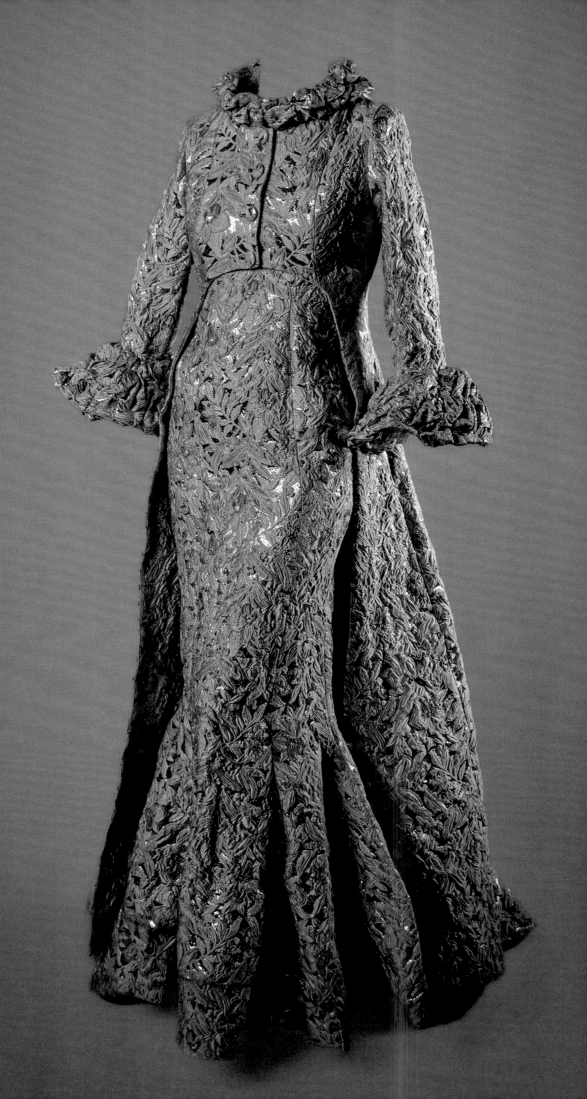

## A New Stage of Life

# MAJESTIC COUTURE

**American Theatre Wing Awards**

When an organization of your peers recognizes your work, it is the highest honor. So when Cicely's friend, acclaimed stage and screen actor LaTanya Richardson Jackson, reached out on behalf of the American Theatre Wing to say they had chosen to recognize her, Cicely readily embraced the homage.

Cicely got her start onstage, relying on her raw talent to connect with live audiences. There are no retakes on Broadway. There are also no retakes on a dress worn for an occasion as important as the American Theatre Wing Awards.

A modern-day American interpretation of old-world European luxury was my inspiration for Cicely's regal brocade ensemble. The occasion called for a majestic look, befitting her achievements as theater royalty, the celebration of the breadth of her work, and her return to the stage in *The Gin Game* and *The Trip to Bountiful*, for which she won a Tony. This was a night for the stage actress Cicely Tyson to *own* the spotlight.

I designed a floor-length, fitted sheath footed with a flounce train in white-gold and yellow-gold brocade, with a matching empire cutaway opera coat. The high cut at the waist highlighted Cicely's slip of a silhouette; the hand-ruched collar accentuated her striking bone structure. The coat's silhouette was absolutely magical on Cicely, I reimagined it several ways in the years that followed. She

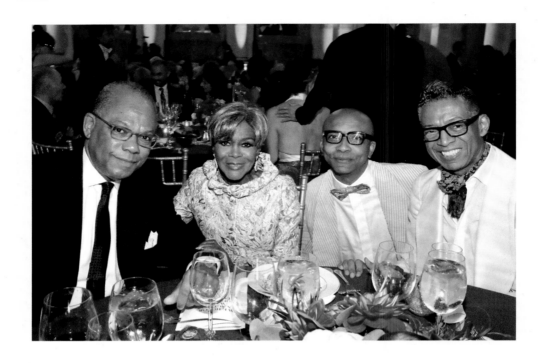

A giant in Cicely's life, the Reverend Calvin O. Butts III, the senior pastor of Harlem's historic Abyssinian Baptist Church, seated with Cicely, Mark-Anthony, and me.

*Photo credit: Courtesy of Annie Watt*

loved sweeping down the red carpet and up to the stage, keenly aware that the luxe opera coat literally followed her like an elegant train. As always, she led the way. I knew we had achieved my vision perfectly—complimenting the theatrical couture ensemble with a modern shorter length silver-gray wig and the beautiful work of glam-team collaborator and makeup artist Armond Hambrick. Mark-Anthony declared it was his new favorite gown on Cicely. From our unfiltered critic, that's high praise! At the event, a well-meaning woman asked Cicely if her gown was Dior. Cicely replied proudly, "No, but a couturier just as important. It's my designer, B Michael." To Cicely's amusement, the woman was my stalker all of that evening.

That night, Cicely was duly honored by two industry power couples. Celebrated stage and screen actor, director, and producer LaTanya Richardson Jackson and her husband, award-winning world-renowned actor Samuel L. Jackson, were joined by author and film and television producer Tonya Lewis Lee and her husband, the trailblazing, award-winning film director, producer, screenwriter, and actor Spike Lee. These were just some of the esteemed honorary co-chairs. The "Cicely Tyson Celebration Choir" serenaded her. Joining Cicely's table as a special guest was a dear friend and respected leader, the influential Reverend Calvin O. Butts III of the Abyssinian Baptist Church—where Cicely was a devout member—making it a divine event.

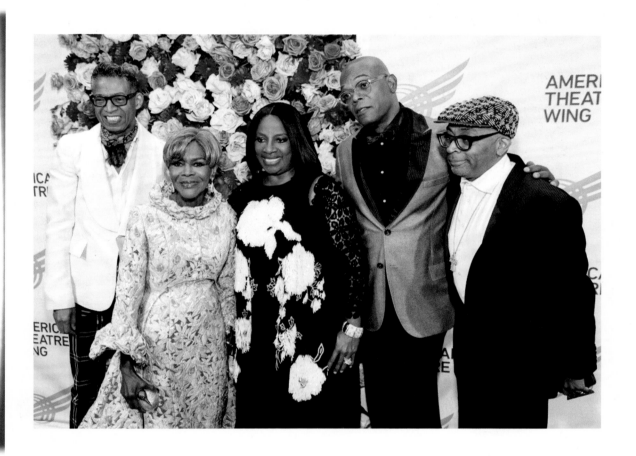

Trailblazing luminaries of film and theater celebrate Cicely's moment.
*Left to right:* me, Cicely, LaTanya Richardson Jackson, Samuel L. Jackson, and Spike Lee.

*Photo credit: Courtesy of Annie Watt*

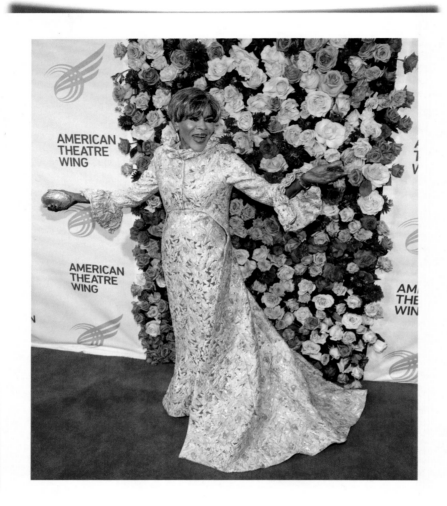

Cicely, looking joyful and dramatic, on the red carpet
of the American Theatre Wing Awards at the Plaza Hotel,
New York City, September 2016.

*Photo credit: Rob Kim / Getty Images*

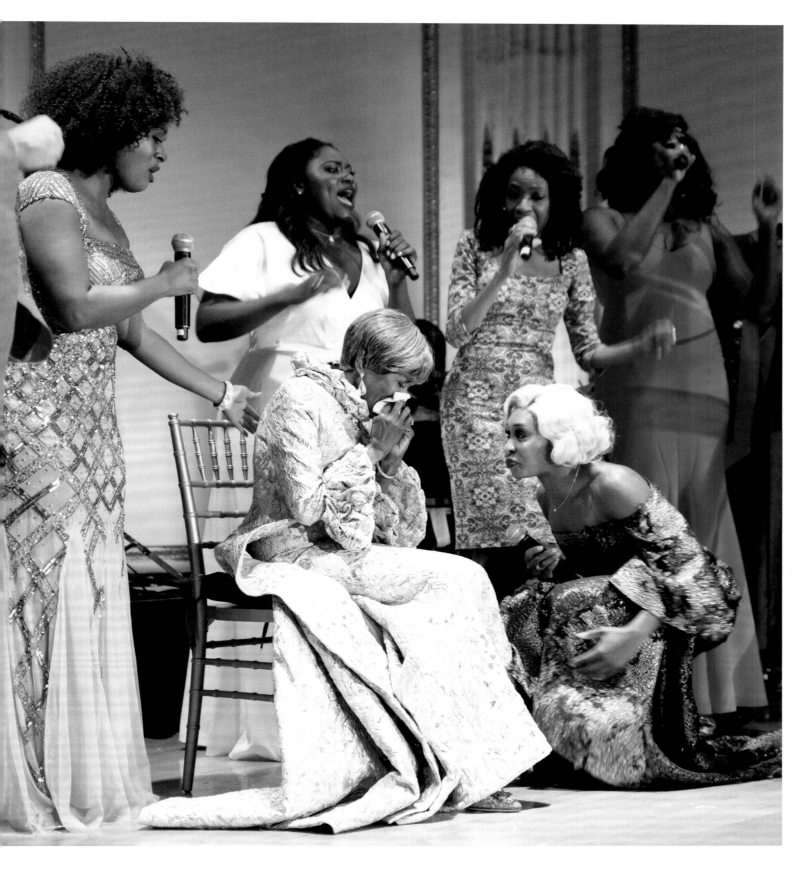

An all-star group of stage and screen actors performing a musical tribute to Cicely on the Plaza Hotel's grand ballroom stage. Surrounding Cicely are Cynthia Erivo *(kneeling)* and *(standing, left to right)* Saycon Sengbloh, Danielle Brooks, Adriane Lenox, and Amber Iman.

*Photo credit: Courtesy of Annie Watt*

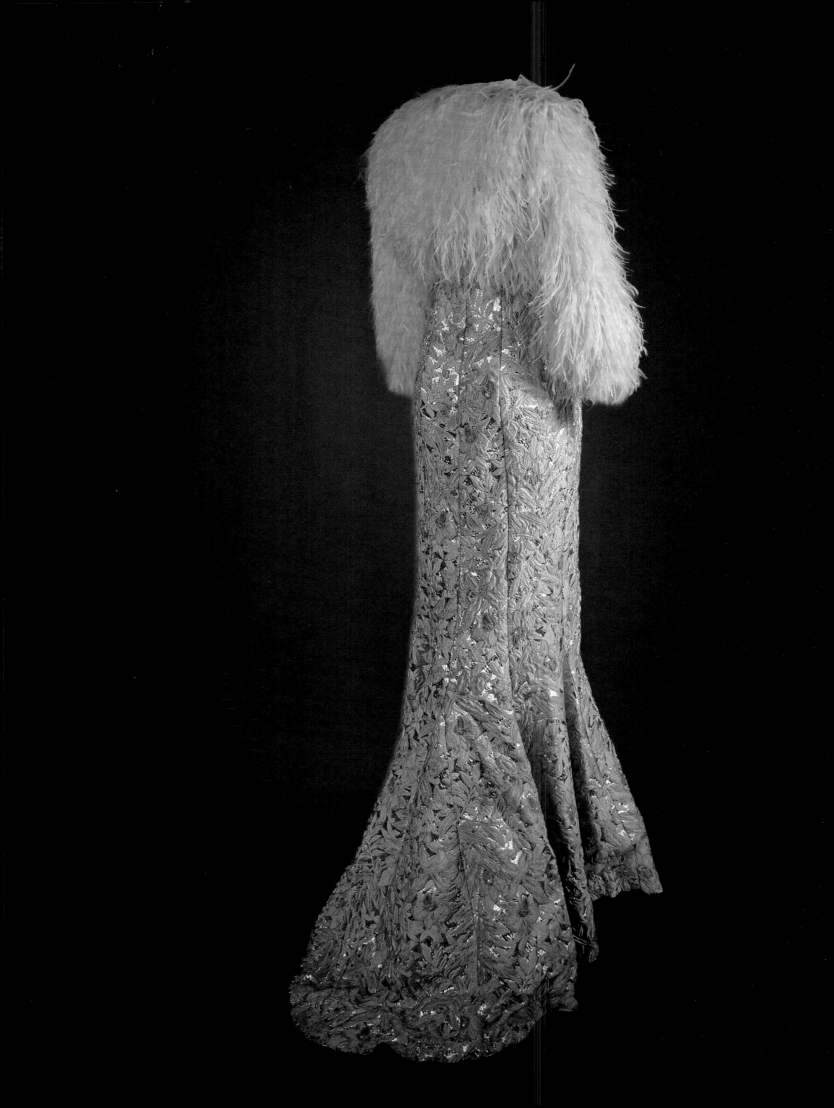

# THE THEATRE WING UNDER GOWN'S ENCORE WITH AN OSTRICH FEATHER JACKET

**Mission Society of New York City
Honors Diahann Carroll**

The legendary Diahann Carroll was honored by the Mission Society of New York City at their annual Champions for Children Gala in 2017. For Cicely, Diahann, and me, it felt like a reunion. Diahann Carroll and Cicely had a long history; they shared a sisterhood above and beyond their iconic work on stage and screen. I recalled when I first met Diahann in the eighties on the set of the ABC television series *Dynasty*. Diahann took me under her fabulous wings, as I was new to the whole Hollywood scene and naive. So, on this New York evening in April 2017, coming together to celebrate Diahann being recognized by an organization that Cicely, Mark-Anthony, and I all believed in, was a meaningful reunion.

It is known in fashion circles that women dress for other women. When those women are internationally known for their sense of style and glamour, and their names are Cicely and Diahann, there are great expectations. For this occasion, I had the delicate balance of two divas to consider. For Cicely, I chose the gown she wore under the empire opera coat for the American Theatre Wing Gala the previous year. I added a white ostrich jacket. The overall effect was one of balanced glamour. We used the exact look again for the 2017 American Ballet Theatre Fall Gala.

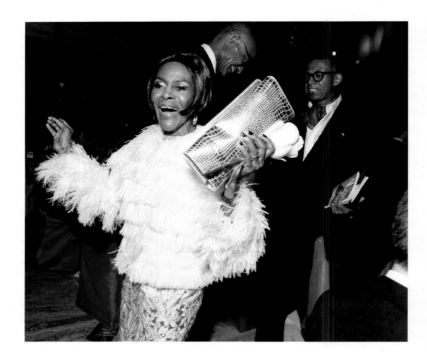

Something else Cicely and I had in common, we loved to dance.
Here Cicely is on the dance floor at American Ballet Theater's
opening night performance gala, New York City, October 2017.

*Photo credit: Rob Kim / Getty Images*

## American Ballet Theatre Fall Gala

For the American Ballet Theatre's opening night gala in October 2017, Cicely and I were the guests of our dear friends Aaron and Susan Fales-Hill. As an homage to some of the dance world's Black American trailblazers, Aaron and Susan also invited Carmen de Lavallade, an iconic dancer, choreographer, and actor and the widow of Geoffrey Holder, another tremendous contributor to the tapestry of American dance, theater, and film. As a child, I was mesmerized by Carmen de Lavallade, who appeared as an orator onstage at Yale's Woolsey Hall with the New Haven Symphony Orchestra as the backdrop. Later, when my paternal grandmother, who had taken me to the performance, questioned me about Carmen's reading, I confessed I was too awestruck and missed the poetry. What I could recall precisely was Carmen standing with perfect posture, her hair in a chignon showing off her perfect chiseled face, wearing a ball gown fitted from her tiny waist to a grand sweep onto the glorious stage. This image remained in my mind's eye as the epitome of timeless glamour. I later learned that Geoffrey Holder, also a costume designer, had designed that ball gown for his wife. Before Geoffrey passed away in 2014, I designed the coat he wore for one of his last public events.

In the winter of 2017, Carmen was honored at the fortieth annual Kennedy Center Honors. For the televised ceremony, I designed Carmen's gown—another full circle and proof that destiny is divine. Cicely and I realized that all these prior roads were leading us to each other. We were no longer shocked by how much our lives had overlapped. As we said before, "Blessed be the tie that binds."

# AN INTRICATE LOOK

The delicate yet precise folds of Japanese origami came to mind as I designed this cocktail dress in a deep sapphire silk Mikado for my 2015 Fall/Winter runway collection. The hand-pleated bodice and sleeves create layers of dimension and celebrate the craftsmanship of couture. When Cicely was asked in 2016 to be an honorary co-chair for the Primary Stages annual gala to support emerging playwrights, we chose this look. I had planned for Cicely to wear this dress for the second time on January 28, 2022, for a live and virtual book party promoting her memoir, *Just as I Am*, which would be released two days prior. The dress was prepped and ready but would not be worn again. Cicely passed away on January 28. This dress now epitomizes timelessness for me. It does not belong to any particular era—like its muse, Cicely Tyson.

Cicely at the Primary Stages Gala in New York City, wearing a cocktail dress with haute couture hand-embroidered pleating, October 2016.

*Photo credit: CJ Rivera / Getty Images*

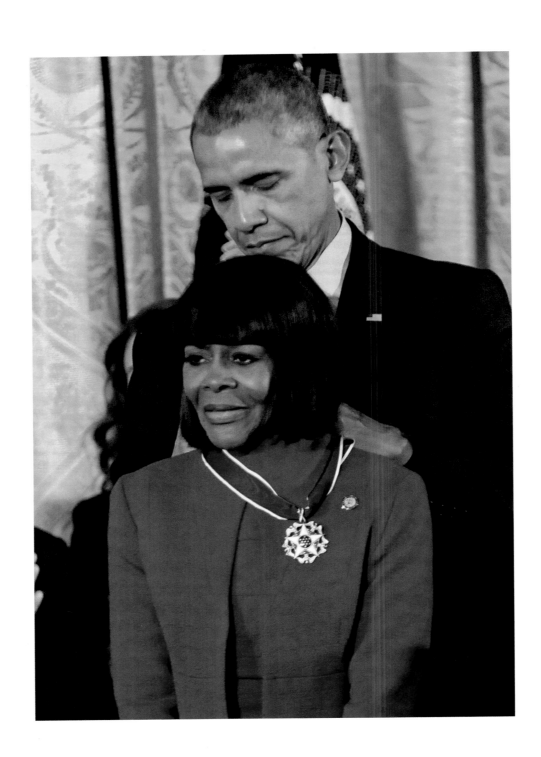

# THE PRESIDENTIAL MEDAL OF FREEDOM

Autumn Red English Wool Bouclé Signature Topper and Sheath

The Presidential Medal of Freedom is the highest award given to a citizen by the US government. President Barack Obama chose Cicely to receive this distinction at the end of his second term. She and twenty-one other honorees—including Robert De Niro, Bill and Melinda Gates, Tom Hanks, Kareem Abdul-Jabbar, Robert Redford, and Diana Ross—were invited to the stage in the East Wing of the White House to accept the medal.

Having never dressed anyone for the Presidential Medal of Freedom, I did some research and even asked a few of my Washington political pals about the fashion protocol. Cicely too was curious and uncharacteristically asked me repeatedly what I had in mind for her to wear. This was a new experience for both the muse and the designer. I concluded that the afternoon event called for an elegant but dignified day look. It couldn't be showy or overshadow the other guests of honor. The ensemble's hue had to complement the patriotic colors of the distinguished medal, a gold and white enamel star on a royal blue satin ribbon. *Red*, I thought, *not a*

Cicely receiving the Presidential Medal of Freedom from Barack Obama, November 2016. I could feel only joy and gratitude that I was a part of that moment as Cicely's fashion designer.

*Photo credit: Paul Hennessy / Alamy Photo Stock*

*bright hue like cherry red*. I decided on an autumnal red with depth and created Cicely's sheath in English wool bouclé. Her matching topper featured a fluted hemline and flared cuffs, one of my signature looks.

On the morning of the ceremony, members of Cicely's family, Armond Hambrick, the makeup and hair stylist, Lois Harris, Cicely's personal assistant, and of course Mark-Anthony with Cicely, and me, gathered at the Washington home of Cicely's dear friend Dr. E. Faye Williams, where we did glam and dressed Cicely. We called it Headquarters. Dr. E. Faye's résumé could easily fill a book. She's an attorney, author, political commentator, civil rights activist, and president of the National Congress of Black Women. At some point, Cicely discovered that her friend planned to wear red too. It's a testament to Cicely's deep relationships that she could say to Dr. E. Faye: "You cannot wear red today." We all laughed—and Dr. E. Faye wore blue. The fact that we made it to the White House on time that

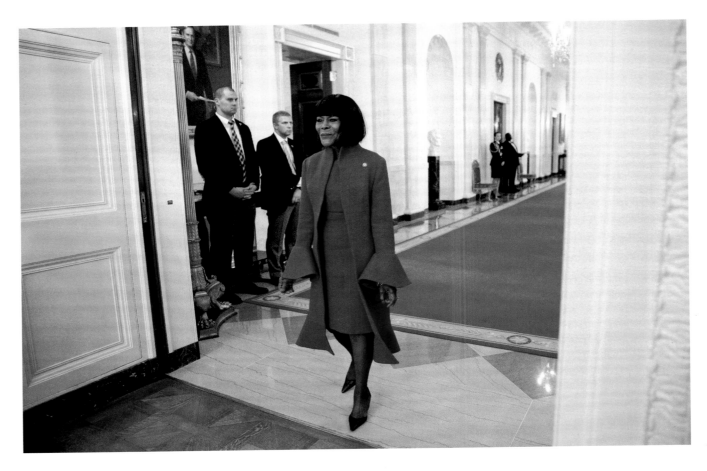

Cicely being introduced as she walks to her
seat for the Presidential Medal of Freedom
awards ceremony at the White House.

*Photo credit: TERS / Alamy Stock Photo*

day is testament to Cicely's love and respect for Mark-Anthony. Only he knew how to prompt her to move a bit faster with a glance at his watch and a raised eyebrow.

As you can imagine, visiting the White House was a "pinch me" moment, although this was now my second visit. Cicely's intimate guest list that day, in addition to those of us that came with her from New York, included her other Washingtonian good friend Minyon Moore, and

for a bit of Hollywood power, her friend Tyler Perry. The post-award luncheon felt like we were in someone's home. We were especially happy that Diana Ross and her family joined us. I'll never forget the moment Tyler Perry and I both admitted that we had taken a hand towel with the White House insignia from the restroom as a souvenir. "You know, we may never be invited again," I said with a huge laugh.

Cicely looking very downtown-meets-uptown at my presentation during New York Fashion Week, February 2017.

*Photo credit: Courtesy of the author*

## CICELY'S REASSURING PRESENCE

New York Fashion Week, Fall/Winter 2017

During New York Fashion Week for the Fall/Winter 2017 collection, I did a presentation in my New York atelier rather than a runway show. The installation on mannequins provided an optimal vantage to appreciate the construction and fabrication of the collection. This setup also meant no seating chart and no worries about what the front-row ladies would wear, most especially my muse, Cicely. To her amazement, I suggested she arrive at her leisure; there was no pressure for her to be in her seat on time—we both enjoyed that relief. I also suggested that she wear something casual, along the lines of her downtown-meets-uptown streetwear. Cicely called me the morning of the presentation to confirm that I did not have something I wanted her to wear. She showed up perfectly cast in her bohemian urban chic style. What I loved the most about her look that day was the fitted vintage cloche hat I always wished I had created.

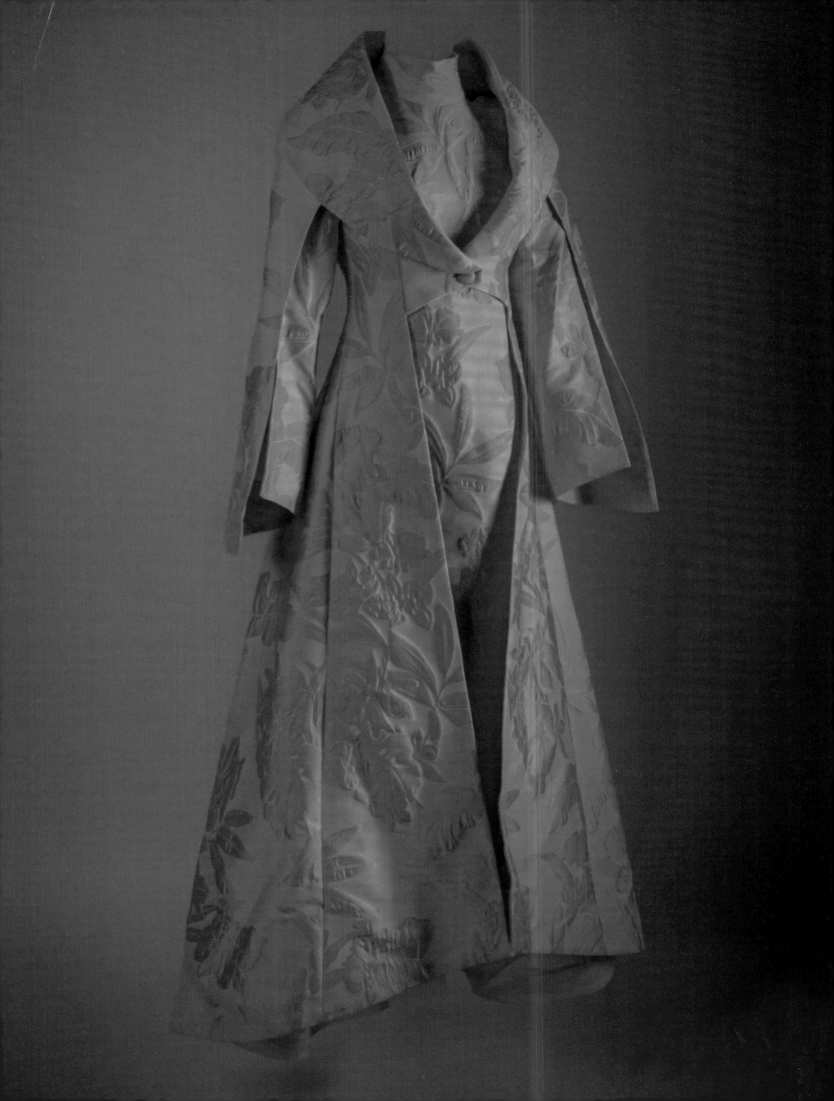

# HAUTE COUTURE KIMONO ENSEMBLE

**Primetime Emmy Awards, September 2017**

The dress I created for my muse for the 2017 Emmys has become a branded visual. Cicely declared it a couture masterpiece. The two-piece ensemble consisted of a cutaway single-button opera coat with a shoulder-sweeping shawl collar and a two-piece kimono sleeve worn over a high-neck evening sheath, all fabricated in French silk brocade. The color combination of fuchsia and red recalled my days as a millinery designer being inspired by the color palette of Yves Saint Laurent's 1989 Spring couture collection. I gave Cicely a swatch to take to the shoe salon at New York's Bergdorf Goodman, and she called me excited to share that she found the perfect hue in our favorite tried-and-true Manolo Blahnik satin pump.

The look Armond Hambrick created for her—short hair with a fringe and a muted fuchsia lip—was very modern. I confess, I could not take my eyes off Cicely that night.

**A Touch of Nerves**

What I remember most about the Emmy Awards ceremony was the moments backstage just before Cicely and Tony Award winner Anika Noni Rose were to appear together to present the award for Outstanding Limited Series to *Big Little Lies*. I perfectly positioned the train of Cicely's demi opera coat and even checked Anika's look to be sure she too was

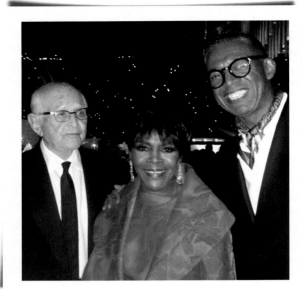

Television's incomparable Norman Lear
with Cicely and me, September 2017.

*Photo credit: Courtesy of the author*

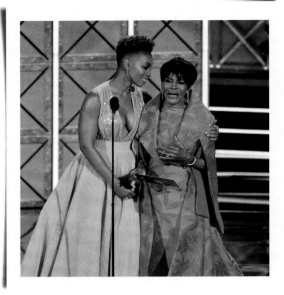

Anika Noni Rose and Cicely presenting
on stage during the sixty-ninth annual
Primetime Emmy Awards at the Microsoft
Theater in Los Angeles, September 2017.

*Photo credit: UPI / Alamy Stock Photo*

ready as they stood side by side, waiting for their dramatic walk onto the stage. I gave Cicely a nod that she was ready and then disappeared and found a monitor. The curtain rose, and what happened next was euphoric: thunderous applause and a standing ovation! I was reminded that there stood a true legend, wearing my creation. I teared up. Even the crew and other celebrities waiting for their own appearances paused. It was so emotional. Cicely later shared with me that it made *her* so emotional that she became nervous. Imagine that! I will always love Anika for her gracious instinct to support and honor the legend standing beside her in that moment.

At the dinner afterward, lots of folks found their way to our table to pay homage to Cicely, who was still radiant and feeling so much positive energy. Meeting Norman Lear was an over-the-moon experience. I don't know which one of us was more awestruck: Cicely, Mark-Anthony, or me! Mr. Lear created *The Jeffersons*, *Good Times*, *Maude*, *Sanford and Son*, and *All in the Family*—television I grew up with and continue to watch—still all very relevant.

Cicely on the red carpet as we arrived at the Microsoft Theater in Hollywood for the Primetime Emmy Awards, September 2017.

*Photo credit: Media Punch Inc. / Alamy Stock Photo*

# THE COURAGE TO BE CANDID

*Elle* Magazine's Women in Hollywood

At the age of ninety-two, Cicely was one of the cover subjects for *Elle* magazine's Women in Hollywood issue (November 2017). The photo used inside for the feature, of Cicely wearing a gown and evening topper from my Fall 2017 collection, was spectacular and would have been a breathtaking cover.

Mark-Anthony and I accompanied Cicely to Los Angeles to attend the related event, a star-studded evening with some of Hollywood's most brilliant and accomplished women. Cicely jokingly noted that most of the honorees might be wearing Calvin Klein, whose denim jacket she wore on the cover and who was the sponsor for the event. Cicely provoked me to go into my fabric vault. I selected a vintage silk and wool brocade in polished gold and black from Abraham, the prestigious Swiss fabric company that had supplied the great couturiers of Paris, including Cristóbal Balenciaga, Hubert de Givenchy, and Yves Saint Laurent. On a buying trip to Europe, I found two vintage Abraham fabrics in small yardages. For this event, I decided to use the smaller cut, knowing it would be enough yardage for only a short dress. The second piece I later used for Cicely's Honorary Oscar. The knee-length dress I designed for the *Elle* event has an asymmetrical high neck, a fitted patterned bodice, a wide waist, and patterned arrow-point sleeves. It felt as if we were adding quietly and meaningfully to the history we were creating in both of our industries—a legendary Black American female actor wearing a Black American couturier's dress.

# STEALING THE SHOW (AT NINETY-THREE)

I may have been more excited than Cicely upon learning that she had been approached by Turner Classic Movies, known as TCM, to be honored with a Hand and Footprint Ceremony to take place at the famous TCL Chinese Theatre IMAX in Hollywood. TCM is always tuned in on our television. Ever since I can remember, I have watched vintage movies, drawing inspiration from the way clothes were worn and used to shape a character. Then came Cicely's question, "What am I wearing for that? You do know I have to get down on all fours?"

At that point, Cicely and I had shared many experiences that required my creative exploration, but this was the first time when the call was not for a dress or gown. We both realized that the physical nature of this ceremony meant Cicely should wear pants.

Cicely and her assistant flew out a day or two before me. I stayed behind to work on what she would wear. The night before the event, Mark-Anthony and I arrived in LA, garment bag in hand. I asked Armond to have a very modern hairstyle for her, a bob with a severe blunt cut in shades of gray. From our years of collaboration, I knew that he would interpret the vision precisely.

Early on the morning of the event, before the call time for the glam, I was at Cicely's suite, and she wanted to see immediately what I had created. When she saw the pant ensemble, she made a loud sound, like a full-bodied chant! She loved it. The ensemble's jacket and sleeves are paneled all around with vertical seams that create an oversize trapeze silhouette. The empire-height trouser is seamed down the front, opening into a vent at the center bottom. I chose Italian cotton and silk brocade in a pearl white and dove gray abstract pattern.

I love this photo. The model in Cicely knew
how to create a photo shoot.

*Photo credit: Sipa USA / Alamy Stock Photo*

The following morning, we were forwarded a *Vogue* article written by Janelle Okwodu, Vogue.com's senior fashion and culture editor. The article was titled, "At 93, Cicely Tyson Is Still a Fashion Risk-Taker." Okwodu wrote, "The actress arrived in a show-stopping look by designer B Michael." It made us both happy to see our collaboration recognized. Cicely exclaimed,

"They can't ignore us; at some point they will have to make note."

Cicely waving to the crowd of celebrities, family, and friends who gathered to witness the Hand and Footprint Ceremony, April 2018.

*Photo credit: UPI / Alamy Stock Photo*

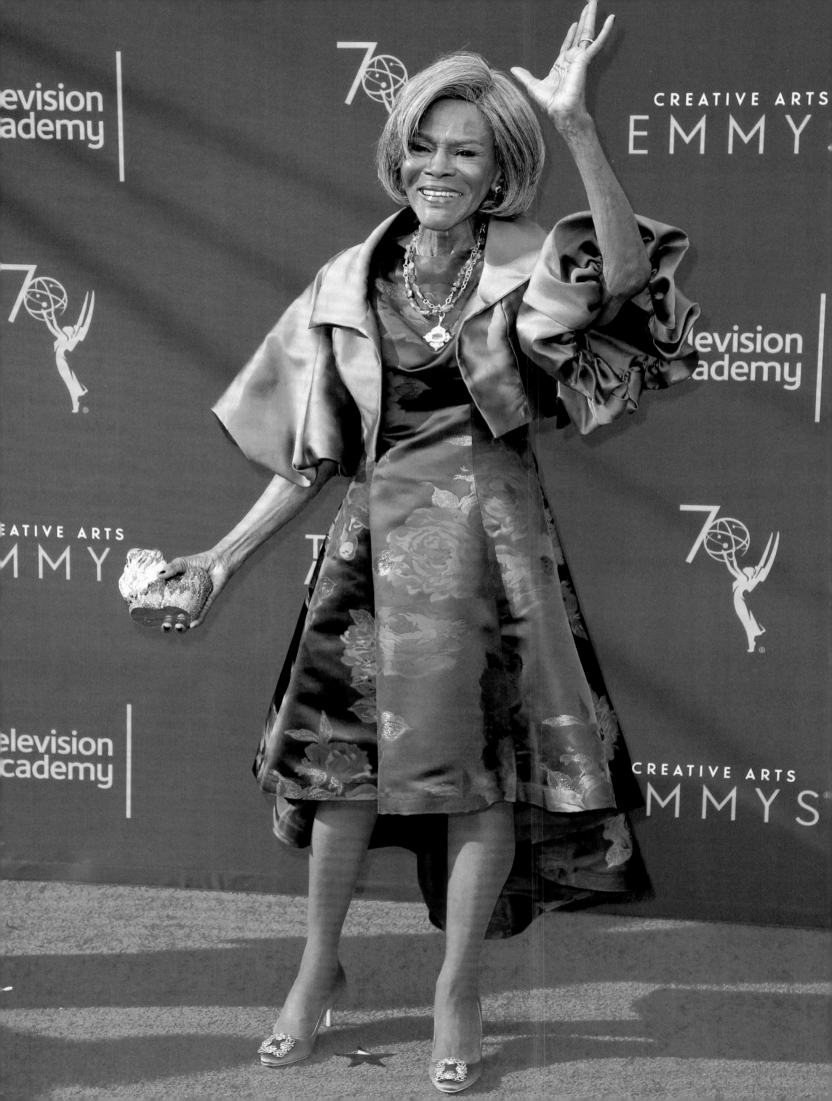

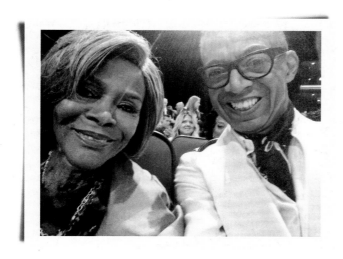

In our seats at the Creative Arts
Emmys, taking a selfie to send to
Mark-Anthony.

*Photo credit: Courtesy of the author*

## SHINING IN A CONSTELLATION

I played hooky from New York Fashion Week in September 2018 and accompanied Cicely to the Creative Arts Emmy Awards. Cicely was nominated for Outstanding Guest Actress in a Drama Series for her role as Ophelia Harkness in *How to Get Away with Murder*. Cicely felt it was important to attend in support of the show and cast. I sensed that she did not want to be too gussied up. The dress should have quiet presence but be elegant enough for Hollywood royalty. The cocktail-length dress I designed for the occasion has a wide high neckline and fitted bodice with princess seams opening to a full sweep with a waterfall train at the back, fabricated in a black and fuchsia cross-dyed silk Mikado patterned with large abstract roses. The look was topped with our go-to: a lavender awning-sleeve bolero. The necklace is from Pamela Froman Fine Jewelry, and the fuchsia satin pumps by Manolo Blahnik made another appearance.

Cicely loved the dress we whipped up. The look turned out to
be a hit! A year later, when *Vanity Fair* added Cicely to the 2019
Best-Dressed List, the lead photo the magazine selected is of
Cicely wearing that dress at the Emmys.

*Photo credit: Media Punch Inc. / Alamy Stock Photo*

## Hope, Healing, Love, and Pride

# THE HAT

### Aretha Franklin's Funeral

This is the story of The Hat. We were in a hotel suite in Detroit, preparing to leave momentarily to attend Aretha Franklin's funeral. Our car was already waiting in the queue just behind Aretha's family, all of whom were staying in the hotel. We were all leaving together to motorcade to the church. With only a few minutes to get downstairs, I said to Cicely, taking the hat out of the hatbox, "Let me place the hat on you, and we've got to get going."

Cicely declared, "I can't wear that hat!" Cicely protested that the people sitting behind us would be upset with her.

I confess that, although I had another smaller hat with me, I never presented it as an option.

When Cicely and I walked out of the dressing area into the suite's sitting room, where our dear friend Valerie Simpson, who would be riding with us was waiting, she looked up at Cicely and said, "I hope you all are ready for that hat!" The Detroit based glam team, Valerie and I, all agreed, that Cicely had to wear the hat. I expressed to Cicely that it was appropriate for her, as Hollywood Royalty and important for this occasion, as the Queen of Black American culture, to wear the hat in homage to the Queen of Soul. Cicely wore the hat, and the rest is history!

The moment we stepped into the church there was what I could only describe as a supernatural response to Cicely's arrival in that

Cicely speaking from the podium
of the Greater Grace Temple
in Detroit at Aretha Franklin's
funeral, August 2018.

*Photo credit: Paul Sancya / Associated
Press*

hat. It was ethereal and powerful—indeed it
was the arrival of a queen, bringing with her
hope, healing, love, and pride. I knew then we
were in harmony with the Universe.

Only Aretha Franklin could command an
audience for what would be an epic eight-hour
funeral. Cicely spoke in the second half of the
service; we were both amazed after several
hours of moving to all the emotional music that
the hat had managed to remain in place, as did

the dress of black double-faced wool crepe with
sculptured silk bodice and paneled sleeves—
always our go-to. Her black leather elbow-
length gloves were never removed, of course.
While in the church, a young costume jewelry
designer presented me with a bracelet he had
made for Cicely, with the hope she would be
attending the funeral; graciously, Cicely put the
bracelet on over her glove.

From the grand podium of the Greater

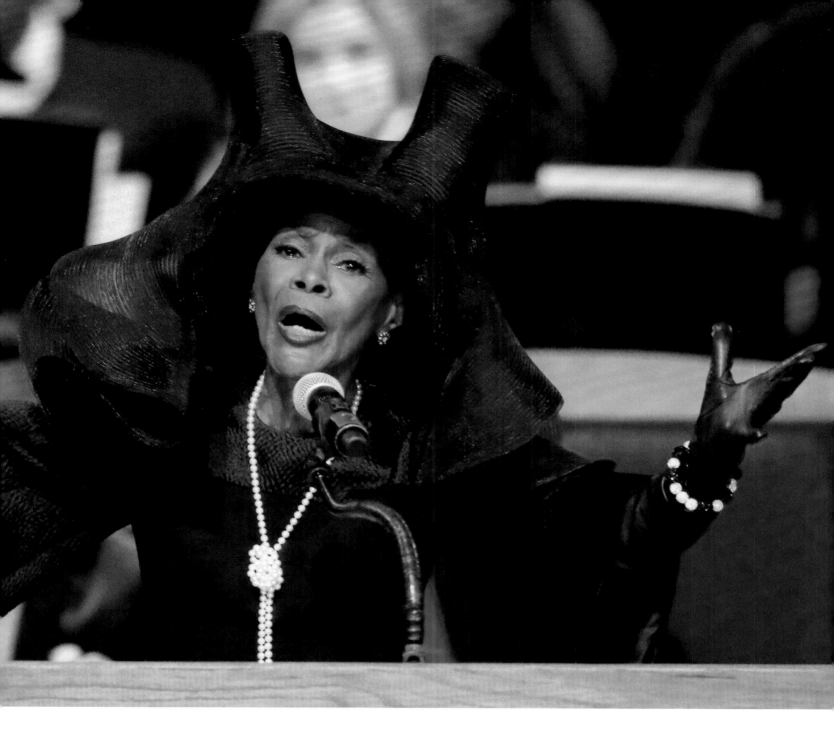

Grace Temple where Cicely stood, her face, enshrouded by the hat's rippling horsehair, completely covered the large live streaming video screen. It was breathtaking! Cicely gave a poetic performance, in character, of "When Aretha Sings," inspired by the great poet Paul Laurence Dunbar's "When Malindy Sings." We were all mesmerized. What we didn't know is that social media and the internet had just gone ablaze! The image of Cicely in the hat

went viral! When we finally returned to the car, I turned on my cell, and it chimed with notices for what seemed endless messages—we were shocked to discover how the world had responded to Cicely in The Hat. That hat would now always be a part of the narrative of our story.

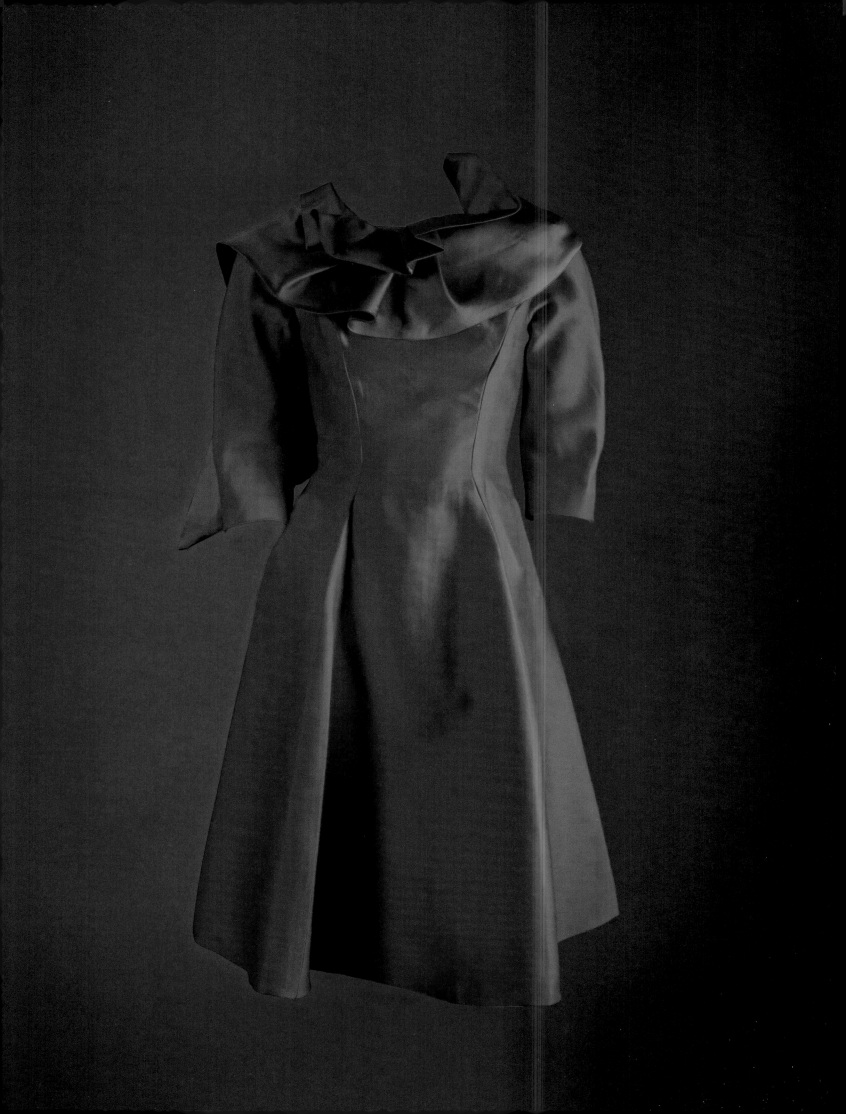

# THE TIMELESS RED DRESS

**TIME Magazine Cover**

Divine plan is the only way I can speak of the dress Cicely wore for the February 2019 cover of *TIME* magazine. The only style direction the editors gave me was that they wanted her to wear red. As was typical, Cicely teased me about what I was considering, "How many red dresses do you have?" recalling the Red Heart Dress she had worn twice. This would need to be another dress in red. I knew how important this cover was to Cicely as a testament to her lifelong work as an actor and activist. I knew how important it was for me too, as a Black American fashion designer, to have my dress on this cover. Once again, Cicely and I would quietly and effectively move the needle of history.

Here is the backstory. A few years prior, Mark-Anthony and I had a conversation with Elaine Nichols, supervisory curator at the Smithsonian National Museum of African American History and Culture, who advised us to begin to archive my work. I still had in my possession the very first dress that went down the runway of my very first show on the Mercedes-Benz New York Fashion Week schedule in February 1999. It's literally Look #1 of my first collection. I was planning to have the dress framed to be used as a piece of art.

Working late the night before the cover photo shoot, I can tell you with *divine* clarity, I suddenly thought of the dress! Placing the dress on a mannequin in the atelier, I saw it needed

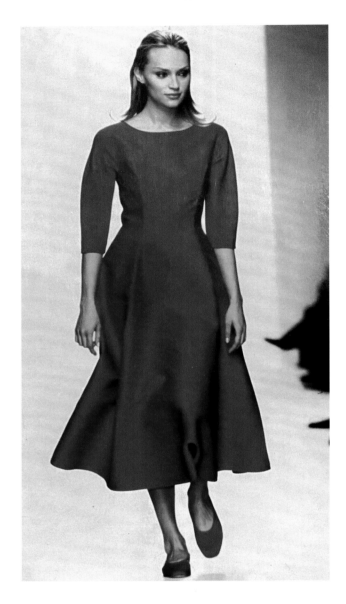

A model in Look #1 of my very first collection, shown at Mercedes-Benz New York Fashion Week, Bryant Park, New York City, February 1999. The red silk-wool dress is constructed with the center front of the dress and the front piece of the sleeve cut in one piece. It is shown here with dyed-to-match ballet flats.

*Photo credit: Dan Lecca / courtesy of the author*

something to fill in the neckline. Again, *divine* intervention. I had, among the remnants of fabric I never want to part with, a large piece of red silk-wool, the exact type and color of the fabric I used for the dress twenty years earlier!

I had my trusted pattern maker, Reyes Cruz, bias-cut the remnant, and I placed it around the neckline of the dress and began pinning something to become a collar. Reyes then stitched it, and it just evolved right before us.

I couldn't wait to show Cicely the following morning when we gathered at the location for the shoot. I remember what Cicely said about the dress: "I never want to take it off!" Cicely insisted that she wear the Red Dress, as we affectionately referred to it, for several parties around the country given to toast her Oscar. If there is a single dress that speaks to my design sensibility for timeless couture, it would be this dress.

## The Collar as a Prop

Table-top dressing is what designers should consider when most of the black-tie evening will be spent sitting at a table. A fabulous train is great for walking in but remains under the table for the evening. Because I love to use fabric creatively, I view the collar as a prop to add punctuation to a look. A great collar frames the portrait of its wearer and gives the other guests at the table something beautiful—or at least interesting!—to look at. Cicely loved wearing "fussy" collars and inspired me to experiment with them.

It would be years later when I would understand the significance of being a Black American designer showing on the New York Fashion Week schedule. Mark-Anthony and I have wondered how my publicist at that time, Eleanor Lambert, who took me on as a rising talent and passed away in 2003 at age one hundred, would have appreciated the history Cicely and I made for American fashion.

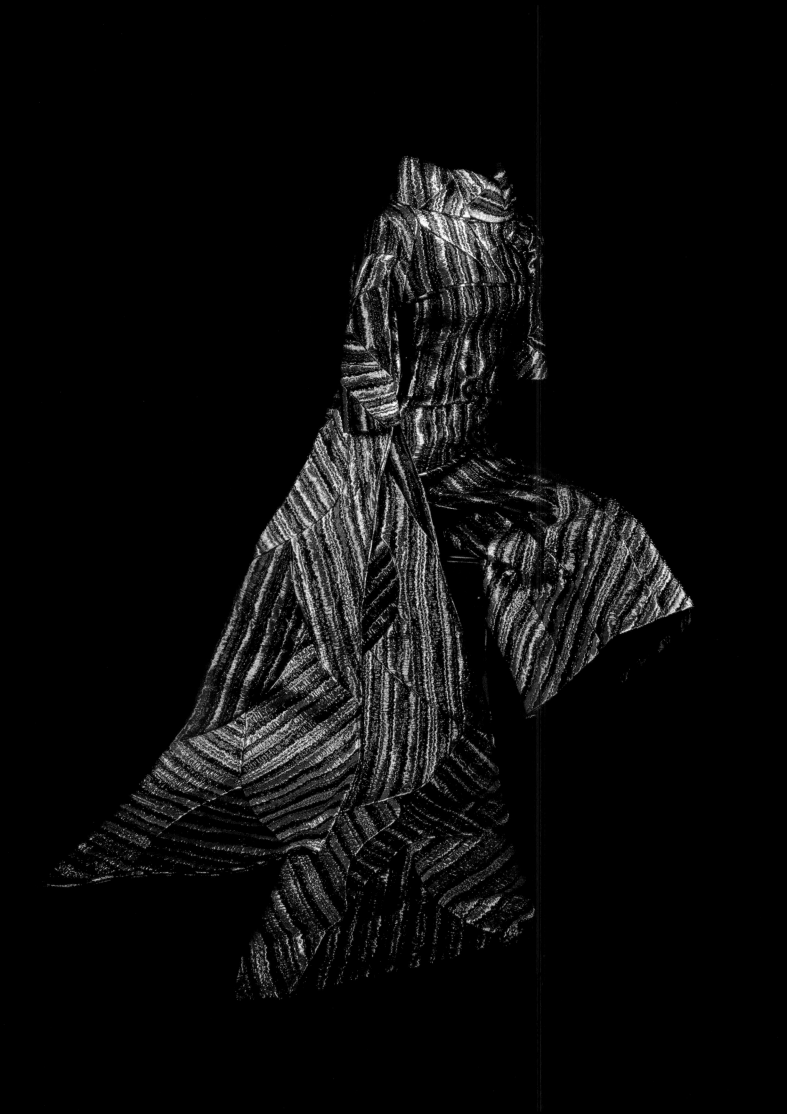

# HAUTE COUTURE "EMPIRE" ENSEMBLE OF ONE HUNDRED FORTY-FOUR PIECES

**The Honorary Oscar**

Cicely and I spoke often. She would call me daily at 9:30 a.m. If we needed to discuss an upcoming event, we would know we had that time reserved to take care of it. But even if we had no work together at that particular moment, she would still call and, if I had scheduled something else because I thought we had no business to handle, she would leave a message. "It's me! It's me!" she would say on my voicemail, laughing.

One day in particular she telephoned me in the early evening. We had spoken several times that day, so I did not expect to hear from her until our usual morning call the next day. When I picked up, Cicely was sobbing incoherently. Immediately I thought, *What happened?!*

Finally, Cicely managed to tell me that she had just gotten off the telephone with her manager, Larry Thompson, and with John Bailey, the president of the Academy of Motion Picture Arts and Sciences. On the call, John Bailey told her that she would be receiving an Honorary Oscar.

I too immediately welled up. Once Cicely and I regained our composure, she said, "Well, you know what this means for you: all the world will want to know what you are going to design for me to wear."

There is a funny little story between us, dating to the gown I designed for her Tony

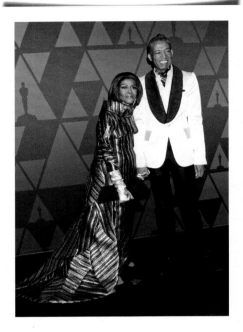

Cicely and I on the red carpet for the gala dinner and ceremony for the tenth annual Governors Awards, December 2018.

*Photo credit: Kathy Hutchins / Alamy Stock Photo*

win in 2013. I told Cicely I sought the Almighty to inspire me for that gown. So on this night, Cicely reminded me of my statement and asked, "So, you went to the Almighty for the Tonys, where are you going for the Oscars?"

That gave us some much-needed comic relief. Only Cicely could deliver such a well-timed statement in such a moment.

In the weeks that followed, we were inseparable. My role was as Cicely's sounding board for all the details and demands that come with the territory. We also had our own lanes. Cicely had a speech to consider, and I had a dress to design.

As news of Cicely Tyson's Honorary Oscar got out, the offers to dress her started coming in—one designer's offer even included filming a reality TV segment of him working with Cicely and doing the fittings.

Cicely's position was clear: "These people really don't know who I am. If they knew me, they'd know who is designing my Oscar dress."

I recognized the importance of the charge I had been given. The dress would, for all of history, be a part of the narrative about when she was honored for her life's work. I had to build a dress that could have been worn fifty years ago, would be considered modern in the present, and would still be relevant in years ahead—like Cicely's work.

Starting with a clean canvas, I sketched several dresses. We draped two muslins before I clearly envisioned the form that the dress would take. The pattern for the haute couture ensemble consisted of 144 pieces. From my fabric vault, I selected a vintage (circa sixties) silk brocade of pale blue, silver, and black by Gustav Zumsteg's Abraham of Zurich. I wanted to change the vertical pattern by having the fabric meet at the seams and go in different directions, which meant that each pattern piece had to have a swatch pinned indicating the

Cicely on the red carpet of the tenth annual Governors Awards in 2018, the evening she received her Honorary Oscar. *Vogue*'s headline read, "At 93, Cicely Tyson Gets Her Due from Hollywood and Delivers a Timeless Fashion Moment."

*Photo credit: Kathy Hutchins / Alamy Stock Photo*

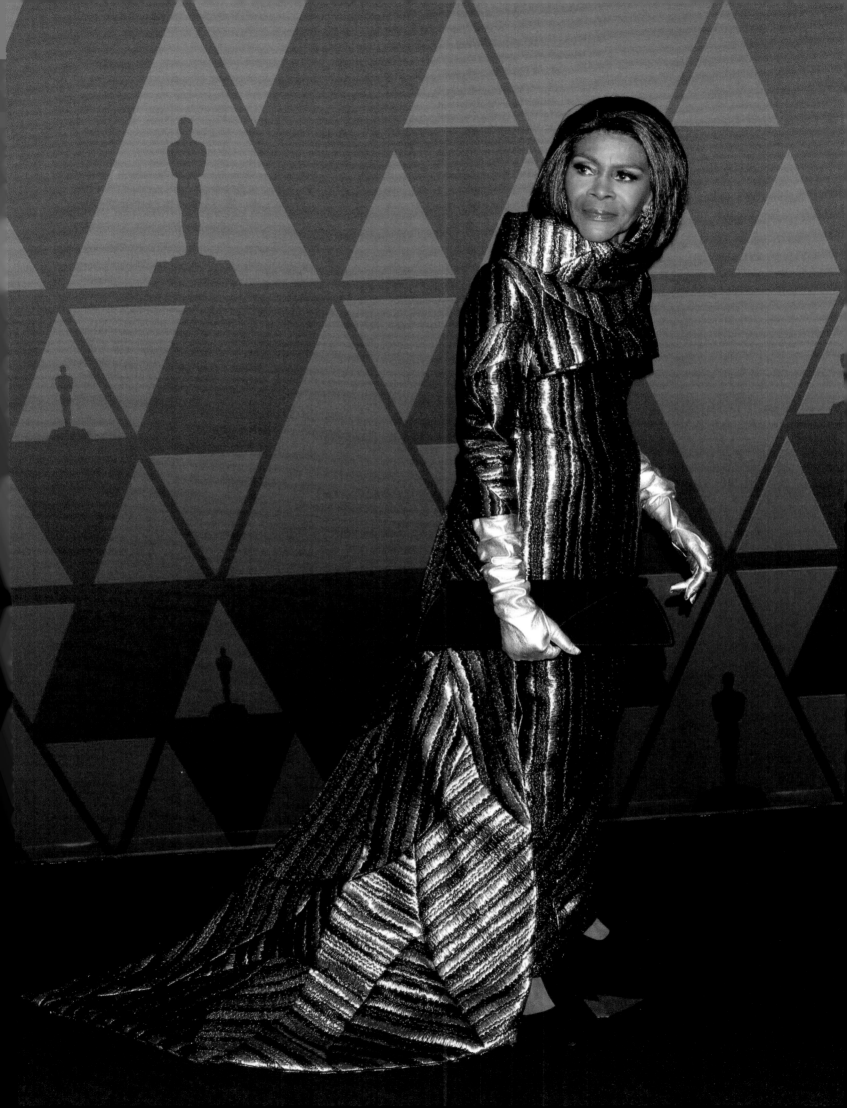

"These people really don't know who I am. If they knew me, they'd know who is designing my Oscar dress."

stripes' direction. Each of the 144 pieces had to be individually cut, a process that took a series of days, before the sewing could begin. The shape was a fitted column with a diagonal-blocked hemline, topped by an empire-cropped bolero that buttoned in the back, a high collar, and three-quarter sleeves, with an asymmetric train, which itself required 104 pieces to swatch and sew. The process was traditional haute couture. The dress took close to two hundred hours to make. I loved that this dress extended my work as a fashion designer to realize another tier of artistry. It's a creative high I did not want to come down from.

### Glam and Accessories

Breaking with our usual pattern, I arranged a full-dress rehearsal in my atelier, complete with hair and makeup. I shared my inspiration with our trusted makeup and hair artist, Armond Hambrick. I envisioned a deep pink lip, which Armond masterfully created with a blue undertone. It really was perfect and modern. The wig was mixed gray and was slightly curved, framing Cicely's face, very sleek and just the right amount of drama. Cicely and I were both excited about the silver metallic leather gloves, which created some sort of futuristic glamour—at least in our imaginations. The black wool-crepe, east-west shaped clutch was designed by couture accessory designer Mark Paige, a Black American designer I have often commissioned to create handbags for my runway collections. I didn't tell Mark I planned to use the bag for the Oscars, so you can imagine how surprised he was.

After much consideration, I selected earrings of rare tanzanite and white diamonds from Helen Yarmak. For the shoes, we of course went with the Manolo Blahnik black satin pumps with the rhinestone buckles.

### Oscar Day

The Governors Awards is the event held to give out the highly regarded Honorary Oscars to industry icons in various categories. It is

The making of the dress. Reyes Cruz, my pattern draper for almost two decades, managed the detailed couture craftmanship of the garments. Cicely would often say to Reyes, "You always make me feel happy." She had a special adoration for Reyes who would always take hands-on care of Cicely during her frequent visits to the atelier throughout the years.

*Photo credit: Courtesy of the author*

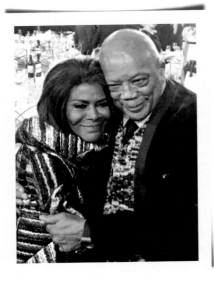

Cicely sharing a moment with Quincy Jones, the master behind so much music that has impacted American culture.

*Photo credit: Courtesy of the author*

held in November, several months ahead of the televised Oscars. The Governors Awards Gala is a coveted invitation-only event attended by the governing board of the Academy of Motion Pictures Arts and Sciences, as well as Hollywood luminaries. Cicely made history by being the first Black American woman to receive the Academy's Honorary Oscar. She was honored alongside publicist Marvin Levy and composer Lalo Schifrin. On the morning of the event, I joined Cicely in her suite for a quiet breakfast and overview of the day. What I didn't tell Cicely was that I was feeling a migraine coming on and a nervousness that I had never felt before. I realized I was internalizing her nervousness, combined with my anxiety that the Oscar dress for Cicely Tyson was highly anticipated and would be on the world stage and go down in history.

Furthermore, I would be escorting Cicely, a role that would have gone to Arthur Mitchell, a close friend of Cicely's who had escorted her to the Oscars in 1973 when she was nominated for her role in the film *Sounder*. Arthur had died a few months earlier in September 2018. I was overwhelmed with nerves and emotions. I did find the strength to get through all of the demands of the day. When Cicely was finally escorted to the stage where she would receive

the statue, I could literally feel the tension leaving my body. What I felt then was euphoria!

*What a night!* In a room with the top echelon of Hollywood, Cicely's table stood out. Oprah Winfrey, Shonda Rhimes, Tyler Perry, Ava DuVernay, Mark-Anthony, and yours truly all sat at the table alongside family and a few close friends from both coasts.

So many actors and industry titans made their way to our table to pay homage to Cicely! Onstage, Cicely was introduced by her good friend Quincy Jones—himself a trailblazing record producer, musician, songwriter, composer, and film and television producer. Quincy told the audience, "Her work, grace, dignity, class, humility, and profound professionalism firmly placed her on the pedestal of Hollywood royalty."

Cicely was then presented her Oscar by Ava DuVernay, who gave Cicely a moving tribute. Later, on Twitter, Ava wrote, "The speech I've been most proud to make—ever. Presenting Queen Cicely Tyson with her Honorary Oscar."

Again, in a very profound way, Cicely and I broke a glass ceiling. We had not considered that, for the ninety-second Academy Awards, I would be the first Black American fashion designer to dress a Black American Oscar recipient.

Wear Date  18 Nov. 2018

2 pcs.
Total Pattern
92 piece[S]

Fabric
Haute Couture Brocade
color
Metallic Blue/Crystal

## "B" Is for Bolero

**T**he bolero is the one item every one of my couture clients has in her B Michael wardrobe. I've made this wardrobe essential in many variations. The bolero is my design solution for a multitude of situations, from providing warmth (I am not a fan of shawls) to fashionably providing appropriate modesty for ceremonial protocol. The bolero, modern and versatile, allowed me to dress Cicely in strapless gowns, creating glamour or an upbeat chic look. I also used the bolero on Cicely with sleeveless day dresses, which was more modern than the typical jacket and dress expectation of a woman at a certain age. As my muse, Cicely wore the "B" bolero almost as a signature look with countless variations. Some designs were fabricated to match a dress or gown. Some styles were sleek, and others were over-the-top. There were even feathery versions.

The pièce de résistance of all the boleros would be the one I designed for Cicely's Oscar gown. This bolero, which topped the sleeveless sheath gown, had an asymmetrical train in the back—made with more than a hundred pattern pieces, sewn individually of vintage Abraham of Zurich fabric. I consider it one of the masterpieces of my life's work—forgive my lack of modesty!—and I give the glory to the creative energy of being an artist.

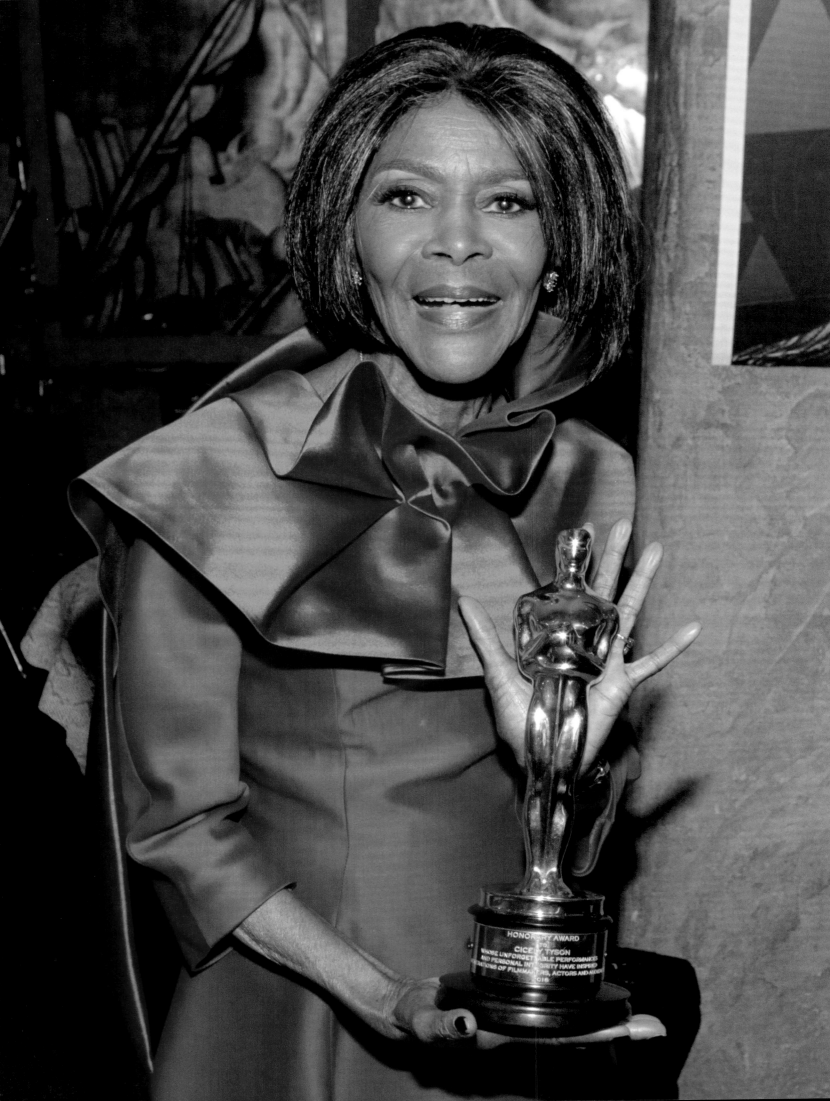

# MAKING THE ROUNDS OF OSCAR TOASTS

## The Timeless Red Dress Returns

### Let the Parties Begin

Forty-five years after being nominated for her role in the classic film *Sounder*, Cicely Tyson was awarded an Honorary Oscar. Understanding that Cicely was driven by the roles and the characters she was able to speak through, rather than the glitz and fortune that is associated with Hollywood, it's ironically poetic that Cicely received almost every award any artist would covet, including the Presidential Medal of Freedom, bestowed in 2016 by President Barack Obama. When it was announced that Cicely would be receiving her Oscar, the requests started from all ends. So many of Cicely's friends wanted to be present to witness the occasion and celebrate with her. Mark-Anthony and I decided to ask some of our personal friends to host a private gathering for Cicely to share a celebration toast with her friends. We selected three of the key cities important to her: Los Angeles, Washington,

Cicely at Ashford and Simpson's Sugar Bar Restaurant in New York City, December 2018. Celebration hosted by Valerie Simpson. Many of her friends held the statue and took photos. Cicely made sure there was enough Oscar to go around.

*Photo credit: Media Punch Inc. / Alamy Stock Photo*

DC, and New York City. They all said yes! Cicely was beyond excited. Cicely would bring Mr. Oscar to every party and wanted to wear the Red Dress and the Oscar wig to every one of them. This made my life easy, and Armond loved knowing what the glam look would be in advance.

### Los Angeles

Los Angeles was the setting for the first of the parties, which took place at the home of the hosts, Derrick Williams and Adriane Hopper Williams, a dynamic couple who are among other things award-winning television producers.

BeBe Winans, the celebrated gospel and R & B singer, a dear friend to Cicely, did an impromptu performance of her favorite song from his repertoire, "Stand." It made sense that Cicely loved the song, written by award-winning gospel singer Donnie McClurkin. The lyrics are a call to stand up for yourself, your beliefs, and your faith. Cicely would tell Bebe that for her funeral she wanted him to sing "Stand," and when he got to the lyrics "You just stand," she would stand erect from her casket. We laughed. The day of her funeral, Bebe did sing the song, and as much as I wanted Cicely to keep her promise, it was only her great spirit that would *stand*.

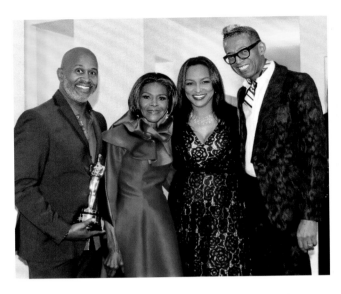

Cicely and me with Derrick Williams and Adriane Hopper Williams in their Los Angeles home, November 2018.

*Photo credit: Courtesy of the author*

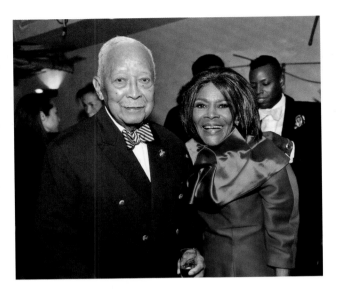

Mayor David N. Dinkins, New York City's first Black mayor and a close friend, sharing a moment with Cicely at Ashford and Simpson's Sugar Bar, December 2018. Armond Hambrick, Cicely's trusted makeup and hair artist, is standing behind her.

*Photo credit: Courtesy of the author*

## Washington, DC

Friends new and old, ranging from politicians to Washington's movers and shakers, mixed in the chic city home of my longtime friends Dr. William Ebbs and Larry Crenshaw Cicely, wearing her uniform, worked the room, with Oscar in hand, as if she were running for political office.

## New York City

Ashford and Simpson's Sugar Bar is a world-renowned place to see and be seen, the kind of place that celebrates live music and sumptuous comfort food. The Thirds always went there to decompress in a safe space where we could enjoy the night and be inspired by great music. Cicely loved the whole red snapper fish introduced to her many years earlier by Nick Ashford. Cicely's New York circle of friends and family were invited by the Sugar Bar's co-founder and owner,

Valerie Simpson, to gather to honor her. Celebrated artists from film, stage and dance, politicians, the social-set, and even the Reverend Calvin O. Butts III and his wife, Patricia Butts, were in the crowd. A party Truman Capote would have been proud to attend.

Cicely Tyson was in her glory. It was the perfect finale.

## And Back to Los Angeles

At the age of ninety-four, Cicely was a party enthusiast. The weekend of the televised Oscars, we attended Common's star-studded fifth annual Toast to the Arts, in West Hollywood at Ysabel, a well-known restaurant and lounge. Cicely insisted she wear the Red Dress once more. Adding gloves, we gave it a different spin. We partied into the late night.

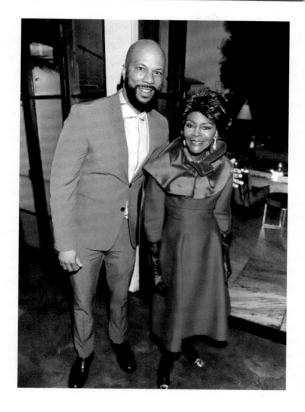

Common and Cicely posing together at the Toast to the Arts, February 2019.

*Photo credit: Arnold Turner / Freedom Road Productions*

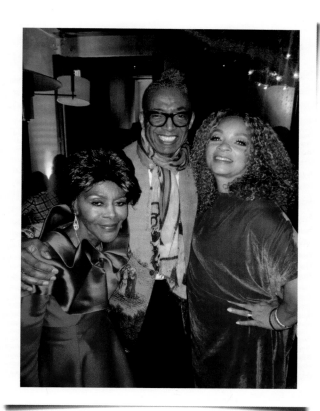

Cicely and me with Ruth Carter, the acclaimed costume designer who would win the Oscar for her work in the record-breaking film *Black Panther*, February 2019. They both wore my couture gowns to the Oscars, and both went home with a statue. Here both women are in red; we said laughingly that they got the memo.

*Photo credit: Courtesy of the author*

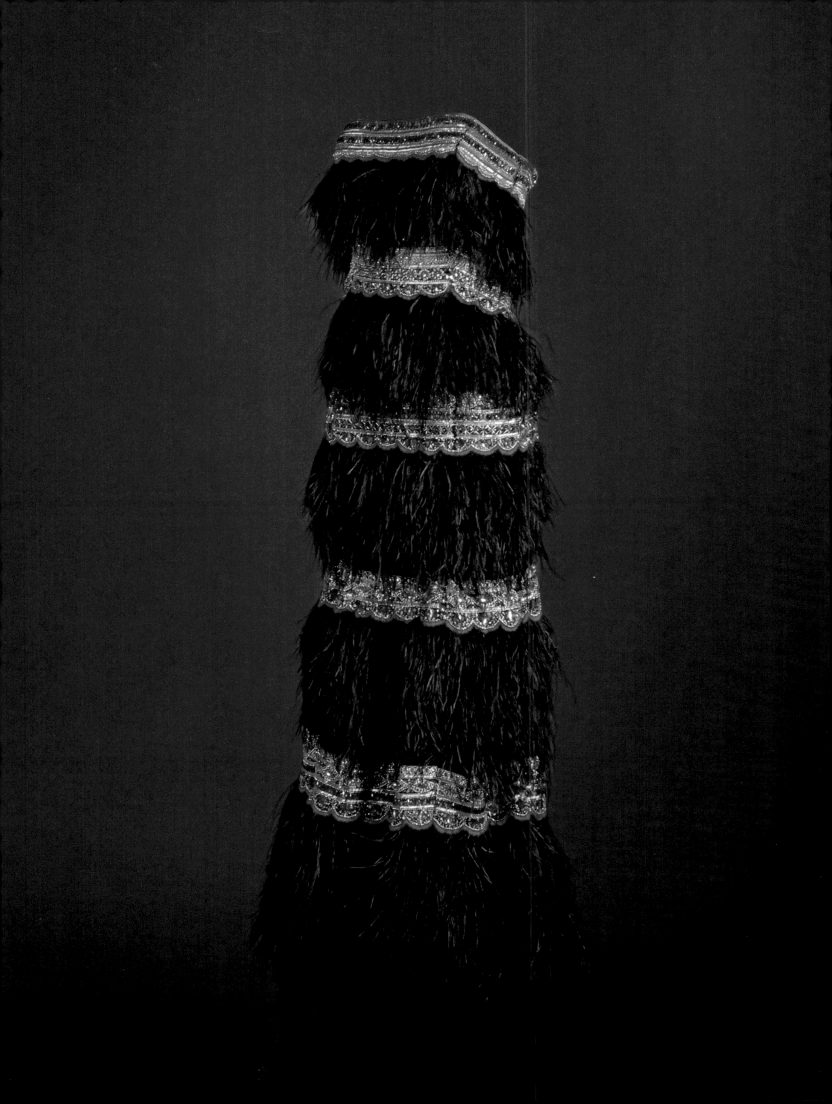

# MODERN-DECO "HOLLYWOOD" EMBROIDERED GOWN

**2019 Academy Awards**

In February 2019, we continued the Oscar festivities and went back to Los Angeles to attend the televised version of the Academy Awards. During the live Oscar night ceremony, Cicely and the other esteemed recipients of Honorary Oscars would be acknowledged. For me, it was a night of high adrenaline and expectations. I was also commissioned to create a look for the renowned costume designer Ruth Carter, with whom I had collaborated on Whitney Houston's *Sparkle*.

In one night, I had gowns on Cicely Tyson, the first Black American woman recipient of an Honorary Oscar, and on Ruth E. Carter, the first Black American woman to win an Oscar for Best Costume Design in a Film. For the first time in the ninety-one-year history of the Academy Awards, a Black American fashion designer had dressed two Oscar winners.

The fashion press headlines should have noted that fact. But this was in 2019, before the exposure of systemic racism in luxury fashion.

The red carpet is like the fashion Olympics. The press collateral that fashion designers acquire from that moment builds brands and allows designers to grow by offering aspirational collections and products. The retailers see the value created by the hype and seek out those designers. Historically, few independent Black American designers have been given entrée. On this exceptional occasion, and many others, Cicely Tyson gave this designer access.

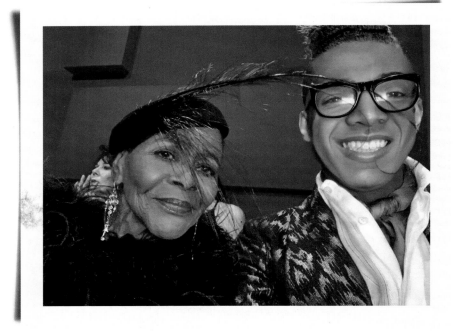

Selfie taken in our seats inside the Dolby Theatre in Los Angeles.

*Photo credit: Courtesy of the author*

## Ceremony in Los Angeles

I dressed Cicely in a strapless fitted gown with fluted train for the ceremony. In contrast to the gown for the Governors Honorary Oscar evening, this gown is completely embroidered with bands of Swarovski crystals and jet beading, separated with embroidered jet-black ostrich feathers. To create a sleeve, I cheated and used a sheer silk long-sleeve T-shirt and covered it with a black ostrich bolero. I couldn't imagine what Cicely's hairstyle should be with all the feathers. During the atelier fitting, I spontaneously pulled out the felt "halo Crown" with the feather plume cascading slightly across Cicely's face. Of course, Cicely loved how sassy it was. The custom earrings by Pamela Froman, the Beverly Hills jewelry designer, were created only hours before. A vintage red crystal Judith Leiber bag and the go-to black satin Manolo Blahnik pumps with rhinestone buckles finished the look.

## *Vanity Fair* Oscar Party

The celebrated *Vanity Fair* after-party was another moment I will always hold dear. This was Cicely's night, and she generously shared it with me. I had the esteemed role of escort, designer, and hand squeezer for the star-studded party, which, for the first time, Cicely attended as an Oscar recipient. You won't be surprised that even in a space filled with A-list stars and industry moguls, Queen Cicely, holding court in the area designated for her and guest, never got to move around, as most found their way to her to pay homage. This was the finale of three months of Oscar parties. My work now complete, I decided that night that I would party like it was 1980!

Cicely on the red carpet of the ninety-first Academy Awards at the Dolby Theatre in Los Angeles, February 2019.

*Photo credit: Sipa USA / Alamy Stock Photo*

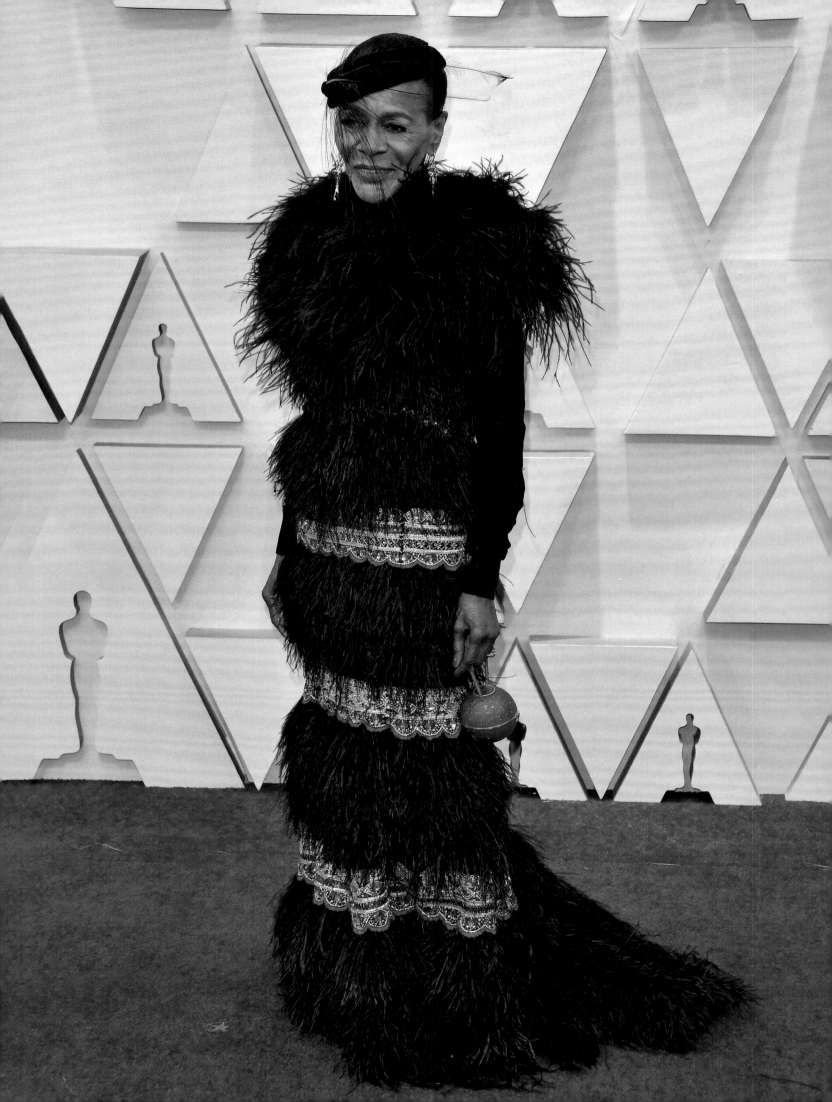

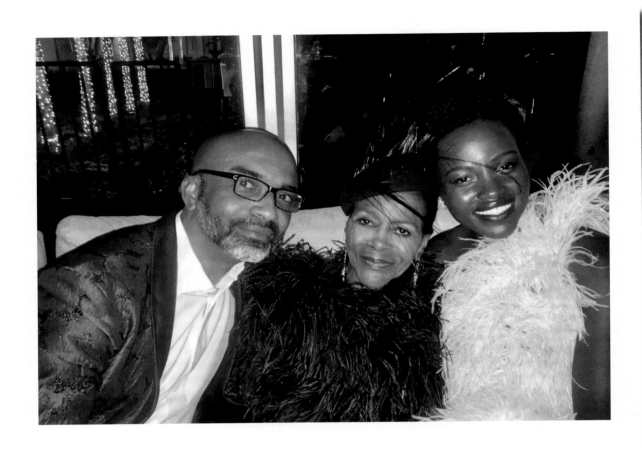

A night for feathers: Mark-Anthony hanging out with Cicely
and Lupita Nyong'o, who won an Academy Award for Best Actress
in a Supporting Role in 2014 for the film *12 Years a Slave*.

*Photo credit: Courtesy of the author*

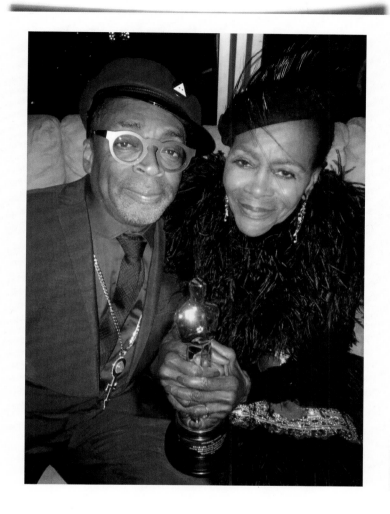

A night for firsts. Here is a great moment captured with critically acclaimed director Spike Lee, who won his first competitive Academy Award for his film *BlacKkKlansman*.

*Photo credit: Courtesy of the author*

# THE PRINCESS GODET BLACK DRESS

*Vanity Fair's* **Hollywood Issue**

For the famous Hollywood issue of *Vanity Fair*, February 2019, Cicely was photographed by the highly acclaimed photographer Annie Leibovitz. Viola Davis wrote the article that accompanied the photo. She wrote, "Ms. Cicely Tyson is elegance personified." For the record, Viola and Cicely both achieved the Triple Crown of Acting, winning a Tony, an Emmy, and an Oscar. Viola later added a Grammy win in February 2023 for the best audiobook, narration, and storytelling recording of her memoir, *Finding Me.* I know the energy of Cicely cheered her on!

The shoot was going to take place at the Abyssinian Baptist Church. That's Cicely's church, and thanks to her, it's also where Mark-Anthony and I worship. As important as this iconic edifice is to us, I was concerned that the setting would cast a cliché image of Cicely. I felt Cicely should be photographed in something formal and onstage, an opportunity to immortalize her as Hollywood royalty. It became clear that I was not going to win this creative impasse; I focused on creating a look that would be sophisticated and elegant. The style request was for red, a hat, and polka dots—but under my watch, there would be *no* polka dots. Cicely wished she could wear "the uniform," the "timeless" red dress she wore for the cover of *TIME* magazine.

Giving us options, I created two red hats: one had an off-the-face brim that's very old Hollywood, and the other was very avant-garde.

Cicely, with a big smile, standing between Annie Leibovitz and me inside the main sanctuary of the historic Abyssinian Baptist Church in Harlem, December 2018.

*Photo credit: Courtesy of the author*

I also designed a black profile, offset-brim hat that, in a burst of last-minute creativity, I combined with an open crown fascinator with elongated black plumes. Cicely wore that fascinator to the Oscars the following February.

For the look, I had two choices. The first had a tailored, fitted top with a vertical paneled-seam peplum and a matching paneled-seam pencil skirt in black double-faced wool crepe. The other option, a black dress also in double-faced wool crepe, featured black duchess satin at the bodice and as a cascading godet in the front princess seam. Inspired by the red uniform, I draped duchess satin at the neckline to create a collar. In the end the black dress and black hat were selected, to my delight. Cicely was regal.

When I saw the photo, I easily understood why Annie Leibovitz is a genius. I'm so grateful I lost that battle. What a memorable photo of Cicely, seated on the pew that has her mother's name engraved with the title of her hymn of choice, "Blessed Assurance."

The photo symbolizes Cicely's faith and love for her work; the image will be an archival treasure for the Abyssinian Church and for the Harlem community, including Hollywood and worldwide.

There was a glorious energy throughout the shoot. Cicely and Annie, two artists and consummate professionals, energized each other. Annie's team, with me and Armond, who was there to do his glam magic with the makeup, sat back and enjoyed the show. Annie wanted to photograph Cicely in all the variations I had designed. Cicely, a former model, knew well how to flirt with a camera pointed at her. As a loyal reader of *Vanity Fair*, I always look forward to the annual Hollywood issue. On this day, to be a part of it in collaboration with Cicely was a fantasy realized. When the issue hit the newsstands in New York City, Cicely was in Washington, DC, where it had not yet been distributed. She called us to ask that we run out and buy a bunch of copies. I loved that she could still get excited.

CT
FOR VANITY FAIR
* ADD SLEEVE
* DRAPE - COLLAR

BLACK DOUBLE-FACED WOOL - BLACK - DF SATIN

Cicely sharing a moment with her dear friend Pauletta
Washington at the American Film Institute's forty-seventh
Life Achievement Award Gala, which honored Denzel
Washington, June 2019.

*Photo credit: Courtesy of the author*

**B**Michael is among the most talented innovators of the fashion world. With all the outstanding accomplishments he's achieved, I'm most grateful for the relationship with my friend Cicely Tyson. He cared for her deeply, always assisting in keeping her front and center in maintaining her fashion statements until the end of her life.

He is a master at his craft.

**—Pauletta Washington**

# A FAMILY FEELING

American Film Institute Life Achievement Award
Honoring Denzel Washington

Evening Blues

There have been times when Cicely's dress was the same hue as the backdrop on the red carpet or the theme-color appointments in a gala venue. When that happened, Cicely would ask if I had called the planner or host. For the evening of the American Film Institute's sixty-seventh Life Achievement Award Gala honoring Denzel Washington, the blue of Cicely's ensemble was picture-perfect. Her strapless gown was slightly A-line with a triplet of inverted pleats in the back forming a train. The bodice of the dress and the pleated train are in the same silk blue faille as the ruffle-framed demi opera coat, which was worn buttoned over the bodice of the dress. The white silk faille of the body of the dress created the right contrast for the blue to shine. The wig was tinted blue and cut in a severe bob that landed an inch above the collar. Armond's deep pink lip and the fuchsia satin and rhinestone buckle Manolo Blahnik pumps helped create some punch. The look's point of view defined Cicely's influence as my muse. Imagine the fashion headlines Audrey Hepburn and Givenchy would have made showing up as we did for a grand Hollywood party. Cicely was radiant from the inside out. I couldn't help but feel emotionally high.

## Emotions and Glamour Filled the Room

Living in the moment is more than a poetic new age cliché. When I reflect on nights like this, I remember how Cicely basked in all the love and energy she received and shared. None of us could have known that the following year, the world as we knew it would go on pause. For many people there, that night would be their last opportunity to spend time in Cicely's company.

Most of the evening's speakers went up to the stage of the massive room to speak about Denzel. Cicely, however, spoke directly from our table on the dais. She told the audience that Pauletta and Denzel had met on a film project with her and that she was godmother to one of their children. It was a big Hollywood night that felt at times like a family reunion.

Denzel Washington, Cicely, Pauletta Washington, and I share that first moment of seeing each other as we were arriving to celebrate Denzel at the American Film Institute Life Achievement Award ceremony, June 2019.

*Photo credit: Courtesy of the author*

Cicely on the red carpet of the Life Achievement Award Gala honoring award-winning actor, director, and producer Denzel Washington.

*Photo credit: UPI / Alamy Stock Photo*

AFI
LIFE
ACHIEVEM
AWARD

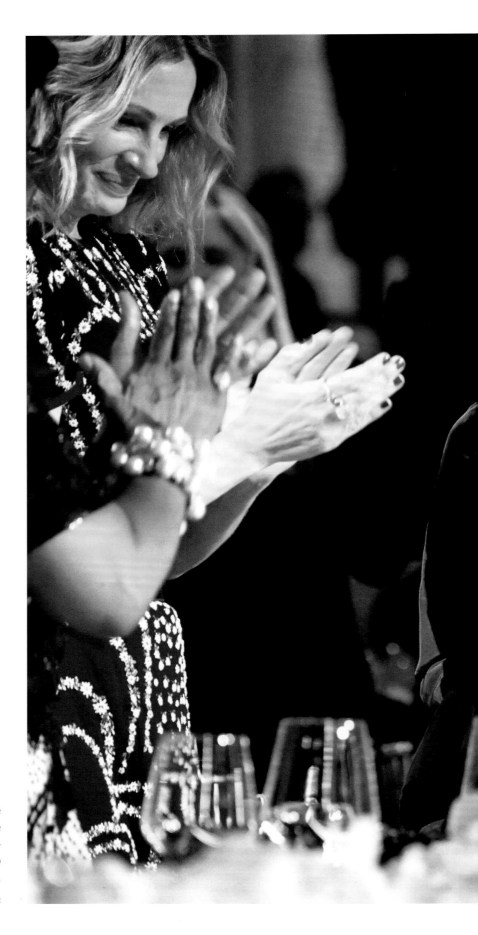

When Cicely concluded her tribute remarks from the honoree table, she received a standing ovation. The award-winning actor Julia Roberts, standing to the right of Cicely, joins in the applause.

*Photo credit: Kevin Mazur / Getty Images*

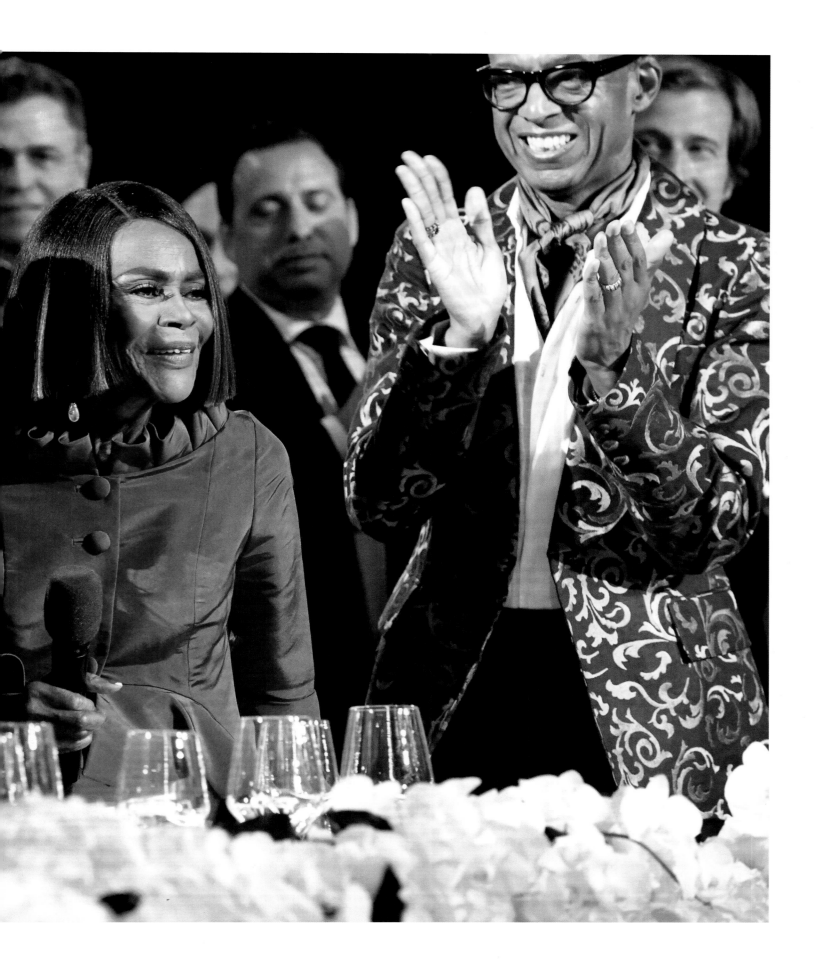

# THE DEEPEST BEAUTY

Transcending the Hype, Our No-Glamour Code

Cicely and I had an ability to ascend to a space that was devoid of the hype and expectations of the world we worked in. Mark-Anthony captured this moment, which so well defines the depth of the spiritual connection and trust that Cicely and I shared. After busy days attending Hollywood black-tie events, screenings, and even a photo shoot, Cicely declared, "I am checking out of this hotel, and I am going to join the two of you on Venice Beach." Mark-Anthony and I have been blessed with access to a house right on the beach, the home of very dear family friends. It is one of our favorite places to escape. Cicely was craving our bohemian, off-grid style of rest and relaxation with the no-glamour code and unguarded emotions.

Cicely and I taking a morning walk to visit with the majestic ocean. We were not chatting; we were there to hear what nature wanted to reveal through the music of the rushing waves.

*Photo credit: Courtesy of the author*

# SHINING A POWERFUL LIGHT

Opening of the ARRAY Creative Campus

**W**hen they see us" became a code phrase between Cicely, Mark-Anthony, and me. It reminded us that we are all connected. That within our respective experiences the common denominator is the basic human right to be seen and heard, in a park, in Hollywood, or in fashion. We want to be seen for our humanity, gifts, and contributions to society in America and globally.

One evening, that phrase took on an even deeper meaning. Ava DuVernay, a modern mogul of film and television, invited us to an evening of multiple triumphs: the opening of the ARRAY Creative Campus, the new headquarters for her production company; her nonprofit, ARRAY Alliance; and her indie distribution arm, ARRAY Releasing. The campus is located in Historic Filipinotown near downtown LA.

Guests were invited to the ARRAY Campus's intimate theater for a screening of an episode from one of Ava's newly released projects, the Netflix miniseries *When They See Us*, which was about the men known as "the Central Park Five."

Cicely outside the ARRAY Creative Campus in front of the billboard promoting the Netflix miniseries that Ava DuVernay produced and directed, *When They See Us*, June 2019.

*Photo credit: Courtesy of the author*

The men themselves were the guests of honor.

I was deeply moved by the storytelling Ava shared of what happened in Central Park back in 1989. The case impacted the lives of those five men—all incarcerated for a crime they did not commit but indicted because of racist assumptions about them. That group of five could have included me.

Following the screening, we were invited to one of the campus's buildings for a festive, intimate dinner. Cicely, Mark-Anthony, and I often talked about how special and meaningful that evening was. Cicely shared what it felt like, so many years since her start in Hollywood, to see a Black American woman found her own studio. As an artist and entrepreneur, I too was inspired by Ava's accomplishments.

What is the appropriate fashion for an evening that is not about fashion? Too much style and glamour would seem out of place. Yet as Cicely's designer, I always wanted her look to be inspiring, so for this occasion I dressed her in a respectful way. The Chevron Dress, named

Cicely and I arriving at the Primetime Creative Arts Emmy Awards, September 2019.

*Photo credit: Courtesy of the author*

Cicely on the red carpet "striking a pose," September 2019.

*Photo credit: UPI / Alamy Stock Photo*

after its geometric silhouette, was fabricated in ecru silk-wool piqué. The topper was knitted with wool velveen bouclé yarns, embroidered with white shredded ribbons, and framed with black grosgrain. The look gave Cicely an elegant, calming presence, which was embraced by the evening's honored guests as well as the star-studded crowd.

## Primetime Creative Arts Emmy Awards

For our attendance with Cicely at the seventy-first Primetime Creative Arts Emmy Awards in Los Angeles, Mark-Anthony and I wore, under our B Michael couture evening jackets, the T-shirts we received the night of the screening for *When They See Us*. We chose the T-shirts to make a statement of support for Ava DuVernay's Netflix miniseries, and we wore them in solidar-

ity with the five men we met, who now have names and a presence for us.

We were feeling a pulse coming from our faith for a new experience. It's interesting how much emotions can influence our fashion choices. This is one of the few times I have used fashion to make a social or cultural statement. It felt right! Cicely was proud of our decision to wear the T-shirts and intentionally referred to them throughout the evening.

## The Swallow-Tail Jacket at the Emmys

Although Cicely was nominated for an Emmy in 2019, in the category Guest Actress in a Drama Series, for her role in *How to Get Away with Murder*, her reason for attending the ceremony was more about supporting the cast and the show's producers than about her own nomina-

Muslin draping showing the front and back of the swallow-tail jacket, circa 2019.

*Photo credit: Courtesy of the author*

tion. What I recall about the night is that we had fun. Cicely was feeling great about the look I created for her, which was all about the quintessential menswear cut—the swallow-tail jacket—but made for a woman. The design was inspired by a commission I had done for Valerie Simpson.

The Gothic-inspired swallow-tail jacket features hand-stitched fluted cuffs and was made with fabric imported from France, a metallic silk and wool brocade. The abstract pattern in navy, metallic-silver, and deep fuchsia could be artwork. Underneath, Cicely wore a strapless fitted gown with a box-pleated train in navy blue textured silk duchess satin. When I saw that Cicely's neckline would be too open, I envisioned filling it in with ropes of various beads.

I reached out to Beverly Hills jeweler Pamela Froman. Knowing that it was for Cicely—or, as Pamela refers to her, Aunt Cicely—Pamela

agreed to meet me at her work studio. Pamela and I spent the afternoon pulling out trays of vintage pieces from her early collections with the help of her young son Hudson. Not only did we find beautiful necklaces in assorted beads and gems, but the pièce de résistance of the hunt was the Maltese cross we discovered. Armond's lipstick, a soft pink with blue undertone, and the Manolo Blahnik fuchsia satin pumps (making their third Emmy appearance) provided the perfect finish.

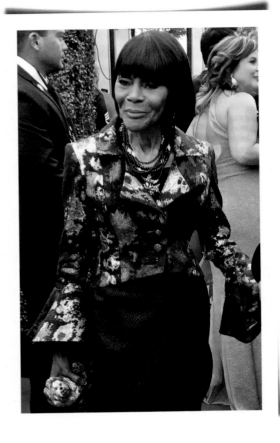

LEFT: I love this close-up of Cicely, which shows the combination of the Pamela Froman neck jewelry and the luxuriousness of the fabric, September 2019.

*Photo credit: Faye Sadou / Media Punch Inc.*

RIGHT: Handmade jewelry by Pamela Froman Fine Jewelry, Beverly Hills. The necklaces are 18-karat yellow gold with diamonds; black spinel, grape garnet, and tanzanite beads; and black Italian leather. The pendant is a sterling silver Maltese cross with various gemstones.

*Photo credit: Courtesy of the author*

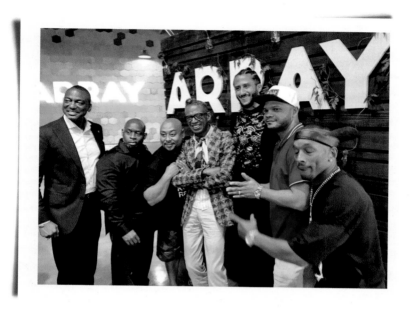

TOP: I felt both honored and connected standing with these gentlemen. For me, this photo captures the breadth of the civil rights movement in the twenty-first century. Whether we're coming from a courtroom, a sports stadium, or a New York Fashion Week show, in this photo we all share the same dynamic. With me, *from left to right*: Yusef Salaam, Antron McCray, Raymond Santana, Colin Kaepernick, Kevin Richardson, and Korey Wise.

*Photo credit: Courtesy of the author*

ABOVE: Mark-Anthony showing off the *When They See Us* T-shirt, worn under his B Michael couture tuxedo jacket, on the red carpet of the Primetime Creative Arts Emmy Awards, September 2019.

*Photo credit: Courtesy of the author*

Two strangers with connecting energies: Cicely
embracing the woman at the table next to us at Sunday
brunch at Maison Harlem, November 2018.

*Photo credit: Courtesy of the author*

# WHEN STYLE IS AN ENERGY

The Thirds traditionally attended the 11 a.m. worship service at the Abyssinian Baptist Church. Often, when attending church, we applied the no-glamour code. One Sunday, Cicely sported a fitted turban and no makeup. As was typical for us, we stopped at Maison Harlem, one of our favorite restaurants, for Sunday brunch.

The three of us were feeling spiritually elated by the moving music of the choir—in my opinion, perhaps the best gospel music in all of New York City—and the relevant and provocative sermon by the church's senior pastor, Reverend Butts. So, it's no wonder that the essence of Cicely's energy attracted a stranger at the table next to us. The family at the other table politely interrupted us to say that their mother, who did not speak English, was taken by how beautiful Cicely was. He then asked if Cicely was our mother. Before we could answer, Cicely said yes. Clearly, the family had no clue that this was Cicely Tyson, the iconic, award-winning actor. They saw a family, like their own, having a Sunday meal. Then a rarity: Cicely asked if their mother would please allow us to take a photo of the two of them. When the two women strangers, now bound by energy, came together for the photo, I can tell you it was as if a bright light illuminated the two of them. I'm sure both women felt as if they had been touched by an angel.

Clearly, the family had no clue that this was Cicely Tyson, the iconic, award-winning actor.

# THE
# RED CAROUSEL
# DRESS

**Grand Opening of the Tyler Perry Studios**

I have rewritten this narrative several times, struggling to find the most effective way to describe the 2019 unveiling and gala—grossly understated—of the Tyler Perry Studios, a major motion picture lot built on a former Confederate army base in Atlanta, Georgia. With more than three hundred acres, it is one of the largest production facilities in the country. The founder of the film studio, himself pre-eminent, shared his accomplishment by recognizing some of the icons who had inspired his achievement. Tyler Perry named each of the twelve state-of-the-art sound stages after other trailblazers who had used their platform to move the arc of history. Cicely was there to unveil the Cicely Tyson Sound Stage.

There are no words to express what we all witnessed. We were awestruck to stand on the grounds of the Tyler Perry Studios and be surrounded by so many Black American luminaries from all sectors of culture. I went back to New York refueled and determined to meet my charge, as an independent fashion designer and luxury brand, to move the needle forward and achieve equity in the fashion industry in America and globally. That is my legacy.

I thought of the Tyler Perry Studios' unveiling as a major fashion event. This would be an occasion to be celebratory and unapologetically high-fashion. When we arrived, Cicely remarked that I must have requested the red roses along the red carpet

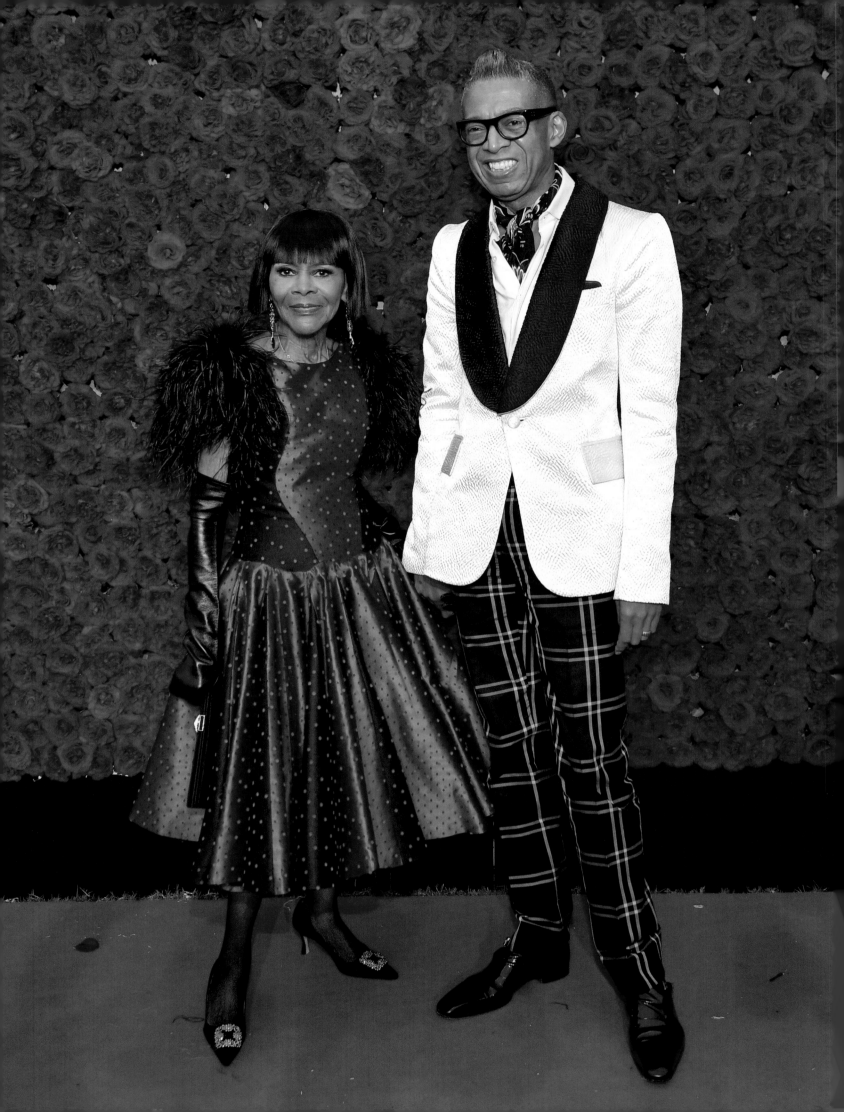

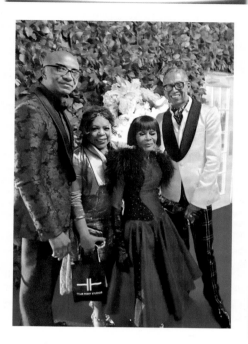

Realizing at the end of the evening that we had not taken a photo together, we posed for this one just before we exited. All of us—Mark-Anthony, Valerie Simpson, Cicely, and me—are wearing B Michael couture.

*Photo credit: Courtesy of the author*

to match her dress—which was color-blocked in scarlet red and black silk Mikado under an overlay of black French tulle with red point d'esprit. The tea-length dress has an elongated torso and paneled, curved seams, and the godets of the dress open to a carousel sweep. The length of the dress would allow Cicely to walk the vast lot to each of the sound stages for their unveiling.

I wore a cherished gift from Valerie Simpson: Nick Ashford's custom-made evening shoes in black patent leather. Knowing Nick Ashford had walked in those shoes elevated my steps as I considered what that night represented.

Tyler Perry's studio opening in 2019 reminded me of a key moment in my friendship with Cicely. Three years into our relationship, we had shared many events,

Cicely and I on the red carpet arriving for the grand opening—and I do mean *grand*—of the Tyler Perry Studios in Atlanta, October 2019.

*Photo credit: Prince Williams / Wireimage*

meals, moments, and dresses, although we had not fully expressed our fashion relationship publicly. (Oprah's Legends Ball was quite intimate, not a public event.) But when Cicely asked me to design her gown for the opening of Tyler Perry's first motion picture and television production studio in Atlanta in 2008—the first step in that massive production center—I realized the event would be widely publicized. I designed an ensemble with one word in mind: "icon." That was when Cicely found out that she would be honored with a namesake sound stage, alongside stages named after other Hollywood luminaries whom she counted as her dear friends: Ossie Davis, Ruby Dee, and Sidney Poitier. That studio—the first opened by a man of color—would be baptized by a lineup of legends, trailblazers that achieved and persevered with passion and undeniable excellence. Those journeys would help make Tyler Perry the manifestation of what's possible.

That first studio opening was an important and personal event for Cicely. What I designed for her would have to convey glamour but also

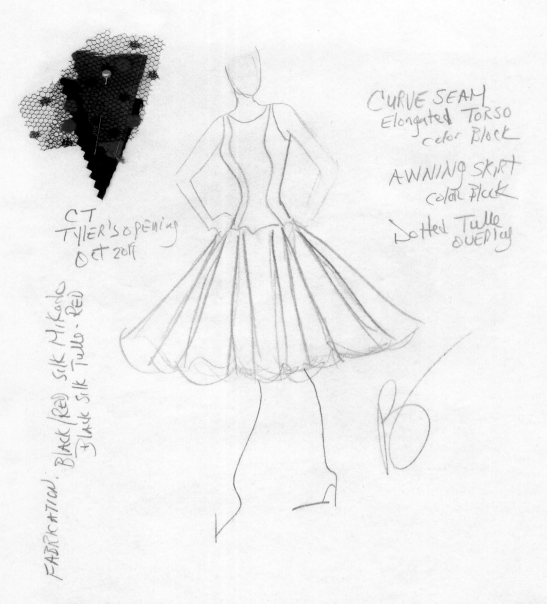

CURVE SEAM
Elongated TORSO
color Block

AWNING SKIRT
color Black

Dotted Tulle
overlay

CT
Tyler's opening
Oct 2011

FABRICATION: Black (Red) silk Mikado
Black silk Tulle - Red

the emotion she felt at having a studio named after her, given that her passion and her life had been so dedicated to the industry. I wanted her to feel as glorious as that moment.

For Cicely's look, I played with texture and the power of silhouettes. An eight-ply silk-satin fitted gown in black hugged her figure as if it were liquid, but the showstopper was a topper in silk chiffon that had poet sleeves and was embroidered with hundreds of delicate silk petals. I lined the topper with pale pink satin to soften the midnight hue and add a whisper of femininity. Cicely was never static, so the ensemble moved and fluttered. She knew how to create space with her body.

When Cicely took the stage, I knew she would look every inch the Hollywood icon I had envisioned. I did not accompany her to the opening but waited with bated breath to hear from her. Her review of the event focused on how magnificent the occasion was and how blessed she felt to witness such an achievement in her industry. I asked her how her gown was received, and she said she "wowed" the crowd in her ensemble. I was so pleased that I had helped give her what she deserved.

Pencil sketch of the Red Carousel Dress, originally shown with my Fall/Winter 2016 runway collection, February 2016.

*Illustration credit: Courtesy of the author*

# SUNDAY BEST AT THE OPENING OF THE
# TYLER PERRY STUDIOS

The extravagant celebration of the grand opening of the Tyler Perry Studios continued on Sunday. Tyler hosted an elaborate gospel brunch after the church service, which was held on the studio's lot in a church that replicated the one in the film *The Color Purple*. For all its glamour, the tone of the service was edifying, reminding all in the room of the Greatest Source of our gifts.

Millinery being my first love, I was very excited that the invitation for the Sunday festivities encouraged the ladies to wear their best hats, and many did. There is something wonderful about looking across a venue, or in this case a sanctuary, and seeing all the dramatic hats: the women are regal, and the men find it alluring. Of course, Cicely wore our favorite silhouette: a shoulder-width hat, swept off the face and cascading on her back. Cicely didn't believe in the "rule" that a woman's hat must be in proportion to her height. My philosophy is that it's all about one's carriage. The hat Cicely chose, of azalea Swiss straw braid with a border of a bicolor straw, gave the recycled dress and bolero a festive "Sunday best" look.

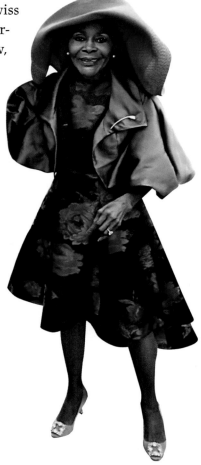

Cicely dressed for early Sunday morning worship on the grounds of the Tyler Perry Studios, October 2019.

*Photo credit: Courtesy of the author*

# THE GOLD AND BLACK STRIPE DRESS

**Best in Business Tribute**

In 2019, Mark-Anthony and I received the Company to Watch Award at the Best in Business Awards Gala, thrown by the Manhattan Chamber of Commerce.

Cicely, who was always very public about our fashion collaboration and personal relationship, stepped up to pay homage to Mark-Anthony and me in front of more than five hundred of New York City's most influential business and civic leaders. Wearing the haute couture black and gold striped dress I created in 2017 for *Elle* magazine's Women in Hollywood event, Cicely spoke prior to our appearance onstage. She was anchored by Valerie Simpson, dressed in an evening blue tuxedo, and another very dear friend Myrna Colley-Lee, a renowned, award-winning costume designer for theater, who wore my signature Exit Suit in navy Italian double-faced wool crepe.

"With over a decade of friendship and design collaboration, I have witnessed their hard work, perseverance, grit, and growth—not just in their business and luxury fashion brand, but in them as a couple," Cicely said. Many of the guests wore B Michael couture to support and celebrate with us.

# FAREWELL TO OUR FRIEND, DIAHANN CARROLL

Elegant, swellegant"—that was how Cicely described Diahann Carroll, her friend of more than fifty years at Diahann's memorial in 2019. *People* magazine reported that the tribute to Diahann at the Helen Hayes Theatre in New York City's Theater District was a poignant and joyous remembrance. The invitation-only event felt intimate, although the theater was filled. Speakers included Carmen de Lavallade, Lynn Whitfield, Angela Bassett, Laurence Fishburne, Lenny Kravitz, and Susan Fales-Hill, whose late mother Josephine Premice was a kindred spirit to both Diahann and Cicely—in the theater and in life. I was honored that the last person to speak onstage, Diahann's daughter Suzanne Kay, wore something I had made for her mom several years earlier: my black wool crepe Exit Suit, titled as such because the details on the back are meant to be seen as one exits the room.

Imagine me as a child watching Diahann Carroll in *Julia*, playing television's best-dressed nurse ever! Then I grew up and met Diahann professionally when we were both connected to the hit TV series *Dynasty*. Diahann became my fairy godmother at a time when I found myself in an industry that had no mercy for a naive newcomer.

In keeping with Diahann's iconic image of flawless elegance, I dressed Cicely in an understated couture blouse of black tulle that was embroidered with black satin ribbon, creating an all-over abstract pattern. I lined the cropped blouse with black silk-wool. The scarf-tie collar and trumpet sleeve were unlined. The sheerness of the sleeves reminded me of a black lace mantilla veil, so appropriate for mourning. The high-waist skirt in a black and charcoal pinstripe was cut on the bias in the front. The skirt's box pleats were only visible in the back when Cicely was walking. Diamond oval hoop earrings provided the only bling. The look was appropriate, feminine, and dignified—a nod to who Diahann was.

## An Intimate Dinner: "Carpe Diem"

The day of the memorial service was a long one. We had to be at the Helen Hayes Theatre early on the morning of the memorial for Diahann. Cicely had been given a dressing room for Armond and I to prepare her glam and clothing. Lenny Kravitz and Laurence Fishburne were in

A photo we all cherish taken on the evening of Diahann Carroll's memorial service. The seven of us dined at Le Bilboquet in New York City and stayed until closing. *From left to right:* Laurence Fishburne, Lenny Kravitz, Cicely, me, Valerie Simpson, and Mark-Anthony. (Missing in this photo is Armond Hambrick.)

*Photo credit: Courtesy of the author*

the room next to ours, and next to them were Susan Fales-Hill and Suzanne Kay, so the reunion and the flood of emotions started before we even entered the theater for the official tribute program.

The tradition of gathering after a funeral or memorial service was exactly what was needed. The repast was graciously hosted by Susan and Aaron in their lovely Manhattan residence for a few close friends and family of Diahann's. By early evening, Mark-Anthony, Cicely, and I decided we would take our leave. As we were getting ready to depart, Cicely said that she wanted to stop somewhere for a relaxing dinner. Mark-Anthony and I could sense in Cicely's spirit that she wanted to cling to the feeling of together-

ness a little longer, so I called Le Bilboquet, one of our favorite Upper East Side bistros. We invited Armond, Lenny, Laurence, and Valerie to join us, making it an extended family dinner. Of course, as we often did, we stayed past the restaurant's closing. Another lesson for us all to live in the moment. That night would be the last time Cicely would enjoy breaking bread with her godson Lenny and her good friend Laurence. Carpe diem.

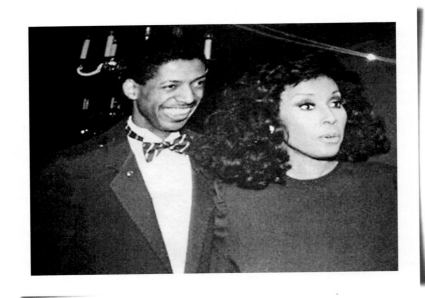

# A SPECIAL PLACE IN MY HEART

**A**s the designer of the licensed millinery collection B Michael for the TV series *Dynasty*, I often traveled for events. I went to Waltham, Massachusetts, for a big black-tie benefit gala hosted by Yolanda Cellucci, founder of one of the most successful bridal and evening wear stores in the northeast, Yolanda's of Waltham. The hats were in the gala's fashion show, and I was the guest of honor. Diahann Carroll flew in to support me as a friend and to lend her star power. I remember well the navy blue wool knit dress she wore, fitted to her waist and opening to a moderate sweep. It was perfect and matched my dark navy tuxedo. How I wish I had designed that dress!

Diahann with me promoting my *Dynasty* millinery
at a fashion show and black-tie gala hosted by
Yolanda Cellucci, founder of Yolanda's Bridal Salon
in Waltham, Massachusetts, circa 1984.

*Photo credit: Courtesy of the author*

Cicely and me on the red carpet at the Metrograph movie theater in New York City's Lower East Side.

*Photo credit: Sipa USA / Alamy Stock Photo*

## FOREVER AN ACTOR

*A Fall from Grace* Film Premiere

The week of January 12, 2020, had an unrelenting schedule, beginning with two days of promotion for the Netflix film *A Fall from Grace*, a thriller that was produced, written, and directed by Tyler Perry. The film's New York premiere followed. Cicely played Alice, a dark and seemingly confused elderly woman. What I loved about dressing Cicely was the contrast I got to create relative to her various character roles. When promoting the film, Cicely's presence would remind the world that she was Hollywood royalty.

For the first day of press events, I dressed Cicely in one of my favorite day-dressing looks: a bolero with a zigzag front closure and paneled point sleeves on top of a sheath with raised zigzag seams that run the full length of the dress. The English wool bouclé in autumn orange was perfection against Cicely's skin. For a pop of shine, I selected a costume gold medallion necklace that had been given to Cicely by her great-niece. The clean line of the bob-cut wig and Armond's subtle orange lip color looked effortlessly chic.

The next day, we had two live morning shows, *Good Morning America* and the *Tamron Hall Show*. Staying with the theme of rich color, which would light well for television without overpowering the other cast members on set, I selected a deep purple English wool bouclé empire sheath from my Fall/Winter 2015 collection. For protection against the New York City January morn-

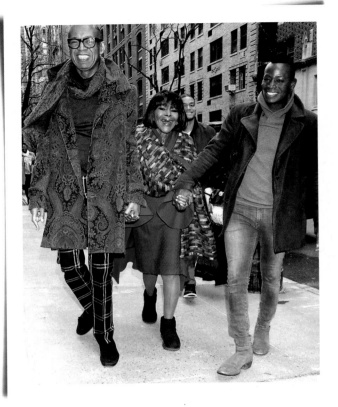

Making the rounds of the morning shows to promote the film *A Fall From Grace.* Cicely, wrapped in my couture stadium shawl, Armond Hambrick the makeup artist (*right*), and I are arriving for the Tamron Hall Show in New York City, January 2020.

*Photo credit: Media Punch Inc. / Alamy Stock Photo*

ing, I wrapped Cicely in a stadium-scale shawl of multicolor wool and metallic yarns that I had had woven in France.

That evening was the film's New York premiere. The understood dress code was downtown dressed-up with a spin. I dressed Cicely in what my grandmother would have referred to as a "walking suit"—a matching coat and dress. The fitted A-line coat with a leather collar was fabricated in a beautiful silk and wool cloque, the aubergine and plum tones creating an abstract floral pattern. Under the coat was a dress of the same fabric. That night, it took longer to get the black microfiber Dior booties on Cicely than it did to dress her. It was hysterical! To add glam, Armond styled an asymmetrical wig and

gave her a mauve lip color. We were a potpourri of prints because I never changed clothes from the morning's rounds. As I reflect on my memories of the night, just three months before the world would go on pause, I recall lots of laughing. This was one of the nights we stayed for the duration of the party. For many who attended that evening, it would be their last time in Cicely's company. They will recall her as being vibrant and sassy.

Cicely taking a little break between press junkets for her film *A Fall from Grace,* January 2020.

*Photo credit: Courtesy of the author*

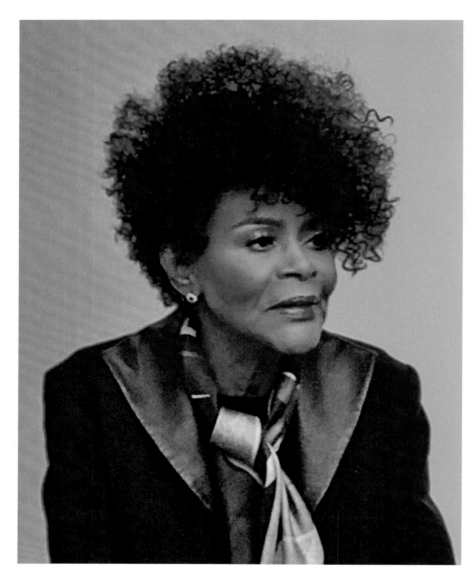

Close-up of the modern look Cicely sported to promote
*Cherish the Day* for the OWN network, January 2020.
Hair and makeup by beauty artist Tré Major.

*Photo credit: Courtesy of the author*

Cicely and Ava DuVernay being interviewed in one of the many rooms turned into makeshift studios.

*Photo credit: Courtesy of the author*

# A VERY MODERN WOMAN

*Cherish the Day* Press Junkets

January 2020 started with a demanding schedule. Cicely, then ninety-four, was running on full steam—so I certainly couldn't complain. After Sunday and Monday's events for the film A *Fall from Grace*, we flew on Wednesday into Los Angeles and drove to Pasadena, where Cicely would participate in press junkets for *Cherish the Day*, a new anthology series created and produced by Ava DuVernay. Cicely's character, Miss Luma Lee Langston, is a legendary star of stage and screen from decades past. When Cicely was preparing for her role, she consulted with me about how she felt the character would dress, in clothing that reflected a past era of glory.

To create a visual juxtaposition from Cicely's role, I dressed her in sleek, modern pieces. From my 2018 Fall/Winter collection, I selected a navy blue double-faced wool crepe topper with a black leather sailor collar. Underneath, Cicely wore a slim black double-faced wool crepe skirt with black leather seam piping and a matching top. From my accessory bag, I pulled a multicolor scarf. Black fishnet hosiery and the microfiber Dior booties completed the outfit. Cicely, an ambassador for natural hair, was thrilled when I showed her an inspiration photo for the hair I

envisioned. Los Angeles–based beauty artist Tré Major masterfully created the makeup and captured my hoped-for style.

Cicely was amazed that she had the opportunity to work for Black American producers, including Oprah Winfrey, Tyler Perry, Shonda Rhimes, and now Ava DuVernay—each of them breaking through barriers and achieving unparalleled success. Ava DuVernay told one interviewer, "Each day she [Cicely] walks on the set is a master class."

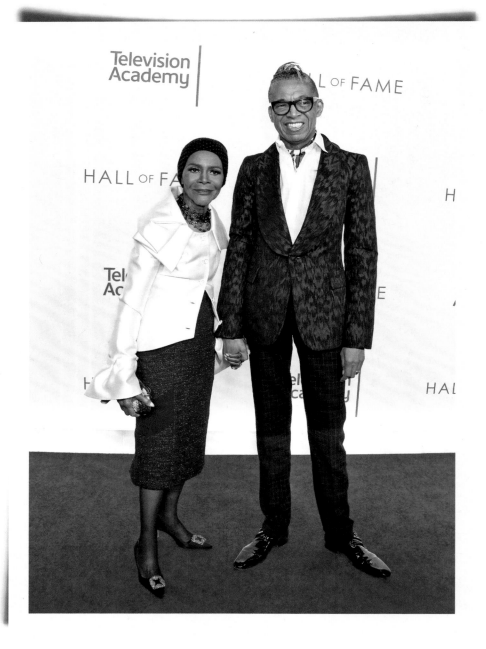

The journey we shared between the two white blouses
has disrupted cultural and fashion history in America,
creating a new paradigm.

*Photo credit: Courtesy of the author*

Cicely listening to Shonda Rhimes's presentation for Cicely's induction into the Television Academy Hall of Fame.

*Photo credit: Courtesy of the author*

## OUR FINAL RED CARPET

The Journey Between Two White Blouses

**J**anuary 28 will forever be a meaningful date in my life. On this date in 2020, Cicely was inducted into the twenty-fifth Television Academy Hall of Fame. She was jubilant. The ceremony was also Cicely's last red-carpet event. On that monumental date, one year later, Cicely Tyson passed away. I will always observe January 28 as the Cicely Tyson Holiday.

The formal invitation for the Hall of Fame ceremony requested cocktail attire. I designed a tailored blouse in white silk and wool. The collar and cuffs were draped and stitched on the mannequin, and the arch-shaped center front was closed with signature covered buttons. The high-waisted slim skirt with paneled side seams was elongated to the calf and fabricated in black wool tweed. The necklace, a soft medal spiral with smoky glass beads, filled in the neck. The faithful black satin and rhinestone Manolo Blahnik pumps were perfect. For this event, Los Angeles–based beauty stylist Tré Major did Cicely's flawless makeup. The fitted skullcap was an in-the-moment decision: the idea of hair with the collar was too much. Cicely loved the way she looked, and that made me happy.

The Thirds took flight to Los Angeles the day before the event. Cicely invited a few close friends on the West Coast, including Vince Wilburn Jr., Miles Davis's nephew. Additionally, Valerie Simpson and her daughter Nicole Ashford came from New York. Cicely was so excited as she worked on the guest list, it was as though she

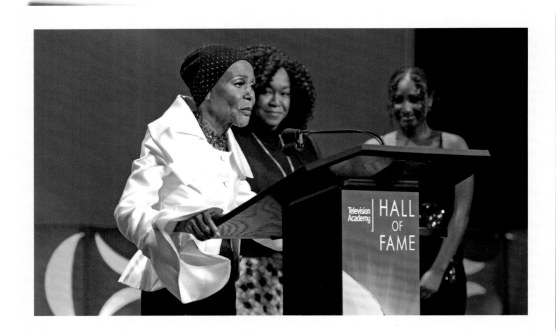

Inductee Cicely captures the photographers' attention at the
twenty-fifth Television Academy Hall of Fame at the Television
Academy's Saban Media Center, North Hollywood, January 2020.

*Photo credit: Invision for the Television Academy / AP Images*

were hosting a private party. We enjoyed the process of preparing for the big event.

The twenty-fifth Hall of Fame class of five included some of the industry's greatest contributors: Bob Iger, the chairman and CEO of the Walt Disney Company, which includes Pixar, Marvel, Lucasfilm, and 20th Century Studios; Geraldine Laybourne, who oversaw the creation of Nickelodeon and cofounded Oxygen Media; Jay Sandrich, a five-time Emmy-winning director of such classics as *The Mary Tyler Moore Show*, *Soap*, *Benson*, *The Cosby Show*, and *Golden Girls*; and Seth MacFarlane, also a five-time Emmy winner who created *Family Guy* and *American Dad*. But for many attending the ceremony in the Television Academy's Saban Media Center, the pièce de résistance was Cicely Tyson.

## Our Last Public Photo Together

As she had done many times when returning to her seat, Cicely discreetly asked me how her speech was. It amazed me at first, and frankly I felt I was not qualified to respond with a critique. Cicely explained that we should always be free to share with each other whatever needed to be said, whether it was constructive criticism or encouragement. That became a code we shared with responsibility and practiced with trust. My answer to her question that evening spoke to her storytelling. Yes, I had heard the stories before, as many had, yet there was always something new to discover with each retelling. It was like rewatching a great classic film and hearing a line you didn't hear the first five times.

Cicely
TV-Ac
WEAR DATE
Jan 28, 2020

TOP
DRAPED COLLAR
+ CUFF

"B's last red-carpet look for Ms. Tyson was for her induction into the twenty-fifth Television Academy Hall of Fame on January 28, 2020, exactly one year before she died. It didn't strike him until much later that he used the same starting point he had for the Legends Ball look that had brought designer and muse together fifteen years earlier: white shirt, black skirt—an elegant base open to flourish, just like the lady herself."

—**Bridget Foley**

# INTERVIEWING MY DEAR FRIEND
## DURING THE PANDEMIC

The First Appearance

After seven pandemic months with no agenda and certainly no need for the glam team, Cicely received a call from Shondaland.com, and it was a blessing to our ears. The request was for Cicely to do a virtual presentation for the digital platform. Shondaland is the global media company founded by award-winning writer and producer Shonda Rhimes who, as you know by now, was a respected and dear friend. Cicely loved the concept and agreed to do it on the condition that I be the videographer. Of course, I had no real choice, and we were longing for something creative to inspire us. So, for Cicely, I accepted the title of couturier-videographer. I read her the questions off-camera, then recorded her point of view on several topics, including voting.

I arrived at Cicely's home so we could motor together to my atelier for the Shondaland.com video recording. Armond would do hair and makeup, and we were all excited as it had been a long time since our last such gathering. Cicely greeted me with a scarf tied on her head, which did not strike me as different. Then she said, "I have a surprise for you."

Cicely's first appearance during the pandemic, August 2020. This photo was taken in my New York City atelier during the videotaping for Shondaland.com.

*Photo credit: Courtesy of the author*

Cicely removed the scarf, revealing gray and purple-tinted highly styled cornrow braiding. I was shocked, in part because I had seen Cicely just the day before. She explained that she saw a woman in the elevator of her building with braids and had gotten the Harlem salon's address from her. That afternoon, she had gone uptown on her own, and well . . . *surprise!* Cicely admitted she was a little nervous about my reaction, especially not knowing what I had in mind for her to wear for the videos we were to shoot that day (for Shondaland.com and the Emmys). By the way, Armond was even more shocked than I was, and his wigs never left the bag.

I selected a vivid coral silk faille jacket for the video, thinking the color would pop on camera;

Cicely during the videotaping of her virtual Emmy acceptance speech, which was never used, August 2020.

*Photo credit: Courtesy of the author*

the color also felt happy—which was important for that time. This was Cicely's very first virtual appearance, and she enjoyed being on camera dressed up only from the waist up.

## Virtual Emmy Acceptance Speech

Cicely's management team, Larry Thompson and Robert Endara, thought that as long as I was videotaping Cicely for Shondaland.com, I could also videotape her pending acceptance speech for the upcoming Primetime Emmys. Cicely was nominated for her intense role as Ophelia Harkness in the television crime drama *How to Get Away with Murder*. Cicely referred to the show's producer, Shonda Rhimes, as "the genius." For the Emmys, I changed Cicely into a silver and black pyramid-sweep topper and added earrings, and her lip color was changed to red. Cicely did not win, however, and the videotaped speech was not needed.

# "YOU'RE IN MY HEAD"

This morning, as I began writing this chapter, which covers my experience working alongside Cicely in the two months before the release of her memoir, *Just as I Am*, the first email I read shared the news that Cicely's book received an NAACP Image Award for Outstanding Debut Author. Though physically apart, we remain connected by "the tie that binds." I should not be surprised by this coincidence; it speaks to the close dynamic of our spiritual relationship and reminds me of the many times Cicely and I said to each other, "You're in my head."

Sometime in early September 2020, it became clear to me that Cicely and her management team had roped me into getting Cicely through the demanding final stages of preparing her memoir for publication. Maybe by default, or perhaps by divine order, Cicely and I were accessible to each other during the pandemic's pause. Cicely trusted me. Cicely's managers, who are on the West Coast, knew they could rely on me, as did the publisher's team. And for me, it was a great honor that I should be entrusted by the Universe with such an enormous charge. This was an opportunity to participate in the archiving of the history of one of America's eminent treasures; Cicely's memoir would be her own telling of her life's story and work.

In the end, I realize that Cicely gave me an extraordinary, rare, and precious gift. Seeing her life unfold in her memoir, and having the privilege of being a part of the process, is something I will treasure and take with me into the forever.

The book was scheduled to drop on January 26, 2021. In the late fall of 2020 through January 2021, we had a rigorous schedule of photo shoots, virtual appearances, and filmed in-person interviews. There was a huge demand for Cicely in anticipation of her memoir. Although

The following series of photos share our finale project. The energy of those days will always be a part of me. We spent those last few months doing what we do best: living, laughing, eating, and always forged in fashion.

We all felt great artistic energy during this photo shoot. Here we are celebrating each other. *From left to right:* Me, Cicely, Armond, and Mamadi Doumbouya.

*Photo credit: Courtesy of Mamadi Doumbouya*

Cicely and I would sometimes complain about the early mornings and long days, the truth is that we were thrilled to have a schedule again after too many months on pause due to the pandemic. Fashion, wigs, and makeup were back on the agenda, and we couldn't have been happier.

## American Library Association Appearance

For Cicely's virtual appearance for the American Library Association, the oldest and largest library association in the world, Cicely jokingly inquired about what I had in mind for her to wear that would give her a studious look. My thought was a high-fashion librarian. Cicely wore a white linen jacquard blouse with a halo collar and balloon-cuff sleeves, which I had created for my new collection. Cicely described seeing a hairstyle of a wavy-curl bob, which inspired the wig Armond styled. Adapting to the new practice of virtual appearances, Cicely found it funny that she still had on her comfortable athletic pants and slippers.

## *New York Times Magazine* Photo Shoot

From that point on, I wanted the looks for the memoir press events to be in some shade of purple, inspired by the cover of her book. The first of the purple looks was a two-piece ensemble. The tailored topper was fabricated in a subtle plaid of purple metallic and wool chenille. The dress underneath had a matching bodice. I kept imagining a severe look for the hair, with a bow rather than a chignon. Georgina Mauriello, founder and chief hair stylist of Georgina's Hair Studio in Orange, Connecticut, collaborated with me from the very beginning of my work as a designer. Armond blended Cicely's natural hair to that of the hairpiece Georgina had provided. A custom lip color completed the palette. Cicely was ready for her *New York Times Magazine* close-up.

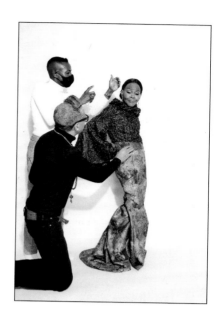
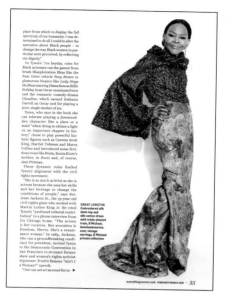

## *Interview* **Magazine Photo Shoot**

The acclaimed artist Mickalene Thomas was commissioned by *Interview* magazine to photograph Cicely for an upcoming article. Mickalene's brilliant set placed Cicely in a space that was nostalgic and poetically powerful. I felt like we were on the set of a story about the Harlem Renaissance. I view *Interview* magazine as being on the edge of pop culture, art, and fashion. I loved the idea that *Interview* reached out to Cicely to promote the release of her memoir. Cicely was interviewed for the feature by a dear friend, Phylicia Rashad, the award-winning actor and director.

Armond Hambrick and I giving Cicely a final prep as we begin the *Zoomer* magazine photo shoot in my atelier, December 15, 2020.

*Photo credit: Zoomer magazine; Editor-in-Chief/ Publisher: Suzanne Boyd, Art Director: Stephanie White, Photographer: Gabor Jurina, Fashion: B Michael, Hair/ Makeup: Armond Hambrick*

For the photo shoot, I designed a fitted top with seamed poet sleeves and a collar draped in soft pleats that cascaded at the back. I paired it with a matching trumpet evening skirt. Following through with my color theme, the two-piece ensemble was fabricated in a deep purple and lilac silk cloque.

As I prepared Cicely for the *Interview* shoot, we had one of those spontaneous Cicely and B moments. Cicely was made up and dressed, and she had a red bandana on her head, which would be removed when Armond was ready to fit her wig. I was not feeling any of our wig options, and on a whim reached for a black velour felt fedora hat—just to see the effect. Typically, I am not a fan of hats with evening-length clothes. I placed the hat on Cicely over the bandana. The three of us liked the unexpected look. When Armond began to remove the bandana, Cicely asked, "Why can't I wear it with the bandana? That's what makes it work." Without protest I agreed, declaring, "You look 'gangster,' and that's perfect for *Interview* magazine!"

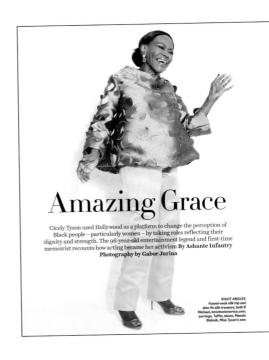

## Amazing Grace

Cicely Tyson used Hollywood as a platform to change the perception of Black people – particularly women – by taking roles reflecting their dignity and strength. The 96-year-old entertainment legend and first-time memoirist recounts how acting became her activism **By Ashante Infantry Photography by Gabor Jurina**

**RIGHT ANGLES**
Funnel-neck silk top and slim-fit silk trousers, both B Michael, bmichaelamerica.com; earrings, Taffin; shoes, Manolo Blahnik, Miss Tyson's own

Another page from *Zoomer* magazine's cover feature.

*Photo credit: Gabor Jurina*

### Very Funny Face

Although the New York City Garment Center was still quiet due to the pandemic, my atelier was now abuzz. On the *Zoomer* magazine photo shoot, I began imagining a scene from one of my favorite fashion films, *Funny Face*—but updated with Cicely in the starring role. This modern version would take place in New York City, and Cicely Tyson would play the model instead of Audrey Hepburn. The costumes would be designed by B Michael, rather than Givenchy. Gabor Jurina, acclaimed internationally for his work in fashion and beauty, would be the photographer instead of Fred Astaire—and no dancing would be required. I shared my fantasy with Cicely, who agreed with the title *Very Funny Face*. In the original film, the magazine editor declares, "Think pink!" In our version, it was "Think purple!"

More purple! The empire top with a hand-pleated collar and angel sleeves was made of embroidered silk crepe de chine. Underneath is a strapless sheath gown with a triple-pleated train fabricated in a silk and cotton impressionist print. The white diamond and amethyst earrings are from my atelier collection. Rather than changing wigs, I felt a chignon would be the epitome of sophisticated glamour and show Cicely's full face; in creative collaboration, Armond's interpretation was perfection. *Very Funny Face*, indeed.

On one page from *Zoomer* magazine's cover feature, "Amazing Grace" was boldly splashed across an image of Cicely. This melodic metaphor came from Ashante Infantry, an acclaimed writer who interviewed both Cicely and me for the article. The interview via Zoom with Cicely took place just a couple of days after her ninety-sixth birthday. Ashante, speaking about her experience interviewing Cicely, described her as "sharp, funny . . . [with] wit and sauciness."

I wanted to create a look that would be uplifting and joyful. I thought about mixing vibrant colors and dressing Cicely in a trouser—for only the third time ever. The look started with an architectural top created with a funnel neck and full sleeves; the front and back hems finished

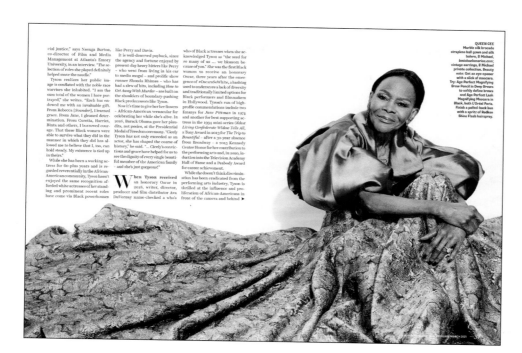

The photo on this two-page layout from *Zoomer* magazine captures Cicely four days before her ninety-sixth birthday.

*Photo credit: Gabor Jurina*

at the center with a slight point. It was made with three fabrics of different colors. The slim-cut trouser with front stitched seam was fabricated in coral double-faced silk gabardine. The earrings we selected came from Taffin, created by James de Givenchy; they featured unmatched precious orange and pink topaz, ceramic, and rose-gold pendants. They could not have been more perfect if we had commissioned them. Our faithful fuchsia Manolo Blahnik satin pumps, grounded the color story.

For another *Zoomer* look, I envisioned Cicely being surrounded by a ball gown. Gabor was considering how to accommodate the vison without physically imposing on Cicely. To Gabor's amazement, Cicely the high-fashion model positioned herself on the floor, and I began arranging the ball gown, which consisted of forty-eight panels opening into a sweep of twelve yards of Monet-lavender silk brocade. When the art director of *Zoomer* magazine sent me an advanced look at the layout, I saw what Gabor had captured: Cicely and I were, in the most divine way, the muse and the designer.

After completing the three planned looks for the shoot, Cicely wanted to try on a trapeze-sweep topper in an abstract print of silver and black silk foil. The piece was for my new Fall 2021 collection. Of course, Gabor could not resist photographing Cicely's spontaneous movement, as she was having some fun in the topper. Afterward, the large black horsehair hat worn to Aretha Franklin's funeral, which I kept on display in the atelier, made its presence known. Gabor photographed the hat but agreed that it would be used as an abstract image, as the image of Cicely wearing that hat for Aretha's funeral must remain sacred. We ended the shoot on a high note, and Cicely was feeling wonderful.

Walking Cicely through the courtyard of our apartment complex to
Carol's car at three in the morning following Cicely's birthday celebration,
December 20, 2020. I teased Cicely that she was doing "the walk of shame."
Mark-Anthony snapped this candid photo.

*Photo credit: Courtesy of the author*

# CICELY'S NINETY-SIXTH BIRTHDAY

## "The Walk of Shame"

**D**ecember 19, 2020, came right in the middle of a very hectic time as we prepared for the upcoming launch of Cicely's memoir. For most of the time I'd known Cicely, she would celebrate her birthday by hosting friends and family at the Blue Note Jazz Club to see American trumpeter Chris Botti, with whom she had a special connection. Many of us would also join Cicely in East Orange, New Jersey, for a birthday celebration performance put on by the students at the Cicely L. Tyson Community School of Performing and Fine Arts. But in 2020, New York City—and much of the country—was still on pandemic pause.

Knowing there would be no gathering with family and friends at the Blue Note, and there would be no birthday cake onstage with students singing, "Happy birthday, Miss Tyson," Cicely declared that she was going to use the day to rest and not leave her apartment. As we customarily did for each other, at the stroke of midnight on the morning of December 19, Mark-Anthony and I called Cicely to sing happy birthday to her, making her laugh. We insisted that we would be celebrating her birthday and that she could come to our apartment; otherwise, we would be going to her place. When Cicely had something important to share with us, or if she wanted to chastise us, she would say if you don't come here, I am going to show up at your apartment. So we knew that tactic would get a response. That evening, it was the Thirds and Dr. Carol Wiggins. Carol came into Cicely's life when Cicely's dear friend, the late Arthur Mitchell, asked Carol to always look af-

ter her. Without fanfare, Carol honored Arthur's request with impeccable diligence. Carol picked up Cicely, who was dressed in her most comfortable sweatpants and hoodie, and drove her to our apartment. They arrived around 9:30 p.m. with lots of sushi. Mark-Anthony had the champagne chilled, we had delicious vegan birthday cupcakes ready, and I set a festive table, which is where the four of us sat telling stories and laughing until after three in the morning! We all felt something magical and special. We held on to that energy, knowing it was a moment we would always cherish. The following day, the doorman in Cicely's building teased me about Ms. Tyson's arrival home at 3:30 a.m. My reply: "Yes, it's called 'the walk of shame.'" Over the next few days, I overheard Cicely telling the story: "Can you believe they kept me out until 3:30 in the morning? Even my doorman teased me." She loved every moment.

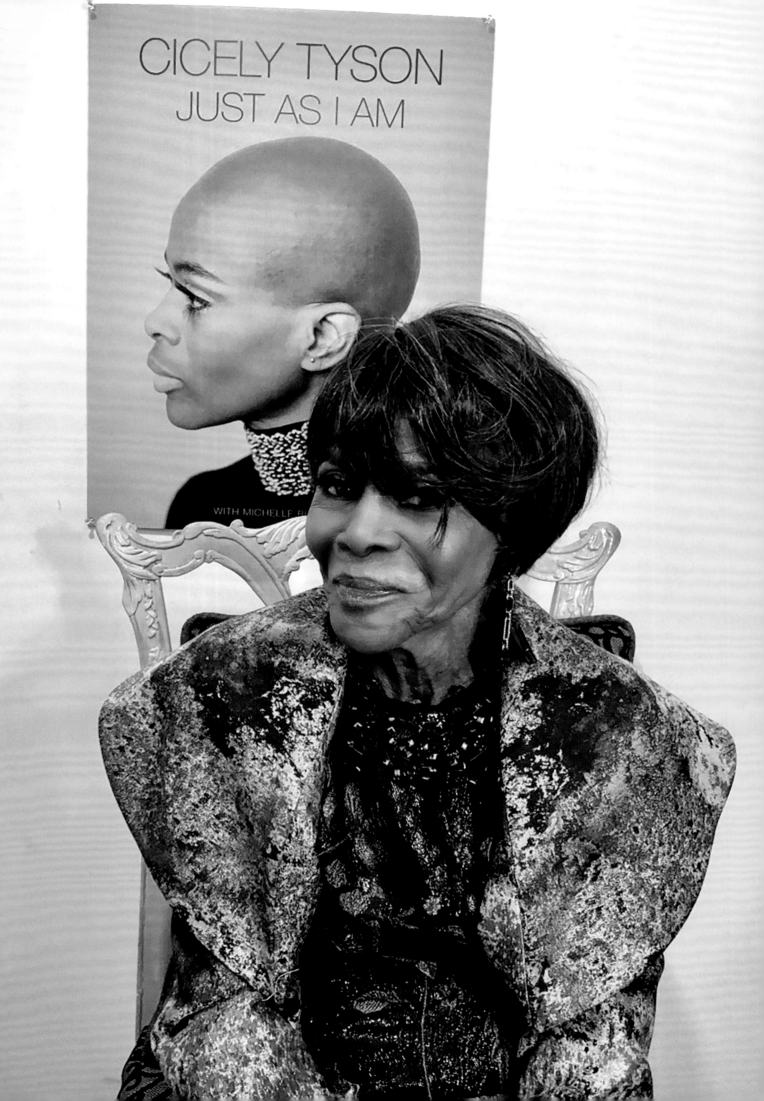

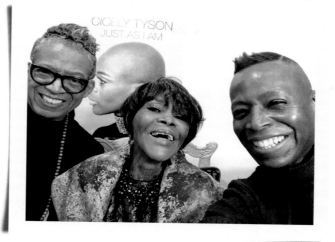

Cicely, Armond, and I posing together with the poster of Cicely's memoir in the background. One of the ways we would decompress after an engagement was by taking a fun selfie.

*Photo credit: Courtesy of the author*

# A LIVE ZOOM

On January 19, we were gearing up for the book's launch date of January 26, just one week away. And although no airports were involved, we had a rigorous schedule. I was with Cicely almost every waking moment. Those of us near Cicely, including her management and the hands-on publishing team from HarperCollins, were all feeling the anticipation. Almost at every turn, Cicely would murmur to me, "I just need to make it to January 26th."

On January 19, we did a pretaped interview for Girls Write Now, a nonprofit organization that mentors young women to build and cultivate holistic writing relationships, The interview was conducted by Whoopi Goldberg, the award-winning American actor, comedian, author, and television personality. The interview would be aired on January 28, as part of a virtual book release event hosted by Girls Write Now, which would also bring on Cicely live, via Zoom. I dressed Cicely in a daytime look for the interview, with a more dramatic look planned for the live appearance. I combined fabrics from the couture garments created for the *Interview* and *Zoomer* magazine photo shoots. The dress, in deep purple and lilac silk cloque, is bordered to match the exaggerated shawl-collar bolero, which was fabricated in my signature silk and cotton impressionist print. The saucy wig and makeup were styled by Armond Hambrick.

Cicely in my atelier after a Zoom interview and visit with Whoopi Goldberg that went into overtime, for the Girls Write Now book release event, January 19, 2021.

*Photo credit: Courtesy of the author*

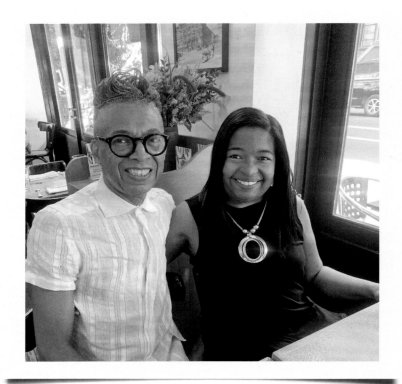

Carol and me at our monthly lunch, a tradition we started in March 2021. At first it was our therapy following Cicely's passing. It has now become dedicated quality time, always including a few Cicely stories, Harlem, August 2023.

*Photo credit: Courtesy of the author*

**B**Michael and Cicely Tyson shared an inextricable link that the world will appreciate forever. Their love was a movement. The flow of this love was one of enormous creativity. It was a dynamic force that melted down barriers in their respective artistry.

The love of light and freedom shines through B Michael's artistry. Through this artist's eye, one embraces this creativity, which shows us more about ourselves. B Michael's level of excellence as a designer of couture and luxury fashion, as a friend, and as a spiritual enforcer has allowed me to feel another love for myself, a self I never knew existed until I looked into my own eyes.

B, I thank you for continuing to channel that love of light in everything you do. Or as Jimmy Dorsey so appropriately wrote, "More than ever, I'm glad there is you!"

—**Dr. Carol D. Wiggins**

Gayle, Cicely, and me.
*Photo credit: Courtesy of the author*

## OUR LAST TIME IN OUR CHURCH

On January 21, the day following the presidential inauguration, Gayle King interviewed Cicely for *CBS This Morning* in the sanctuary of Cicely's beloved Abyssinian Baptist Church. Cicely and I walked through the red door of the church for the first time in more than ten months, arriving for our early call time. We immediately realized how good it felt to be inside the building again after the long pandemic pause. The CBS crew was setting up in the sanctuary, and Armond was set up in the "blue room," the same space we used back in 2018 as a dressing room suite when Annie Leibovitz photographed Cicely for the 2019 *Vanity Fair* Hollywood issue.

At her request, Cicely was dressed in the purple silk crepe de chine top we previously used for the *Zoomer* magazine cover shoot; for me, the purple would be a beautiful contrast to the rich red tones in the church's sanctuary. This time, I paired the top over a mid-calf, A-line dress of double-faced wool gaberdine in the absolute palest shade of lilac. Armond styled the short wig with a messy bang, and the lip was a muted pink. Cicely, looking chic and warm in spirit and nearly distracting the film crew, delivered a memorable interview.

At some point, Reverend Butts walked through, bringing much joy and light to Cicely on that day.

There, on hallowed ground, Cicely felt protected as she spoke openly with Gayle King, who was both an acclaimed journalist and a friend. At the end of the interview, which aired on January 26, Gayle asked Cicely what she wanted to be remembered for. Cicely's response would reverberate: "That I've done my best." As we prepared to leave the church after the shoot, we had no thoughts beyond that moment, not realizing that we would never again return together.

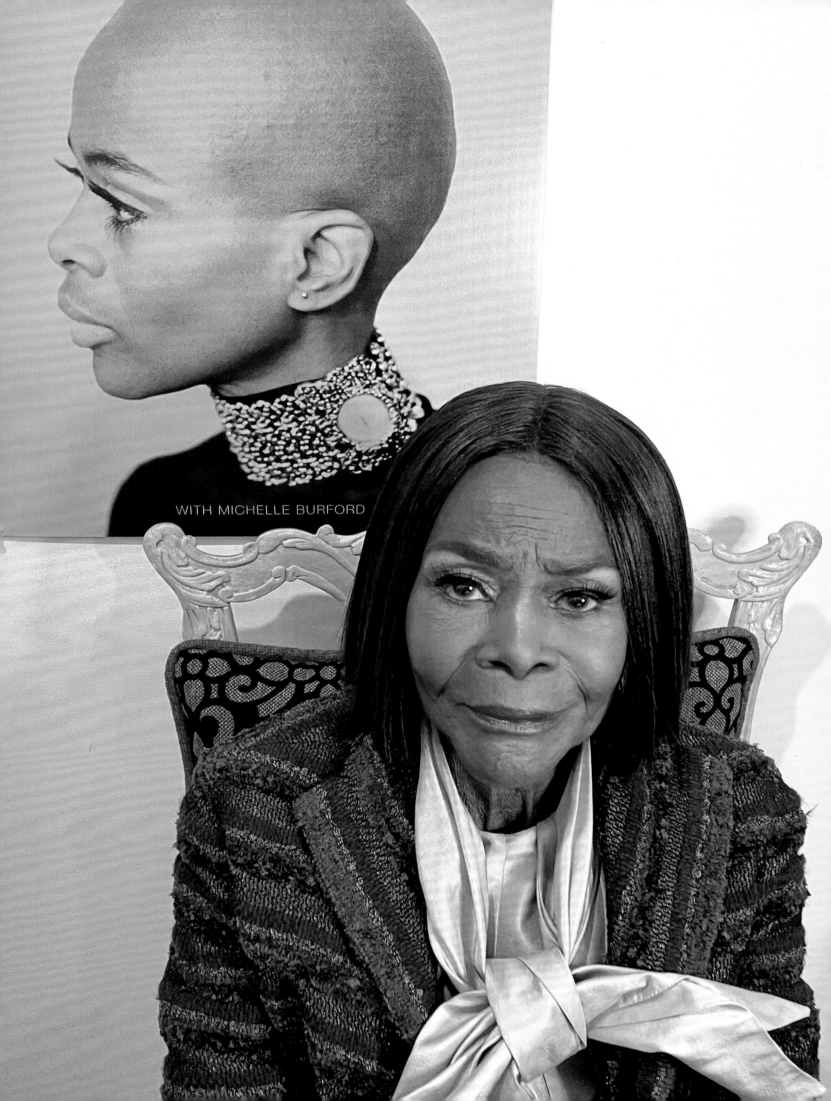

WITH MICHELLE BURFORD

# CICELY SAYS THANK YOU

On January 25, we were feeling the way you might feel the day before an event that you have been planning for two years; we felt a sense of accomplishment, but it was also bittersweet. On that day's schedule, Cicely did a virtual interview with Bevy Smith for her Sirius XM show. Then we participated in the last scheduled weekly Zoom meeting with the executive publishing team from HarperCollins, her West Coast–based management team (Larry Thompson and Robert Endara), and her passionate and shrewd book agent, Jan Miller—all of whom we referred to as "Team Tyson." Visible for the first time on the screen, Cicely thanked each one for their hard work and the successful launch of her long-awaited memoir. It was an emotional moment of triumph.

I point out that Cicely was visible on the screen because, for all of the previous weekly meetings, our camera had been turned off. I always laughed when, at the start of each Zoom meeting, Cicely would look at the attendees on the screen and ask, "Can they see me? I don't want them to see me," to which I would say, "No, they can't see you, but they can hear you."

Cicely had generally dressed casually for the weekly meetings. She told me, "When I got dressed, I just piled on whatever was within reach." Fortunately, and intentionally, on this day Cicely was dressed and in Armond's makeup for her close-up and meaningful thank-you to those who had worked with her, so hard and with excellence, on manifesting her story.

Having completed her virtual interview with Bevy Smith, Cicely prepares for the weekly team meeting on Zoom, January 25, 2021. She is wearing a topper of multiple chenille and wool yarns in shades of aubergine and berry from my Fall 2017 collection. I added a lavender silk shantung blouse with a collar-tied bow.

*Photo credit: Courtesy of the author*

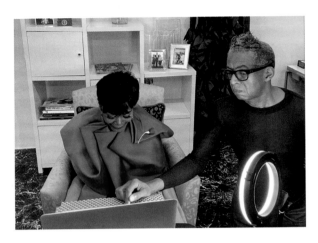

The date is January 26, 2021—the day Cicely's book, *Just as I Am*, went on sale. (*Top*) I am getting Cicely prepped for her virtual interview with Tyler Perry for Barnes & Noble. (*Bottom*) We are taking a moment to capture the monumental day, at my New York City atelier.

*Photo credit: Courtesy of the author*

# THE DAY CICELY'S LIFE STORY ENTERED THE WORLD

January 26, 2021, a date we had been focusing on for the last several months, finally arrived: launch day for Cicely Tyson's much anticipated memoir, *Just as I Am*. On this date, Cicely's story would be available internationally, accessible through most major distribution outlets, online, and in bookstores like Barnes & Noble. I can recall only a few times in my life when I experienced such anticipation, including the day my first runway collection was unveiled during New York Fashion Week in 1999. Even greater was Cicely's expectancy. I was sensitive to her vulnerability as she braced herself to share her story with the world.

Several events were scheduled to highlight the book's launch. The day would begin with Gayle King's segment for *CBS This Morning*, the exclusive first interview on the day the book launched. Following in the late afternoon would be a virtual interview with world-renowned business mogul Tyler Perry for Barnes & Noble's national virtual book event.

I knew I had to design something important for Cicely to wear. I was not going to let the fact that we were doing all of this virtually deprive her of the gratification of being dressed head to toe on the day her memoir was unveiled to the world.

Working into the night over the weekend with my couture draper, Reyes Cruz, I created a fitted top with an oversize bias collar that I draped and pleated on the dress form in a hydrangea purple, double-faced silk gaberdine. For the skirt, Reyes cut several flared panels in turquoise silk organza, which was shirred into a full ballerina skirt. A short wig with bangs and a red lip color matching the signature red Elsa Perreti pin completed the look. We stitched the pin onto the top to surprise Cicely.

The book was a huge success. Confident and elegant Cicely Tyson, the queen of Hollywood, earned a new title: bestselling author.

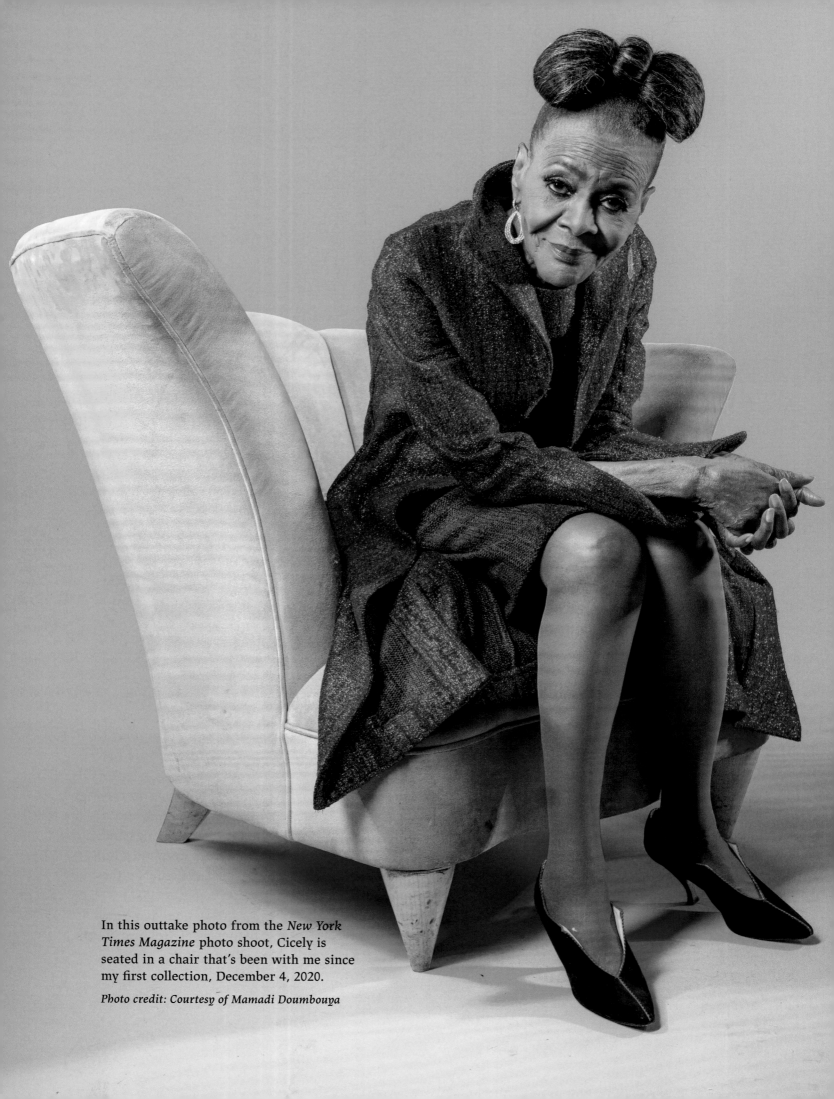

In this outtake photo from the *New York Times Magazine* photo shoot, Cicely is seated in a chair that's been with me since my first collection, December 4, 2020.

*Photo credit: Courtesy of Mamadi Doumbouya*

# AN INTIMATE DINNER WITH THE THIRDS

When the day's events concluded and we were getting Cicely comfortable, she announced that she would be going home with me and that I should call Mark-Anthony and ask him what he was going to do about dinner for the Thirds. Mark-Anthony concluded that she wanted to have an intimate dinner to celebrate her book launch and that this was not to be questioned.

Somewhat miraculously, he managed a dinner of chopped kale salad, grilled salmon, collard greens, and brown rice, with a glass of champagne, of course. The three of us sat at the dining room table, which I had set with plates that Cicely always admired. She sat at the head of the table with the two of us on either side. We hardly discussed the book or the events of the day. We talked about food and cooking, told funny stories, and interrupted each other and laughed a lot. Cicely, realizing how much she had eaten and making fun of my healthy appetite, pointedly remarked, "This is what I needed, some sustenance and some laughs," then uncharacteristically asked, "What's for dessert?" After oatmeal cookies and a pot of lotus tea, Cicely luxuriated in a bath of lavender Epsom salts and slept soundly in our guest room overnight.

The next morning, Cicely woke up around five to get ready for her call. She was scheduled to appear on *Live with Kelly and Ryan*. I suggested that she stay in bed and offered to call and cancel her appearance. She replied, "Absolutely not!" We had a car scheduled to pick us up from my apartment at six so that Armond and I could have Cicely camera-ready by 9:30. She managed to get up and made herself ready. Mark-Anthony assisted Cicely to the waiting SUV. He literally hoisted her up onto the seat. She then hugged him tightly for what felt like moments. Mark-Anthony said nothing to me at the time but later shared that his spiritual instinct had made him aware, then and there, that this was their farewell.

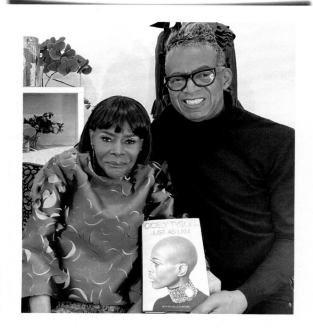

The very last photo of Cicely and me together,
taken in the last few moments of life as we
knew it—as the muse and her designer.

*Photo credit: Courtesy of the author*

# CICELY'S LAST INTERVIEW

**B**y 9:30 that morning, Armond and I had Cicely in full glamour. The virtual interview was scheduled to air in two days, on Friday morning, January 29, 2021. For the feature, I felt the set in the atelier needed some fresh flowers, so I telephoned Cicely's preferred florist, Red Maple Leaf. The bespoke flower studio in New York City had been founded by Saundra Parks, a dear friend to Cicely in many ways. When Cicely noticed the flowers, she declared, "I know these flowers are Saundra's." Wearing the iris purple, chartreuse, and fuchsia combination top, originally created for the *Zoomer* magazine feature, Cicely marveled at how the flowers continued the sculptural texture of her top, declaring that it was "aesthetically genius." She loved it! Though she was known for taking the floral centerpiece home from a gala or dinner, she thankfully left the flowers to be used for the Girls Write Now live virtual appearance the following evening.

## Our Last Photo Together

Lenny Kravitz, Cicely's godson, sent Cicely and me copies of his new book, *Let Love Rule*. We had just received the books that morning, and before getting Cicely undressed, we took a photo as a fun gesture to send to Lenny as a thank-you for the books. Cicely passed away the next day, January 28, 2021.

TOP: Taking a few moments after filming a segment for *Live with Kelly and Ryan* to absorb the momentous events of the previous two days, January 27, 2021. In this photo, a triumphant Cicely is holding a copy of her memoir, *Just as I Am*, which had been released the day before.

*Photo credit: Courtesy of the author*

During the rigorous schedule and workload for completing the book, Cicely frequently said to me, "I don't know what I would do without you," to which I always responded, "You will never have to know."

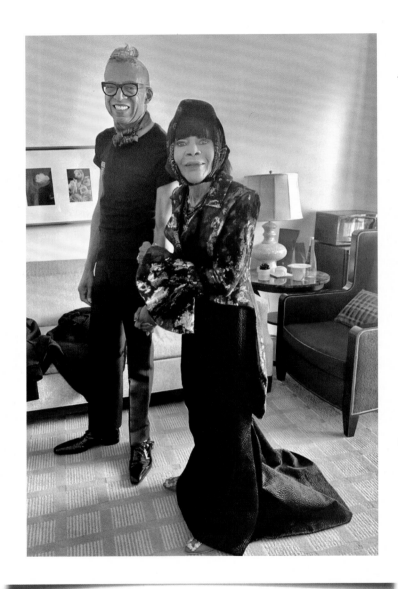

Cicely in her signature bandana, which was used to
hold her hair in place, as we prepare to head out to another
fabulous evening, September 2019.

*Photo credit: Courtesy of the author*

# FINAL DRESS AND EULOGY

When the time came to share my eulogy for Cicely, toward the end of the three-plus hour private funeral service inside the historic Abyssinian Baptist Church, Reverend Butts referred to the elaborate printed program and jokingly introduced me: "We now have what is being called 'an informal eulogy.' I don't know what that means—but I do know what it means—so we are going to ask B Michael to come at this time."

## My Eulogy to Cicely

(Pause first and breathe) There is something that Cicely and I began to say, and we adopted it and it described, at least for the world, it described us. We would say, "Givenchy had Audrey Hepburn, and B Michael has Cicely Tyson."

She was rare, and "rare" means something that is uncommon excellence—that's really who Cicely Tyson was to us who know her well and to her family, and to her art, and to her craft. I don't really want to discuss that with you, because you've heard that, you're reading about it, and you will continue to see it because it's her legacy. And now we are learning things about her the world didn't know . . . like eating fried chicken and drinking champagne on what would be her last birthday. When she left our apartment at 3:30 a.m., I said to her, "When you walk past your building's doorman, we call that 'the walk of shame.'" Those kinds of moments I will cherish. We had something Audrey Hepburn and Givenchy didn't have. I don't even know if I can describe it—we were confidants, we spoke on the telephone multiple times of the day and night. Larry Thompson (Cicely's manager) referred to us as two peas in a pod, and she indeed was the other pea in that pod of mine. As Mark-Anthony said, she would describe us as Thirds. She had this thing that I can't describe. When she walked in that day and we had one thing in mind, clearly God had another thought about what we would mean to each other. The lessons she taught me, and the lessons she was willing for me to share with her, that was the so-wonderful part about our relationship.

It's understanding somehow that I was entrusted with this charge that I recognize now was a divine charge . . . to have such an icon, such a giant of a person, such a big space, that I could be entrusted with . . . it's amazing to me. It's said that your gift will make room for you. I say it often—but I see it now as something different—Cicely came to me for a dress, and God had so

I titled this dress "Fantasy." It's a combination of Cicely's favorite design elements—the floral-draped collar, fluted-cuff sleeves, and the laser-cut silk Mikado in purple orchid.

*Photo credit: Courtesy of the author*

much more in mind for the two of us. I am just so grateful. We do celebrate what Cicely has done over the last seven decades in film and onstage . . . yet I am also sad. This is a person that I was connected to pretty much every day in some way. If you saw her, you saw me most of the time. That is going to be a loss.

I was thinking about a person losing a limb, and one still feels the sensation of the limb even though the limb is gone. That is called "phantom limb pain," and that is what I feel. The limb is gone, but the sensation is still there. You go to use the arm because you're so accustomed to it, you feel it, it's your natural instinct, but the arm is actually gone. I am so grateful the instinct and the feeling will always be there. Cicely would always say to me, "Blessed be the tie that binds."

I was given the gracious and most wonderful gift of dressing Cicely for this final occasion . . . something I've never done, but I've done many firsts with Cicely. Mark-Anthony asked me if I was sure I could do it. I said I'm not sure, but I know I have to do this—I could not imagine any other option. So with Reyes, my couture draper, we made the dress in my atelier. When I arrived at Benta's Funeral Home to go through the process of dressing Cicely, I was a bundle of nerves with the dress ready in my hands, and with the capable hands of the directors we began the process, and immediately the nervousness left me. It felt like what I've always known. I could hear her asking, "Is my foot through? Where's the armhole?"

I heard and felt all of that from this limb that's supposed to be gone. Armond Hambrick, Cicely's trusted hair and makeup artist, came and did the wig and makeup. We were laughing and having conversation. It felt like we were preparing to go to the Oscars or Tyler Perry's opening or something fabulous! As I did that final zip-up of the dress, I thought and said, as she would have, at the end of our preparation, a saying Cicely said her mother would say—and I now say it to you this morning, Cicely: "Comin' to the come to."

# THANK YOU

**Mark-Anthony Edwards**, my partner in life and business, this book is because you insisted that Cicely and I archive our work and story.

**Cassandra Keating,** your skillful and creative work as art director and designer of the draft of the book, since the start of the project, gave me a visual direction for my words and photographs.

**Reyes Cruz,** you are the master couture pattern draper, and I am proud of the work we did for my Muse.

**Armond Hambrick,** your collaboration as makeup and hair artist always provided the perfect interpretation of the vision.

I am honored that you added your words to this cherished archive, **Valerie Simpson-Ashford, Lenny Kravitz, Susan Fales-Hill, Pauletta Washington, Bridget Foley, Dr. Carol Wiggins, The Estate of Andre Leon Talley, and the Abyssinian Baptist Church.**

**Cicely's phenomenal management team**

Larry Thompson
Robert G. Endara II

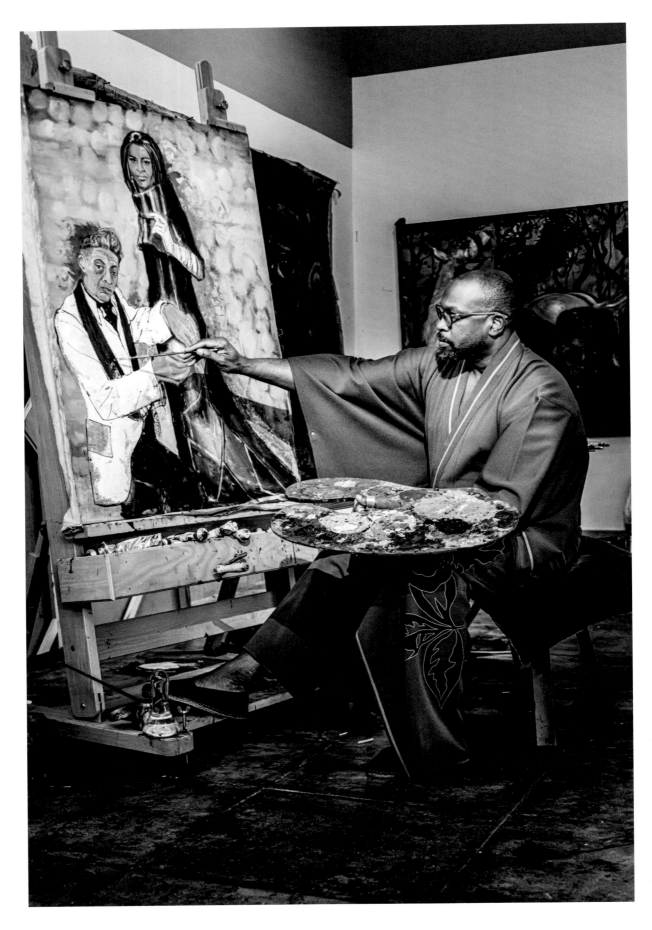

*Photo credit: Toshi Sakurai*

## My exceptional literary agent

Jan Miller and team of Dupree Miller & Associates

## The HarperCollins Publishers dream team

**Judith Curr,** President and Publisher at HarperOne
**Elizabeth Mitchell,** Executive Editor at HarperOne
**Ghjulia Romiti,** Assistant Editor at HarperOne
**Abby West,** Vice President and Editorial Director at Amistad
**Leah Carlson-Stanisic,** Associate Director of Design at HarperCollins
**Stephen Brayda,** Cover Designer and Art Director at HarperOne
**Paul Olsewski,** Senior Director of Publicity at HarperOne

## The contributing photographers

Annie Watt Photos
Christopher Duggan
Mamadi Doumbouya
Akbar Santosa

## The cover painting artist

Chaz Guest, thank you for the masterpiece you painted, "Muse"

---

**In the spirit of *Muse*, Mark-Anthony and I will donate $1.00 for every book sold to be divided EQUALLY between two remarkable organizations that are making a difference today and for the next generation. The donations will be made twice annually as long as the book is sold.**

### The Boys and Girls Club of America

**Mission: To enable all young people, especially those who need us most, to reach their full potential as productive, caring, responsible citizens.**

### Girls Write Now

**Mission: Girls Write Now breaks down barriers of gender, race, age, and poverty to mentor and train the next generation of writers and leaders for life. Together, our community channels the power of our voices and stories to shape culture, impact industries, and inspire change.**

HarperCollins books may be purchased for educational, business, or sales promotional use.
For information, please email the Special Markets Department at SPsales@harpercollins.com.

FIRST EDITION

*Ripped fabric effect on fabric swatches © WellofMike/Shutterstock*

*Photo credits:*
*Pages i, iii, v, 23, 40-41, 117, 125, 139, 163, 175, and 176: Courtesy of the author*
*Pages vi, 4, 16, 38, 46, 56, 62, 70, 80, 86, 92, 100, 110, 114, 118, 130, 136, 156,*
*162, and fabric swatches: Akbar Santosa*
*Page 103: ZUMA Press / Alamy Stock Photo*
*Page 107: Chris Chew / UPI*
*Page 121: Kathy Hutchins / Alamy Stock Photo*

Library of Congress Cataloging-in-Publication Data has been applied for.

ISBN 978-0-06-322174-1

24 25 26 27 28   RTL   10 9 8 7 6 5 4 3 2 1